CHICAGO UNDER GLASS

MARK JACOB *and* RICHARD CAHAN

CHICAGO UNDER GLASS

EARLY PHOTOGRAPHS FROM THE CHICAGO DAILY NEWS

in association with the
CHICAGO HISTORY MUSEUM

with a foreword by RICK KOGAN

THE UNIVERSITY OF CHICAGO PRESS ~ CHICAGO AND LONDON

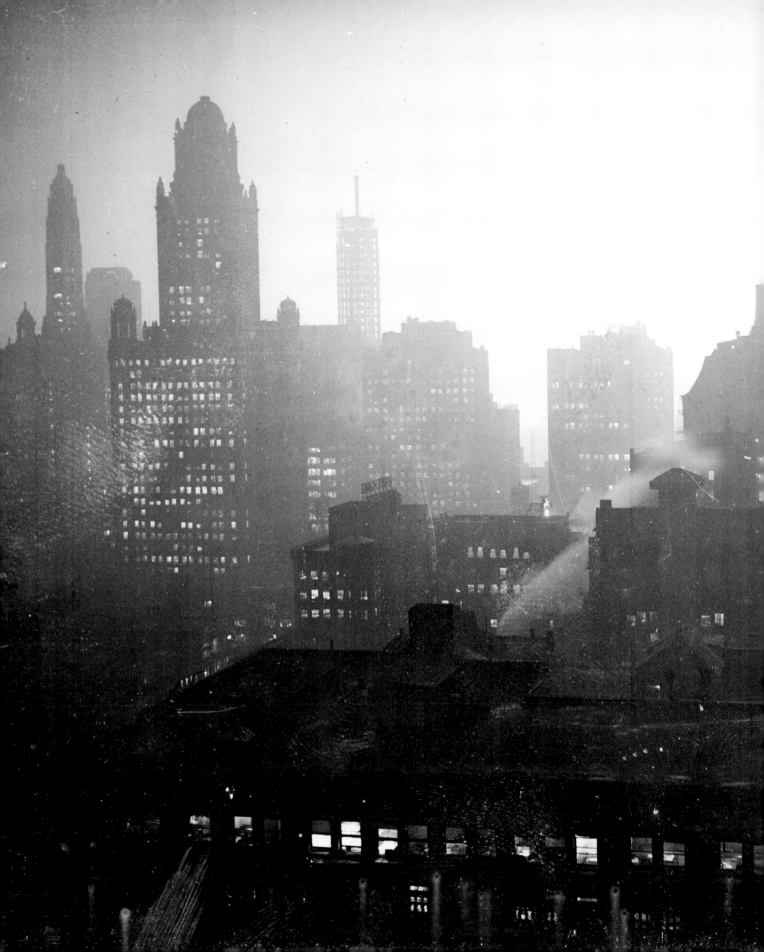

MARK JACOB and RICHARD CAHAN met during the 1980s, when they both worked for the *Chicago Sun-Times*, once the sister newspaper of the *Chicago Daily News*. Jacob served as executive news editor and Sunday editor at the *Sun-Times* before moving on to the *Chicago Tribune*. Cahan worked as the *Sun-Times'* picture editor. He left to serve as the director of CITY 2000, a photo project that documented Chicago in the millennium year. Jacob and Cahan are coauthors of *The Game That Was: The George Brace Baseball Photo Collection*.

Frontmatter Illustrations
PAGE III: In the late 1920s, the *Daily News* began phasing out glass negatives in favor of nitrate film. This image, taken from the *Daily News* offices, was an early effort of the nitrate generation.
PREVIOUS PAGE: The city at night, 1929 (for full image, see page 239).
PAGES VIII–IX: Passengers on the steamer *City of Benton Harbor*, circa 1905 (see page 121).
PAGE XI: *Diana*, by Augustus Saint-Gaudens, in front of the Art Institute, 1909 (see page 243).

The University of Chicago Press, Chicago 60637
The University of Chicago Press, Ltd., London
© 2007 by The Chicago History Museum
All rights reserved. Published 2007
Printed in the United Kingdom by Butler and Tanner Ltd

16 15 14 13 12 11 10 09 08 07 1 2 3 4 5

ISBN-13: 978-0-226-08930-0 (cloth)
ISBN-10: 0-226-08930-4 (cloth)

Library of Congress Cataloging-in-Publication Data
Jacob, Mark.
 Chicago under glass : Early photographs from the Chicago Daily News / Mark Jacob and Richard Cahan ; in association with the Chicago History Museum.
 p. cm.
 Includes bibliographical references and index.
 ISBN-13: 978-0-226-08930-0 (cloth : alk. paper)
 ISBN-10: 0-226-08930-4 (cloth : alk. paper)
 1. Chicago (Ill.)—History—20th century—Pictorial works. 2. City and town life—Illinois—Chicago—History—20th century—Pictorial works. 3. Chicago (Ill.)—Social life and customs—20th century—Pictorial works. 4. Chicago (Ill.)—Social conditions—20th century—Pictorial works. 5. Photojournalism—Illinois—Chicago. I. Cahan, Richard. II. Chicago History Museum. III. Chicago Daily News. IV. Title.
 F548.5.J33 2007
 977.3'110430222—dc22

 2006103503

♾ The paper used in this publication meets the minimum requirements of the American National Standard for Information Sciences—Permanence of Paper for Printed Library Materials, ANSI Z39.48-1992.

To
LISA HALL JACOB
and
CATE GRIFFITH CAHAN

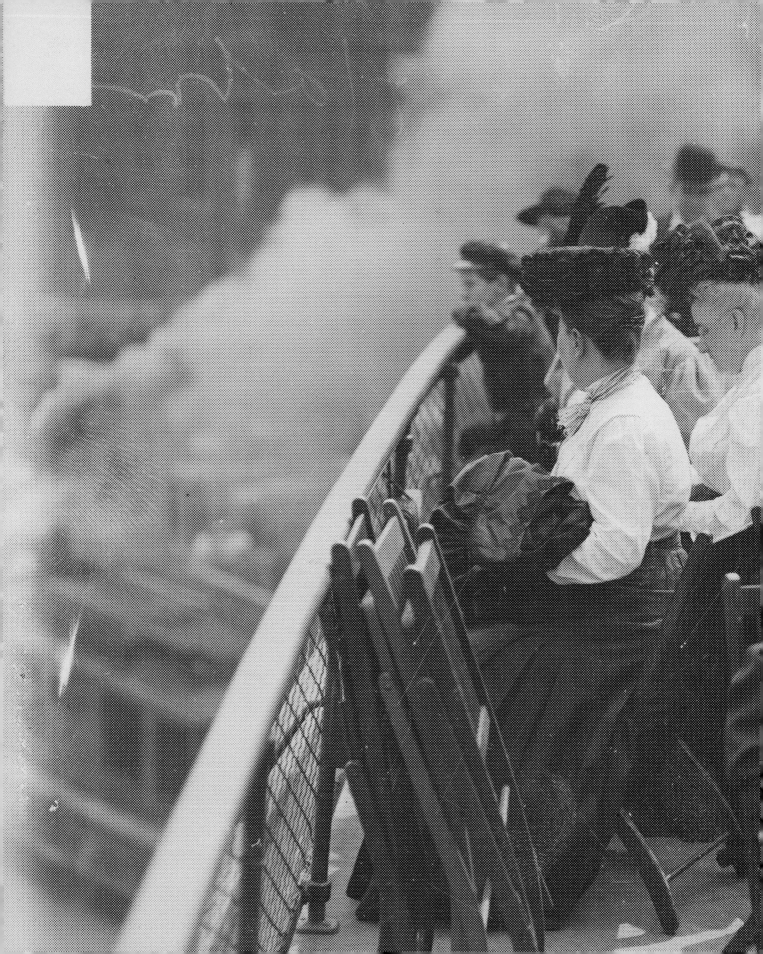

CONTENTS

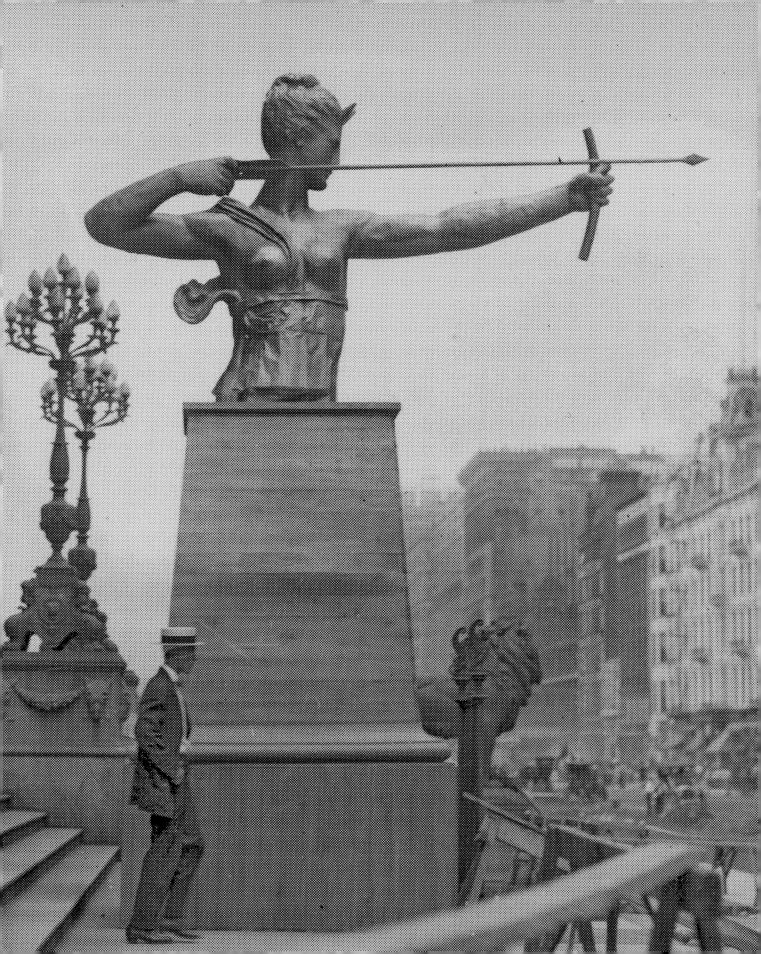

FOREWORD

by RICK KOGAN

In the early morning hours of March 3, 1978, suffering yet another hangover, I flagged a cab headed south.

The cab was a Checker, and the hangover was no more vicious than any of those that had greeted me on every morning of the previous four weeks, a streak never matched before or since—thank God—but one that now seems appropriate to the time.

This hangover marathon began the morning of February 4, the day after Marshall Field V stood on a desk in the middle of the City Room of the *Chicago Daily News* and—with the ghosts of Eugene Field, George Ade, Ben Hecht, Finley Peter Dunne, Carl Sandburg, Peter Lisagor, and so many others covering their ears while the flesh-and-blood faces of Mike Royko, M. W. Newman, Henry Kisor, Richard Christiansen, Lois Wille, and the rest of the current staff turned ashen—announced the paper's imminent death.

For the next month, we (most of us) drank hard and we (all of us) worked hard, displaying what I will always maintain was a collective determination to bury the paper, and a bit of ourselves, with pride and with passion. Those last two months were filled with some of the finest stories ever to appear in the paper, which had been born on a December afternoon in 1875. Hecht, among the brightest stars in the *Daily News'* long life, once described his colleagues as "a reportorial staff half daft with literary dreams." And so were we, in those final days, a staff half daft with proud pain.

The final edition came on March 4 (in no small or unobserved irony, the birthday of the city of Chicago), and in it were many wonderful things: "So long, Chicago," that perfectly jaunty headline, and Royko's final *Daily News* byline—though the column he wrote the day before was the one most remember: "When I was a kid, the worst of all days was the last day of summer vacation, and we were in the schoolyard playing softball, and the sun was down and it was getting dark. But I didn't want it to get dark. I didn't want the game to end. It was too good, too much fun. I wanted it to stay

light forever, so we could keep on playing forever, so the game would go on and on. That's how I feel now. C'mon, c'mon. Let's play one more inning. One more time at bat. One more pitch. Just one? Stick around, guys. We can't break up this team. It's too much fun. But the sun always went down. And now it's almost dark again."

The paper printed the names of everyone on the staff that final day, like some list of battle casualties, which we were in a sense, losers in a fight against the many new armies aimed at doing in the afternoon newspaper.

Then there was Newman's eloquent eulogy: "The *Chicago Daily News*, the writer's newspaper, ends as it began—a momentous Book of Life. But that story isn't over, just the *Daily News'* part of it. A newspaper dies, but newspapering goes on. Life goes on, the sequel and all the tomorrows after that. We die knowing that we did our job to the utmost and to the very end."

And so, the day before, I was in a Checker cab, traveling to meet my friend and colleague Tony Campbell, the paper's business editor, for a game of racquetball, which was merely an excuse for the long steam that we both believed would cure our aching heads and hearts.

The driver was an old man, his accent strong with Eastern Europe.

"You are a newspaperman?" he said.

"Yes," I replied, in no mood for elaboration and not even certain that I would still be one on Monday. I had had job offers, but nothing was certain.

"It is a good and honorable job, to tell people what has happened," said the driver.

"Yes, it is," I said.

At the time the *Daily News* shared a squat gray seven-story building on Wabash Avenue, on the north bank of the Chicago River, with the *Chicago Sun-Times*. (That too is now gone, replaced by a towering Trump concoction.) Both papers' names were atop the building and as the cab climbed toward it, the driver asked, haltingly, "You work for . . . you work for, I hope, the *Sun-Times*?"

"No," I said. "I work for the *Daily News*."

"I am so sorry," said the driver.

As I was fumbling for my gym stuff and briefcase and money, the driver overshot the health club and by the time I noticed was pulling the cab into one of the driveways from which the newspaper delivery trucks came and went. He slammed the cab into park and got out, opening the passenger door. I got out.

"Here," I said, handing him four dollar bills for the $3.20 fare. "And thanks."

"No, no," he said, pushing back my hand and the money. "I cannot take your money."

I started to protest. I didn't feel like playing charity case.

"But no," he said. There were tears in his eyes. "When I come here I learn to read English from your newspaper. I learn about the world. You keep the money, and thank you."

I walked slowly to the health club, where I told Tony this story. We did not play racquetball that morning. We did what we thought more appropriate, even necessary. We walked over to the Billy Goat for drinks.

I would eventually go to work for the *Sun-Times* and later for the *Tribune*, where I now work. But I have never forgotten that cab ride, that driver.

We live in an era when newspapers are not an essential part of most people's lives. People have other, more immediate means of getting the news

(or so they would tell you). Those armies that did in the *Daily News* have only grown in number and in the sophistication of their weaponry; the war against newspapers is now bloodier, claiming more victims every day and making many believe that there will come a day when you cannot hold a newspaper in your hands.

That is why this book is so important. It is a gathering of life, as people lived it and as generations were allowed to watch others living it. Its photos are from before my time and yours, but they are real and they are compelling and they are who and what Chicago was and is and may yet become.

This book is an acute reminder of the power of newspapers. But it is also a revelation. Yes, the *Daily News* was always known as the writer's paper, but here you will find proof that it was also a photographer's paper.

And it's about time. There are few jobs, even today, as anonymous as that of the newspaper photographer. You can read (look at) a paper for decades and not know the name of one of the dozens of people whose work has made you laugh or cry or linger over your afternoon beer or morning coffee.

When, decades ago, I collaborated with my father, a great newspaperman named Herman Kogan, on a pictorial history titled *Yesterday's Chicago*, one of my tasks was to visit retired newspaper photographers—pals of my dad—and see what they had in their personal files. They had a gold mine and a story to accompany each nugget. This experience made me more aware than most of the art of the newspaper photographer, and that knowledge has enriched me.

In this book you too will learn and be enriched, and you could not have two better people to show you the sights. I have known Mark Jacob and Richard Cahan for many years and admire not only their skill but their appreciation for and understanding of newspapers. They have gathered images (and words, let's not forget words) that will transport you, photos as curious and beautiful and weird now as they were then. That's what newspapers used to do. They were the real windows to the world.

In short, then, this book will intoxicate you. And the hangover will be one worth having.

PREFACE

by RUSSELL LEWIS

EXECUTIVE VICE PRESIDENT AND CHIEF HISTORIAN, CHICAGO HISTORY MUSEUM

Chicago in the 1890s was a city of strangers. With a population of 1,099,850 in 1890, swelling to 1,698,575 by decade's end, the city was a polyglot of people, ideas, beliefs, and customs divided by class, race, and ethnicity, but also by congested streets and neighborhoods. Chicago's physical size had exploded too. By 1890 it was the largest city in America in land area.

While it was a decade of achievement for some Chicagoans, for others it was a period of confusion and upheaval. Chicago seemed to be careening out of control. The city was simply too big and too crowded to fully comprehend; no one could wholly grasp the complexities of life that unfolded on a daily basis. Even from the pinnacle of one of the new skyscrapers in the Loop or the top of the rotation of the Ferris Wheel at the World's Columbian Exposition, it was impossible to gain a visual fix on Chicago, and citizens struggled to find visual references that provided a meaningful framework to understand this ever-changing urban society.

The development of shared visual icons for the city and a holistic image of Chicago came from an unexpected source: the *Chicago Daily News*. The *Daily News* published its first half-tone reproduction of a photograph in 1900 and began taking its own photos in 1901. Printing as many as ten editions a day and disseminating them throughout the city, the *Daily News* became a mirror of urban society, bringing to life through images the fascinating stories of the million-plus strangers who made Chicago their home. *Daily News* photographs of civic ceremonies, labor strikes, festivals, disasters, sports events, scoundrels, heroes, neighborhoods, and work united people; these slice-of-life photographs brought the far-flung reaches of the city into its residents' homes, making the city accessible and whole, a city no longer of strangers.

The Chicago History Museum's collection of *Chicago Daily News* photographs is thus significant not only for the visual record of the past burned into its negatives, but also for the transformative role these news photographs played in shaping

Chicagoans' sense of urban society and culture and an identity for the city.

This book, which presents a wonderful selection of *Daily News* photographs, would not have possible with out the generous support of the Erin Konen Memorial Fund, Inc. We are especially grateful to Joe and Judy Konen for their commitment to making this rich collection of images more available to future students of history and for their ongoing support of the Chicago History Museum.

ACKNOWLEDGMENTS

The authors must give thanks first to the people who transported more than fifty-seven thousand glass-plate negatives into the computer age. Leigh Moran, the Chicago History Museum's collection manager for prints and photographs, and Linda Evans, the museum's chief cataloger, were the heroines in the herculean effort to scan and catalog the images. They were assisted by former museum employees Bernard Reilly, Matt Cook, Amy Wood, Cynthia Mathews, and Peter Uribe. The Andrew W. Mellon Foundation funded the project, and Caroline Arms at the Library of Congress was in charge of putting the images online.

Philanthropists Joe and Judy Konen, who love Chicago, embraced the idea of producing a book to showcase the glass-negative photos, and they helped fund the project from start to finish.

The University of Chicago Press was a strong partner. Robert Devens, our editor at the press, displayed both cool expertise and unabashed enthusiasm, as did his colleagues Sylvia Mendoza Hecimovich, Elizabeth Branch Dyson, Mike Brehm, and Joel Score.

A friend and editor who served as a guardian of taste and clarity was Tom McNamee, a widely respected reporter for the *Chicago Sun-Times*. A valued consultant was Michael Williams, whose eye for photographs is surpassed only by his passion for them.

Skillful research assistance was provided by Caleb Burroughs and Galia Halpern, who found many photo gems and added valuable information as they scanned through several decades of newspapers. David R. Phillips was a solid source of information on early twentieth-century photo technology. Photo conservator Carol Turchan also lent her expertise to the project. Our thanks also to Erin Bilyeu for research help.

Others at the Chicago History Museum who provided support were Rosemary K. Adams, director of publications; Russell L. Lewis, executive vice president and chief historian; Gary T. John-

son, president; and Johnson's predecessor as president, Lonnie G. Bunch.

In order to understand the photographers who created these pictures, we talked to Ed DeLuga, who started at the *Chicago Daily News* in 1925 and worked as a photographer with his brother, William DeLuga, for several decades. We also spoke with Ruth Duensing Klotz and Hartland P. Klotz, the wife and son of *Daily News* photographer Hartland Klotz; George Peebles Jr., son of *Daily News* photographer George Peebles; Betty Armstrong, great-niece of the dean of the paper's photo department, Clyde Brown; and Cynthia Gallaher, daughter of Gilbert Gallaher, a *Daily News* picture chaser during the glass-negative era and a picture editor in the next. Former *Daily News* reporters Jack Mabley, Warren V. Prentiss, and Dick Griffin shared memories of their old paper. Special thanks also go to reporter Robert Herguth, a *Daily News* alumnus who cheered on our work, and Kenan Heise, who lent us books, material, and advice despite his loyalty to the *Daily News'* rival, the *Chicago Tribune*.

We encountered many people with special knowledge and passion for their subjects, including Great Lakes maritime historian Fred Neuschel, who deciphered the "Christmas tree ship" photo; Elizabeth McLeod, an authority on *Amos 'n' Andy*; Bertram Taft Smith, who guided us in the works of his grandfather, sculptor Lorado Taft; Marianne Rackliffe, a font of knowledge about Leopold and Loeb; aviation expert Wesley R. Smith, who explained the James F. Scott flying machine; curator Greg Malak of the Will Rogers Memorial Museum in Claremore, Oklahoma; and Bill Steinbacher-Kemp, librarian-archivist at the McLean County (Illinois) Museum of History, who illuminated labor issues of the era.

We thank the Newberry Library and the *Chicago Sun-Times* for permitting us to share the 1929 "team photo" of the *Daily News* photography staff.

We are most indebted to our families, who thrived in this modern age as we explored a century-old world. We have examined and reexamined many pictures in putting together this book, but none compares to our images of Lisa, Maureen, and Katherine, and of Cate, Elie, Claire, Aaron, Glenn, Caleb, and Madeline.

SOURCES

Librarians are the heroes of this book. The staff of the Research Center at the Chicago History Museum kept the microfilm coming and guided us in any number of ways. The Newberry Library's collection of *Chicago Daily News* memorabilia—including copies of the in-house newspaper, the *CDN Circle*—gave us a perspective on the inner workings of the newspaper that was available nowhere else. The Newberry also maintains the manuscripts of several *Daily News* principals, including Victor Lawson and Ben Hecht. Former curator Diana Haskell was particularly helpful in opening up the stacks for our research, and other Newberry employees—Martha Briggs, Diane Dillon, John Powell, and Jill Gage—also lent their expertise. We checked out scores of books (and racked up sizable fines) from the Skokie (Illinois) Public Library, one of the finest suburban libraries in the land, and the Northwestern University Library, which maintains a microfilm collection of the *Daily News* as well as photo periodicals of the age. In addition, the Chicago Tribune Historical Archive provided a modern way to search for long-lost facts, even if the *Tribune* wasn't the *Daily*

News' equal in the first decades of the twentieth century.

The most important books have been the ones that took us back to the early *Daily News*. Henry Justin Smith wrote two novels based on his years at the newspaper, *Deadlines* and *Josslyn*, as well as *Chicago: The History of Its Reputation*, with Lloyd Lewis. Ben Hecht's *Gaily, Gaily* details his early experiences as a Chicago reporter, and his autobiography *A Child of the Century* is based in part on life at the *Daily News*. Robert J. Casey's *Such Interesting People* discusses many top editors at the paper. Melville E. Stone's autobiography *Fifty Years a Journalist* and Charles H. Dennis's biography *Victor Lawson: His Time and His Work* explains the founding of the *Daily News*. The newspaper's history is further detailed in dissertations by Donald J. Abramoske ("The *Chicago Daily News*: A Business History 1874–1901," University of Chicago) and Chi-ying (Jim) Chu ("Henry Justin Smith 1875–1936: Managing Editor of the *Chicago Daily News*," Southern Illinois University) and an unpublished manuscript by Louis L. Pryor ("Years of Transition: The *Chicago Daily News* under Publishers Strong, Knox, Knight," available at the Newberry Library). Ben Hecht's *A Thousand and One Afternoons in Chicago*, a collection of his *Daily News* columns, and Carl Sandburg's *Chicago Poems* display the raw writing talent of the paper.

Several Chicago writers have cleared a path for us, and we are in awe of their talent. Nelson Algren inspired and taught us that Chicago's history is an epic poem with his *Chicago: City on the Make*. Richard Lindberg has produced fascinating accounts of the city's history, including *Chicago Ragtime*, *Return to the Scene of the Crime*, and *To Serve and Collect*. A favorite of both authors is

the incomparable Emmett Dedmon, whose *Fabulous Chicago* is our desert island pick, the book we would select if allotted just one volume on this era of Chicago history. Perry R. Duis, a professor at the University of Illinois at Chicago, took us on a trolley ride back to the age with *Challenging Chicago: Coping with Everyday Life, 1837–1920*. And Alson J. Smith showed us Chicago's special place in art with *Chicago's Left Bank*.

Some concise stories in this book are based on exhaustive and lengthy work by others. *An Accidental Anarchist* by Walter Roth and Joe Kraus is a riveting examination of the still-perplexing Lazarus Averbuch case. Other books of note: *Lindbergh* by A. Scott Berg, *Eastland: Legacy of the Titanic* by George W. Hilton, *Tinder Box: The Iroquois Theater Fire 1903* by Anthony P. Hatch, *Chicago Death Trap: The Iroquois Theater Fire of 1903* by Nat Brandt, *Black Chicago: The Making of a Negro Ghetto 1890–1920* by Allan H. Spear, *Race Riot: Chicago in the Red Summer of 1919* by William M. Tuttle Jr., *Yesterday's Chicago* by Herman Kogan and Rick Kogan, and *Chicago Transit* and *Chicago Maritime* by David M. Young.

A number of periodicals also shaped our views. Along with the *Chicago Daily News*, there were the *Chicago Tribune*, the *Chicago Sun-Times*, *Illinois Issues* magazine, the *New York Times*, the *San Francisco Chronicle*, *Aviation History* magazine, and *Jewish World Review* magazine.

Writers who attempt to interpret history should be wary of the Internet—there is plenty of misinformation there—but they can ignore it only at their peril. Some of the Web sites we consulted were brilliant and illuminating, and their facts were confirmed through countless other sources. The key site, of course, is the Library of Con-

gress's American Memory site, which contains more than fifty-seven thousand *Chicago Daily News* photographs (click "List all collections" at http://memory.loc.gov, and you'll find them). That online archive is being updated with additional caption information as research continues. With a fast connection, you can now view and retrieve photos from the *Daily News* archive faster than a city editor on deadline.

In addition, there is the Chicago History Museum's site (http://chicagohs.org), an ever-expanding resource. Scott Newman's "Jazz Age Chicago" (http://jazzagechicago.com) lends a reliable and readable perspective. Chicago journalist Rich Samuels has amassed an impressive site (http://richsamuels.com) that delivers everything related to early Chicago radio except the static.

The stories uncovered by these researchers have given voice, volume, and definition to the photographs in this book.

CHICAGO UNDER GLASS

CHAPTER ONE

FOCUS AND FLASH POWDER

It is one of the finest collections of early American photojournalism, a stirring chronicle of Al Capone, Babe Ruth, Charlie Chaplin, and the lethal ladies who inspired the musical *Chicago*. There are anarchists too, and suffragettes, quack doctors, society dames, bomb makers, "sporting" women, crooked politicians, aerial daredevils, and astrophysicists.

The *Chicago Daily News* archive of glass-negative photographs covers a breathtaking era in American history, 1901–1930, a rough time captured in a fragile form. The photographs are a window into the early twentieth century, but for almost a century the window was sealed. For up to sixty years, about eighty-three thousand glass negatives were packed away in boxes in the *Daily News* library. They were ignored, left to oxidize, to crack and chip away. In 1960 they were donated to the Chicago Historical Society (now the Chicago History Museum), where they sat for nearly four more decades. But in the late 1990s more than fifty-seven thousand negatives were brought back to life—unboxed and unsleeved, placed on digital scanners, reorganized, and recataloged.

The archive—one of the most comprehensive looks at American urban life a century ago—depicts three decades of breathtaking advances and adventures, a formative era in which Chicago, and the nation, grew up: The nation's travelers and freight haulers unsaddled their horses and climbed aboard horseless carriages and flying machines. Industrialists hostile to labor unions were forced to accept, grudgingly, such revolutionary concepts as the five-day workweek and the

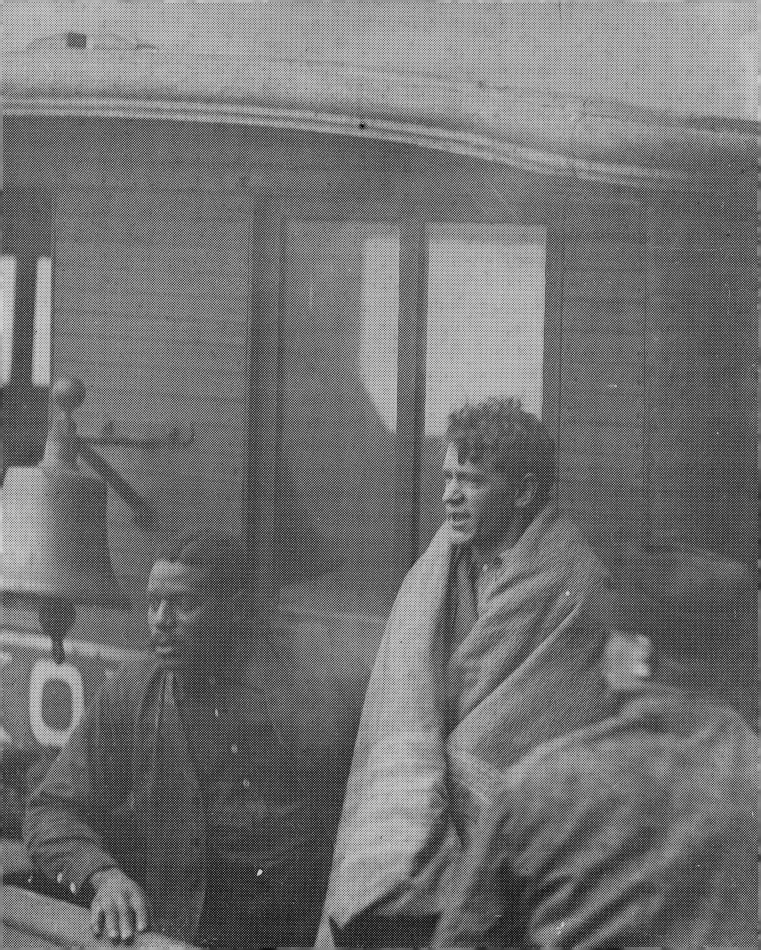

eight-hour workday. A society that had relied on newspapers and word of mouth was exposed to a wider world through motion pictures and radio. The planet survived the Great War and the worst pandemic since the Black Plague. And gangsterism flourished, until the 1929 Saint Valentine's Day Massacre compelled the city to become reacquainted with the rule of law.

Muckraking journalist Lincoln Steffens, visiting Chicago in 1904, described the city as "first in violence, deepest in dirt; loud, lawless, unlovely, ill-smelling, irreverent, new; an overgrown gawk of a village, the 'tough' among cities, a spectacle for the nation." By 1930, though, Chicago was beyond its adolescence and had achieved modern maturity as a world-class city.

Newspaper photography grew up, too. It was at first an artless gimmick. Early photo equipment was too cumbersome and crude to produce subtle, exacting work. The negatives—thin panes of glass coated with photosensitive silver bonded by a layer of dry gelatin emulsion—were brittle and heavy, and the first newspaper photographers could carry only a few plates. That made photographers highly selective in what they shot and hesitant to experiment. What's more, until the flashbulb arrived in 1930, photographers had to ignite flash powder, a diluted form of gun powder, to illuminate their subjects.

Few early *Daily News* photographers had any formal education in their craft, but they had the main qualifications: they were strong enough to handle the heavy equipment, and they knew the city. Their bosses would send them to cover the Civic Opera one day and the Cubs the next. They were shooting for deadline, not for posterity. Their pictures were made to fill the columns of newspapers that sold on the streets for a penny apiece. Never could

they have imagined that a hundred years later their work would be posted on an electronic network, accessible to people around the world.

By contemporary standards, the pictures they took are raw. Most are planned, posed, and prefocused—subjects frozen in front of the camera. There are few peak moments because the equipment limited spontaneity. It would be decades before the term "photojournalism" was coined and anyone like the famed New York photographer Weegee ever thought about creating a sociological record, much less art, with a Speed Graphic camera. But the *Daily News* photographers did indeed create a thorough record of their society, and sometimes they even created art. Their subject was fascinating, and their timing was perfect. Chicago's population doubled in three decades, to 3.4 million by 1930. It was a city that changed by the minute, that helped define the American character, that screamed and whispered, rescued and robbed, loved and hated, created and killed—and showed as much verve and personality as any city in the world.

Now the blur of events has been frozen in these images, and the *Daily News* photographs tell lasting stories of what we were then, and what we still are today.

"HUSTLERTOWN"

The four red stars of Chicago's municipal flag represent four defining events in the city's history: the Fort Dearborn massacre of 1812, the Great Fire of 1871, the World's Columbian Exposition of 1893, and the Century of Progress fair of 1933.

It is the period between the Columbian Exposition, Chicago's debut on the world stage, and the Century of Progress, its encore, that is cap-

tured in extraordinary detail in the *Daily News* photo archive. Certain aspects of the age are well known. Al Capone left a scar on the city's image that remains visible today. Upton Sinclair's *The Jungle* and Richard Wright's *Native Son*, which paint vivid pictures of life during these years, are still required reading. But other features of early twentieth-century Chicago are long forgotten and seem strangely foreign today.

People spoke a peculiar language, with words like *flapper, flivver, hooch, palooka, ragamuffin,* and *flatfoot.* Boxers were pugilists, drivers were autoists, and psychiatrists were alienists. Union enforcers were called Chicagorillas. The public transit service was known as traction. Chicagoans played a game called pushball, featuring a fifty-pound ball six feet in diameter. They enjoyed baseball too, but spelled it as two words: base ball. Women weren't allowed to vote, and the very act of cutting their hair short—into something called a bob—was considered revolutionary. White entertainers painted their faces black to sing minstrel songs and tell jokes.

It was also a time of striking contrasts, of high-minded visions and shocking lawlessness. The Burnham Plan, published in 1909, set lofty goals for the city's development, promising, among other things, a lakefront reserved for the public. But in that same year the Levee district flourished on the Near South Side, serving up prostitution and opium—competing brands of human degradation.

Jane Addams set the standard as a social reformer, as proud of her title as garbage inspector as she was of being a Nobel Peace Prize winner. But charitable works and good intentions in Chicago were often overshadowed by vice and mayhem. An anarchist tried to poison Archbishop George Mun-

delein at a civic dinner. Gangster Earl "Hymie" Weiss was gunned down in front of Holy Name Cathedral. By the mid-1920s, gangsters ruled Chicago with Pierce-Arrows and tommy guns, corrupting judges, police, and politicians.

Chicago was a bastion of industrialism and of labor unrest. The system that produced the Union Stockyards and the Pullman railcar works also spawned unions—and bitter strikes by teamsters, garment and laundry workers, bill posters, and waitresses. The radical Industrial Workers of the World was founded in Chicago, as was a businessmen's association called the Rotary Club. Science competed with pseudoscience and snake oil. Albert A. Michelson, the University of Chicago physicist who won a Nobel Prize in 1907 for measuring the speed of light, is filed in this archive near Robert Stoetzel, a boy transported through a pneumatic tube in a 1908 experiment.

Two distinct communities formed in Chicago in the decades after the Great Fire, and this archive shows them both. One was the Prairie Avenue world of the financiers, industrialists, and mercantile barons who profited most from rebuilding the wickedest city in the west. Businessmen named McCormick, Pullman, Field, Armour, and Swift spread their bounty and boodle, dispensed jobs and money, and created a city rich in idealism, potential, and beauty—if you could forget the stench of the stockyards.

The other community was the hardscrabble, Hull-House world of laborers, clerks, orphans, and immigrants upon whose broad shoulders the city was built. Chicago was a city of quickly forgotten victims and savvy survivors—"Hustlertown," writer Nelson Algren called it decades later. The names of Lucy Parsons, Emma Goldman,

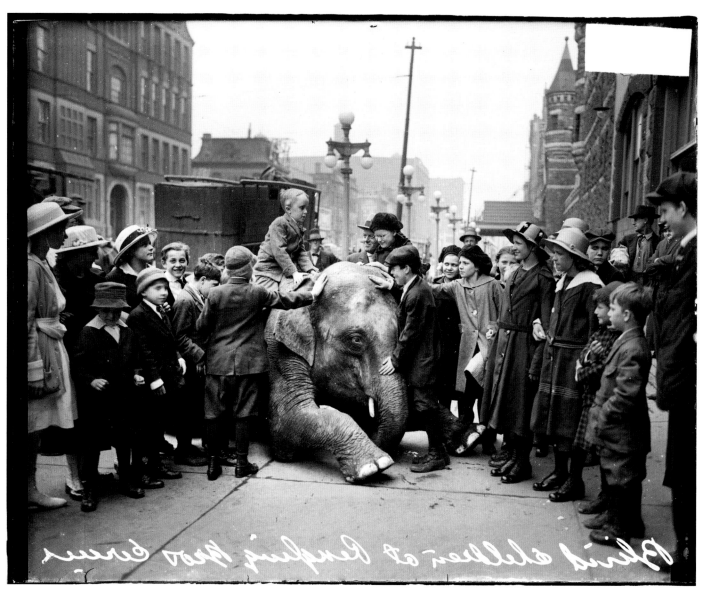

Blind children touch an elephant while visiting the Ringling Brothers Circus in 1917.

Facing page: *Daily News* publisher Victor Lawson founded the newspaper's foreign service, an influential force in Americans' comprehension of world events. But Lawson also understood the importance of local news. "Even a fire in your woodshed, or your garage, would interest you more acutely than the burning of Buckingham Palace!" he wrote.

and Ben Reitman are today emblazoned on few city monuments, but these and other street fighters for the underclass are frequently recalled in these photos. They too helped create a city with a gleaming lakefront and teeming slums.

"A DAILY NOVEL WRITTEN BY A SCORE OF BALZACS"

Volume 1, number 1 of the *Chicago Daily News* came off a tiny, rented press on December 23, 1875. The Great Fire had ravaged the downtown district only four years earlier, but much of Chicago was already rebuilt, and it was clear that this city of four hundred thousand people would regain its title as "Queen of the West."

The *Daily News'* debut was hardly noticed. There were five other major newspapers and several foreign-language papers operating in the city at the time. The established *Chicago Tribune* called the *Daily News* "the latest curiosity of the newspaper line." The new paper was the brainchild of Melville E. Stone, who at twenty-seven had already worked on five Chicago papers. Stone's idea was to create an afternoon paper with "no axes to grind, no friends to reward, no enemies to punish." It started modestly, as a four-page sheet published Monday through Saturday, with ads that boasted, "You can read it and still have time left for an honest day's work." Joined by two reporters and armed with five thousand dollars from a British investor, Stone took space in a four-story building at 123 Fifth Avenue (now 15 North Wells Street), near Madison Street. Decades later, newspaper historian Jason Rogers declared that the arrival of the *Daily News*—independent, condensed, and complete—marked a new epoch in journalism.

The staff wrote copy in longhand on a pine table. When each day's first edition was sent to press, the editorial crew marched down to the basement to fold copies of the *Daily News* and hand them, in bundles of ten, to waiting newsboys. "Here the newsboys congregated to get their copies of 'The Daily Noosk, wan cent,' and their yells could be heard all hours of the day," wrote Ozora Stearns Davis, who chronicled the early years. Those shouting newsboys sold nine thousand copies the first day. But the economic depression that had started in 1873 soon took its toll. Stone ran into severe debt and lost his top reporter, William Dougherty. Despite front-page braggadocio that the young paper had a large circulation, the *Daily News* was losing money. By mid-1876, Stone told the composing room foreman he expected to close the paper imminently. The enterprise was saved days later when Victor Lawson, a high school acquaintance of Stone who published a tiny Nor-

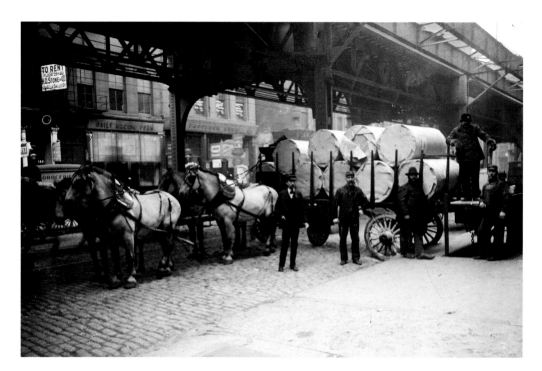

In 1903, huge rolls of newsprint were delivered to the *Daily News* by horse cart. By 1927, the newspaper owned a fleet of motorcycles to get the news to market.

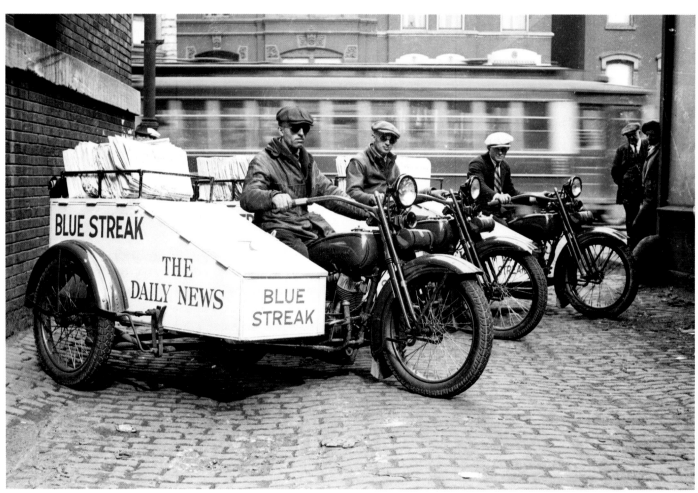

wegian weekly in the building, agreed to buy a majority interest and take over as publisher. He immediately paid off four thousand dollars in debt, gave Stone one-third interest in the paper, and hired him as its general manager and editor.

Lawson was a business genius. He bought a hundred thousand pennies from the U.S. Mint in Philadelphia, transported them to Chicago, and encouraged merchants to hold 99-cent sales so that pennies would be in general circulation for his one-cent paper. Stone was an editorial genius. The paper built a reputation for what he called "detective journalism in the public behalf." No misdeed was too small, or too distant, to track down. During its first years, the paper uncovered massive local election fraud and dispatched reporters to Germany, where they tracked down the scoundrel president of the failed State Savings Bank of Chicago.

By 1877, when the *Daily News'* circulation had reached almost twenty thousand, the paper started breaking even. Two years later, circulation was at forty-seven thousand. In 1880, the eight-page *Daily News* was the leading afternoon paper in Chicago, and in 1885, just a decade after its launch, the newspaper boasted a circulation of one hundred thousand, the largest of any daily in the city. In celebration, Lawson fired off a cannon on the lakefront.

The *Daily News*, "cheap in nothing but its price," was long on vigor. This was one of America's first family papers—directed toward men, women, and children. It was filled with police news, financial tidbits, and tips for housewives. "The paper's most striking characteristic was its compactness," wrote Donald J. Abramoske. "If the stories had been any more concise, they would have disap-

peared altogether. With many items only one, two, or three sentences in length, Stone was able to include something for everybody." But in 1888, Stone announced his resignation, saying he was worn out. Lawson continued to run the afternoon *Daily News* and the *Chicago Morning News*, which Stone started in 1881. Later known as the *Chicago Record*, that paper's all-star staff included writers Eugene Field and George Ade, who were published in the *Daily News* as well.

Lawson saw the *Daily News* as an important nonpartisan force to promote civic good. During his forty-nine years as publisher, he used the paper to promote the World's Columbian Exposition, the building of a sanitary canal to funnel sewage away from Lake Michigan, the establishment of the nation's first juvenile court and juvenile detention home, and the creation of the Chicago Symphony Orchestra. The *Daily News* became a social service agency as well as a newspaper. Its Fresh Air Fund provided medical attention, milk, food, and respite to more than ten thousand mothers and forty thousand children over several decades.

Lawson also earned a top-notch reputation for journalism. Dismayed that most foreign news was obtained from or filtered through international sources, he created a foreign service in 1898, posting reporters in London, Paris, and Berlin to report directly for the *Record*. After selling the *Record* in 1901, he switched the ever-expanding foreign service to the *Daily News*. Lawson's correspondents were among the first to file dispatches from the Spanish-American War in 1898, China's Boxer Rebellion in 1900, and the Russo-Japanese War in 1904–1905. Lawson sent thirty reporters to cover World War I, and the *Daily News* became the first newspaper to syndicate its stories nationwide.

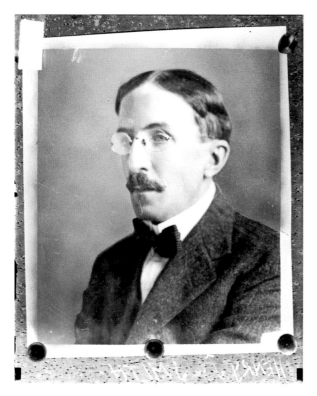

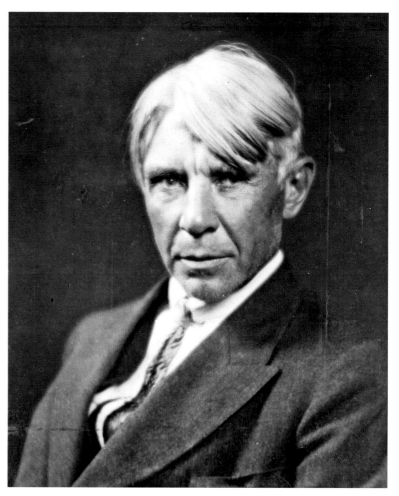

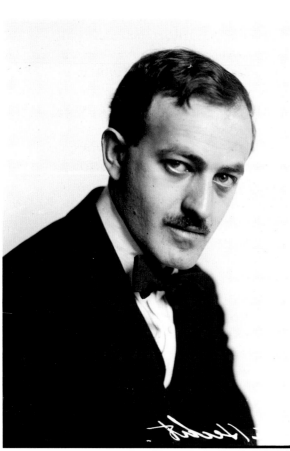

Henry Justin Smith **(top left)** was an inspirational managing editor. "He read each story avidly, as if his desk were a prison cell and tales of the outside world were pouring in upon it," wrote Ben Hecht. The tacks and cork on the edges of this image indicate that it is a "copy shot," a photo taken by someone outside the *Daily News* staff that was rephotographed for inclusion in the newspaper's archive. This and the adjacent photo of Carl Sandburg are the only two copy shots in this book.

Ben Hecht **(left)** got his start in Chicago in 1910 as a picture chaser for the *Chicago Journal*, tracking down—and sometimes stealing—photographs of people in the news. According to his friend Charles Samuels, Hecht "clambered up fire escapes, crawled through windows and

transoms, posing when detected as everything from a gas meter inspector to an undertaker's assistant. In a short while he was recognized as the most adept and audacious picture thief in Chicago." He switched to the *Daily News* in 1914, and his writings—if not his ethics—serve as the standard for the city's journalists today. This portrait was shot in 1918.

Carl Sandburg **(above)**, a native of Galesburg, Illinois, came to Chicago seeking a literary career. His verse first gained notice in *Poetry* magazine in 1914, and three years later the reporter for leftist publications joined the mainstream, writing for the *Daily News*. He stayed at the paper until 1932. In later years, Sandburg won two Pulitzer Prizes, one for poetry and one for history.

During the early 1900s, the *Daily News* built a circulation of four hundred thousand, a hundred thousand larger than that of any other American newspaper of the age. As important and prestigious as the foreign bureau was, the key to the paper's success was that its editors understood how to address simpler interests: love, ambition, health, and money. "There are more romances told or suggested in one issue of a metropolitan daily than you will find in a dozen novels," Lawson wrote.

The *Daily News* was known as a writers' newspaper, primarily thanks to Henry Justin Smith, who served as a top editor for most of the first three decades of the twentieth century. Smith started at the paper in 1899 as a "picture chaser," gathering family photos of crime or fire victims. The job was a litmus test for young newspapermen. Smith must have passed, because in 1901 he took over as city editor despite being only twenty-five, one of the younger members of the staff.

The reserved and moody Smith, who ran what was called the Local Room, was soon in charge of the entire editorial staff—editors, reporters, photographers, and artists. Smith was partial to the writers, and he filled the staff with stars. "He saw the paper as a daily novel written by a score of Balzacs," wrote Ben Hecht, one of his scribes. Smith's staff included poet Carl Sandburg; novelists Hecht and Meyer Levin; John Gunther, who later wrote popular travel books and a stirring memoir of his son's death entitled *Death Be Not Proud*; and Robert Hardy Andrews, who went on to create radio's *Ma Perkins* and *Jack Armstrong, the All-American Boy*. The paper also boasted Pulitzer Prize–winning brothers Paul Scott Mowrer (a 1929 honoree) and Edgar Ansel Mowrer (a 1933

winner), as well as James W. Mulroy and Alvin H. Goldstein, who shared a Pulitzer in 1925 for helping solve the "crime of the century," the murder of Bobby Franks by Nathan Leopold and Richard Loeb. Henry R. Luce worked at the paper as a cub reporter before heading to New York to establish *Time* magazine. Herbert Block, better known as Herblock, started his political cartooning career at the paper.

Not all of these literary lions adapted well to the grind of a daily paper. Sandburg, who worked for the *Daily News* from 1917 to 1932, often arrived at the office with his pockets filled with newspaper clippings, some as old as ten years. "At the end of each day, Sandburg would put his feet on his desk, watch the pigeons and make up a poem, which he would place in a wire basket on his desk," stated a *Daily News* internal memo. Sandburg reviewed movies—an assignment he liked because it gave him a chance to sit in a dark room and compose poems in his head. As the memo put it, "City editors thought he was a terrible reporter, a so-so movie reviewer, and, according to one such editor, 'a pest.'"

Recalled Hecht, coauthor of the classic newspaper play *The Front Page*: "Everybody was so busy being literary that nobody could produce a good murder story. Once I wrote a story involving a triple murder and forgot to mention until the third paragraph that somebody had been killed."

But Hecht, and most others, found the *Daily News* to be a fine brewery for brilliance. "When we were done with stealing photographs, climbing into mansions through bathroom windows, impersonating bill collectors and gas inspectors in our quest for statements from abandoned wives or dentist-slaying paramours, we assembled in a

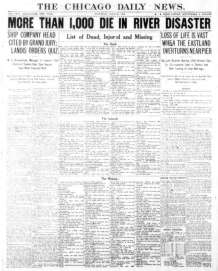

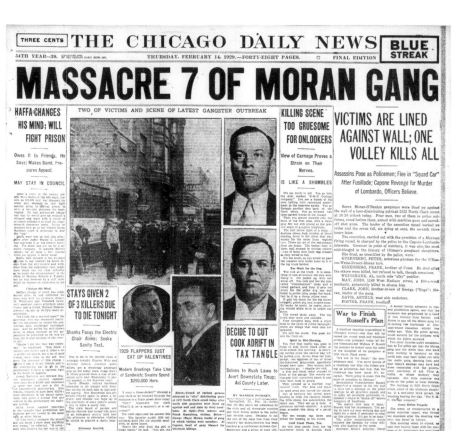

It took decades for photography to stake out a place on the front page, as demonstrated by coverage of the three biggest local news stories of the era. After the 1903 Iroquois Theater disaster, editors decided that the death list was more important than pictures. In 1915, *Daily News* photographers quickly arrived at the scene of the *Eastland* ship disaster, which occurred only blocks from the newspaper's offices, and they took great pictures—none of which ran on page 1. But by 1929, when the Saint Valentine's Day Massacre took place, editors had recognized the credibility and immediacy that photos provided.

half a dozen saloons to brag and cadge drinks . . . and fight with each other," he wrote. "We were the least angry of young men on earth, but we found endless glee in destroying the world."

"NEWSPAPER PICTURES ARE A TEMPORARY FAD"

The *Daily News* built its reputation on words. The idea that pictures could carve out their own space—and their own respect—was accepted only grudgingly and gradually.

Photography was still in its youth at the turn of the twentieth century. A Frenchman, Louis-Jacques-Mandé Daguerre, had been the first to capture a photographic image in 1837. Across the ocean, in the 1850s, *Frank Leslie's Illustrated Newspaper* and *Harper's Weekly* hired artists to roam the world and produce woodcut illustrations of exotic locales, some of which were based on photographs. Thirty years later, Joseph Pulitzer and his *New York World* and William Randolph Hearst and his *San Francisco Examiner* became the first publishers to use illustrations in their daily papers. Both were forced to defend the practice. "A great many people in the world require to be educated through the eye, as it were," wrote Pulitzer in 1884.

The *Daily News* took the lead among Chicago newspapers in the use of graphics. In 1883, editor Melville Stone traveled to New York to meet with Pulitzer after he bought the *New York World* from financier Jay Gould. "One of the early bits of enterprise on the part of the *World*'s new proprietor was the introduction of illustrations," wrote Charles H. Dennis in his biography of Victor Lawson. "Stone was immediately interested and borrowed a member of the *World*'s mechanical force

to introduce the process in Chicago. At the same time, he took into his employ a clever young artist, Jon L. Sclanders, who thus became the first staff artist of a Chicago newspaper. His early pictures were made by the so-called chalk-plate process. The artist took a metal plate coated with chalk and with a stylus scratched lines through the chalk. Then molten metal was poured over the surface and thus the cut was formed. Some of the pictures produced by Sclanders in that crude fashion were strikingly good."

Stone was an innovator, but he did not have a long-term appreciation of the graphic arts. "Newspaper pictures are a temporary fad," he wrote, "but we're going to get the benefit of the fad while it lasts."

And benefit he did.

"When the women of Chicago opened the *Daily News* on January 2, 1884, they must have been surprised and delighted," wrote Donald Abramoske. "There on the editorial page was a heavily illustrated article headed 'Studies in Foot-Wear.' Pictures had been printed before this in the *Daily News*, but they had been extremely rare. Now five of them were published all at once—a remarkable piece of enterprise."

By 1888, pictures—normally a column or less in width—had become a daily feature in the newspaper, and a small staff of artists was in place to make zinc etchings. A decade later, the halftone process was introduced. Photographs were converted into tiny black dots of various size that tricked the eye into seeing what appeared to be shades of gray. In 1897, the *New York Tribune* published the first halftone photo in a mass-circulation daily paper. The following year, portable cameras were introduced. The new Graflex cameras were heavy

leather boxes that would hold four-by-six-inch or five-by-seven-inch glass negatives. The photographer looked down on an image reflected on a plate of ground glass. A shutter made possible exposure times as fast as one-thousandth of a second. Flash powder, which exploded into brilliant light, made it possible to shoot indoors and at night.

In July 1900, William Randolph Hearst, publisher of the *New York Journal*, established a Chicago newspaper called the *American*. Like the *Journal*, the new Chicago paper was packed with photos, often several per page. The *Daily News* was determined to keep up with the competition. "Lawson equipped his presses for color printing and briefly experimented with the use of red ink in his sporting extra," Abramoske wrote. More important, Lawson introduced photographic halftones for the first time on July 31, 1900. There on page 7, with no fanfare, were two fashion photographs, one showing a woman attired in a four hundred-dollar gown and another showing her clad in a fifty-cent cheesecloth frock.

The *Daily News* was in the business of photojournalism.

"WE CAMERAMEN HAVE GOT TO BE WHERE IT'S HAPPENING"

Clyde T. Brown was described as a "pug-nosed, roly-poly 15-year-old kid in short pants" when he answered a newspaper ad in 1895 to work in the *Daily News* mail room. Assigned as an office boy by city editor "Butch" White, Brown was soon transferred to the newspaper's art department after cartoonist John T. McCutcheon and other staff artists noticed that the boy could make impressive sketches.

The art department in those days was a hothouse of talented sketch artists ready to be dispatched to the scene of any fire, riot, or train wreck. In the *Daily News'* coverage of the deadliest fire in Chicago history, the Iroquois Theater fire in 1903, imaginative drawings of panicked, fleeing patrons had a far greater impact than the photographs of the aftermath.

As Will Jenkins wrote in the June 1902 issue of *International Studio* magazine, the artist could "enliven" the facts and could tell a story with more forcefulness, style, and taste than a photographer. "Moreover," Jenkins wrote, "he possesses that most valuable power, the elimination of unimportant detail and of adding emphasis to the essential facts, such as only the practiced journalist eye could select and set down, with the clearness so necessary to any newspaper statement."

But the force of photography—its credibility and instant impact—eventually won out. Clyde Brown worked as an artist for only a short while before picking up the "mobile camera." In 1900, city editor White assigned Brown to assist artist Charlie Wise in setting up the new *Daily News* photographic department. Decades later, the newspaper's employee publication *CDN Circle* would report that in the beginning Brown and Wise were the only "working captive photographers in harness."

The life of an early cameraman was demanding. "The news photographer of the tintype era was a sturdy lad who carried around a dog house facetiously called a camera," wrote Jack Price, a pioneer photographer in New York City. Photographers such as Brown toted not only their hefty Graflex cameras but tripods, flash powder, and other accessories. They had to fully understand

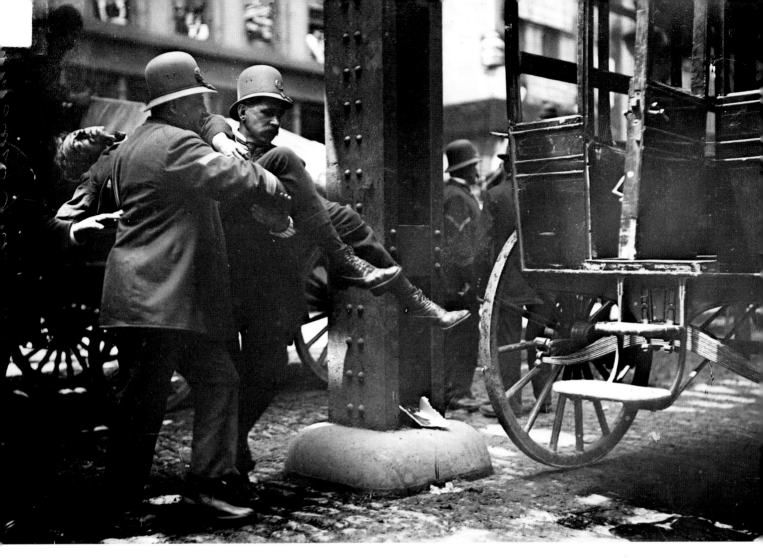

In June 1902, when striking teamsters attempted to stop packers from delivering meat throughout the city, *Daily News* photographers covered the clash in the West Loop. One photograph shows an injured non-union driver being carried to an ambulance. Another shows dust rising from an overturned delivery wagon.

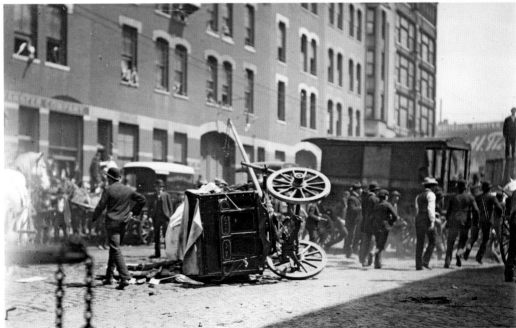

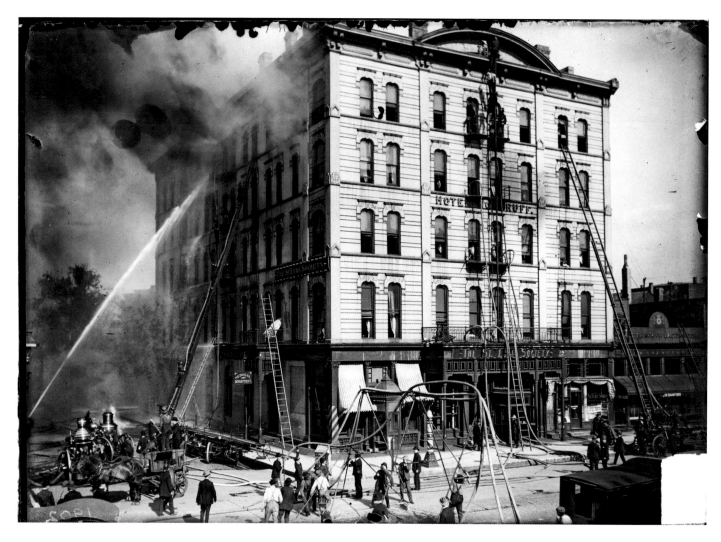

Firemen climb tall ladders while steamers pump water on a blaze at the old Hotel Woodruff, which had recently been converted into a Saint Luke's Society hospital. The photographer climbed to a slightly elevated position to capture this overall view of the building, at Twenty-first Street and Wabash Avenue on the South Side. Ten people died in the fire, which occurred in 1902.

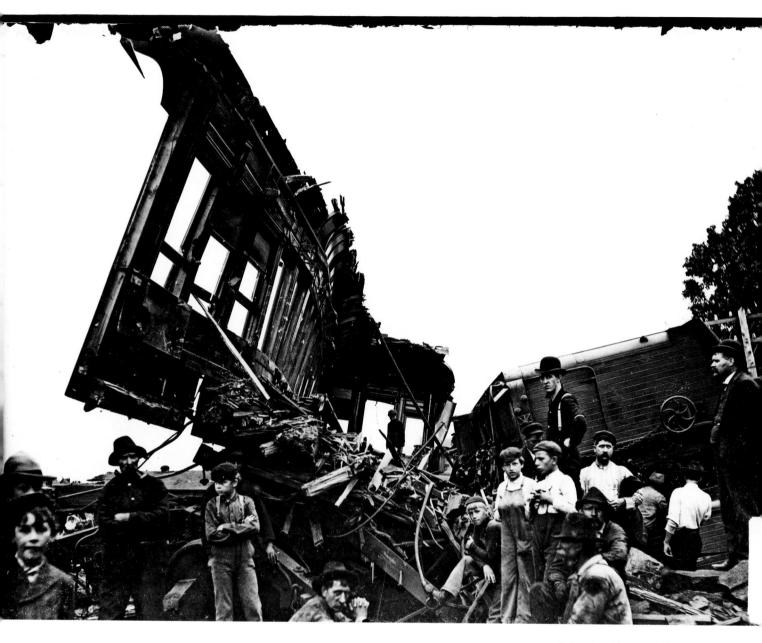

Railroad accidents made for fine photos in the early days. This one shows the remains of a collision between two trains, one carrying a Doremus Congregational Church group on a Sunday school trip. The 1904 wreck, near the Glenwood Station in the south suburbs, killed sixteen people and injured more than eighty.

exposure and be able to handle the dangerous flash powder. They had to get to the scene as quickly as possible—on streetcars in the early years—and be able to work their way into position.

D. D. Cook, in the July 1903 issue of *Photo Era* magazine, described the challenges that early newspaper photographers faced. "Reaching the scene of the tragedy, everything is confusion," Cook wrote. "The swaying mob or morbidly curious humanity, the ambulances, the firemen, and police, all engaged in their work of succoring the injured, caring for the dead, and keeping order. . . . Several plates are exposed under bad conditions, for there is not time to wait until the smoke and dust settles, and then comes the race for the office, with the sometimes gloomy hopes of success, the hasty and forced development, and the record-breaking 'drying stunt.'" Photographers were expected to develop their plates and make prints from wet negatives on bromide paper within fifteen minutes.

It's not clear how long Charlie Wise lasted with the magic camera, but Brown stuck with it for forty-five years. He photographed the city's major disasters—the Iroquois Theater fire and the 1915 *Eastland* steamer accident on the Chicago River—and traveled long distances to document the aftermath of the 1906 San Francisco earthquake and the 1907 earthquake that devastated the Jamaican city of Kingston. He photographed the inaugurations of six presidents and was on the scene of many major Chicago murders, including the Saint Valentine's Day Massacre. By the late 1920s, Brown was known as the most experienced Chicago newspaper photographer, driving around the city in his Studebaker Commander. When he retired in 1945, he was the dean of American newspaper photographers.

Brown was the first chief of the *Daily News* photography department. During the mid-1930s, he became something of an art photographer, dispatched several times to Europe to record life in Holland, Hungary, Ireland, Germany, Yugoslavia, Poland, and Italy for the paper's photogravure sections. But his bread-and-butter work was always news photography. He once told a group of reporters covering a riot: "You men can get up on a house with binoculars or call somebody up on the phone and get your story. We cameramen have got to be where it's happening." In 1927, Brown was assigned to cover severe flooding along the lower Mississippi River. Marooned on a levee near Rolling Fork, Mississippi, he persuaded officials to rescue him and take him to the Poydras levee just minutes before it was dynamited to help save the city of New Orleans.

While the *Daily News* prided itself on the celebrity of its writers, especially its foreign correspondents, it seldom acknowledged its photographers. The foreign correspondents, who took news photos during their travels, were the only staff members consistently credited in the paper for their photography. But their negatives, and those of photographers hired on location by them, are not part of the glass-negative archive.

Back in Chicago, Brown and his staff labored in almost complete anonymity. The vast majority of their work was simply credited in the paper to "a staff photographer of the Daily News." The staff from 1901 to 1930 included Andrew T. Miller, Frederick C. Eckhardt, George Peebles, Hartland Klotz, W. Alden Brown, Robert Stiewe, Russell Hamm, Albert Westelin, Joe Marino, Saverio Salerno, Cliff Thompson, Hume Whitacre, Francis H. Byrne, Milton Brooks, and brothers Wil-

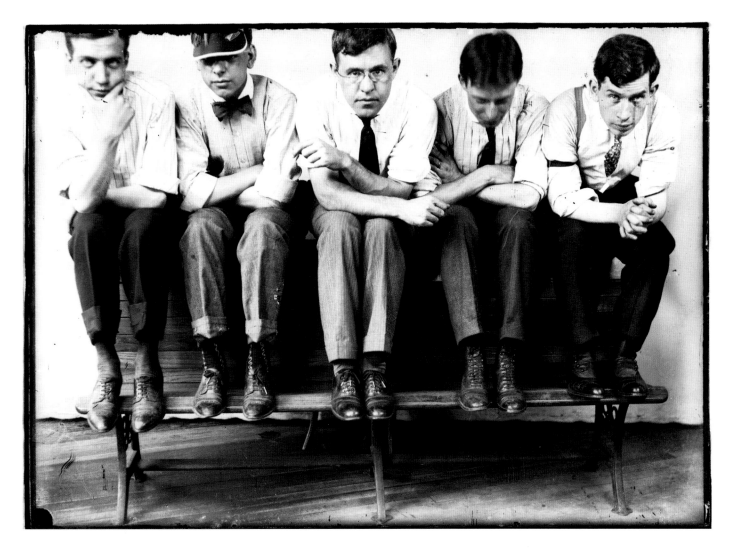

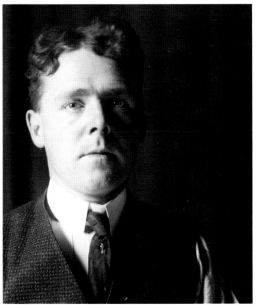

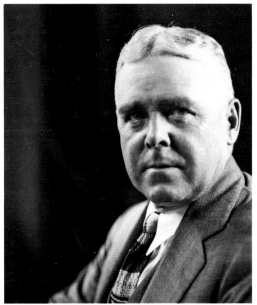

Five members of the *Daily News* art department strike a pose in 1907. The newspaper's artists had a variety of tasks: drawing sketches, creating fancy frames for illustrations, and airbrushing photographs. The first staffers from the art department who were sent out with cameras continued to be called artists, until the job title of "photographer" was adopted in 1908.

Clyde Brown, the *Daily News*' first photo chief, in 1909 and 1928.

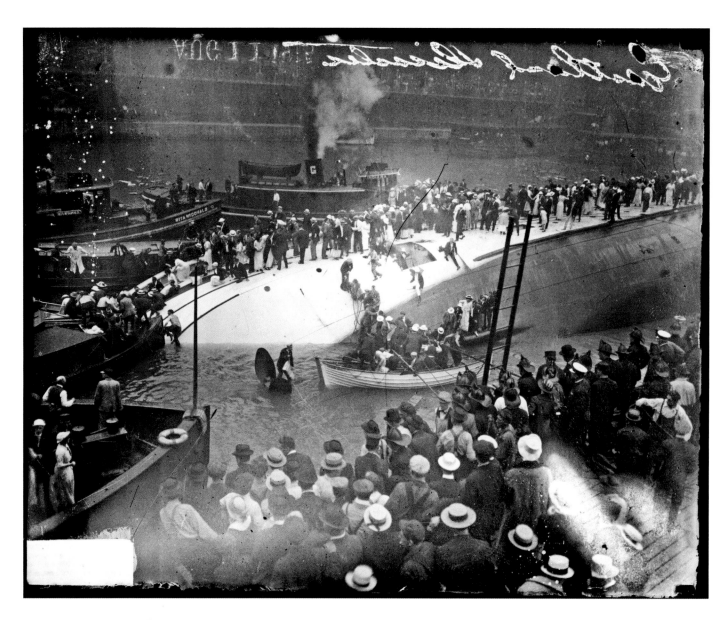

The capsizing of the steamer *Eastland* in the Chicago River in 1915 was an unimaginable disaster that focused attention on the power of photo-journalism. The *Daily News'* Fred Eckhardt rushed to the riverside to take this photograph and others. The pictures created a sensation, but the men with the cameras were not yet part of the newspaper's star system. Eckhardt's extraordinary work was credited in print to "a staff photographer of the Daily News."

liam and Ed DeLuga. The caption for a 1912 photograph also identifies Doc Smalbord and Jens Eriksen, who served as the paper's art director, as members of the photography staff. Most *Daily News* photographers began as "inside men," assisting in the darkroom or studio, or as picture chasers. It usually took years to get on the street with a camera.

Andrew Miller, who had dreams of becoming a comic strip artist when he started at the paper as a copy boy around 1904, worked for decades as Clyde Brown's assistant and later rose to the position of chief photographer. He covered the Leopold and Loeb case in 1924, and worked so closely with Brown that they came to be known around the newsroom as "Clyde 'n' Andy," a play on the radio comedy team of Amos 'n' Andy. Miller liked to tell the story of how he was assigned to go up in a balloon and take aerial photos in 1919, but was called off the job just before takeoff. Once aloft, the balloon exploded and fell to earth.

Fred Eckhardt produced the *Daily News'* most famous spot-news photographs of the era, depicting the steamer *Eastland* capsized in the Chicago River. None of Eckhardt's *Eastland* photos ran on the newspaper's front page, but one of them took up almost half of page 3. The photo was credited generically to a staff photographer. Four days later, Eckhardt's picture had gained such a morbid popularity that the paper ran a front-page box offering copies for five dollars apiece, with proceeds going to disaster victims. Once again, no mention was made of the photographer's name. Eckhardt defected to the *Tribune* in 1920 and spent the last thirty-five years of his career there. When he died in 1966, the *Daily News* obituary made no reference to the *Eastland* photos.

George Peebles, a debonair man who looked good in a homburg hat or a tuxedo, was known for photographing Chicago's rich and famous. "Peebles put society photography on the map," said William DeLuga. Peebles, who started at the *Daily News* in 1922 at age eighteen, was hired, he told his sons, because he could write captions, a skill he had developed in an earlier job for the Underwood & Underwood wire service. He was one of the first photographers to ride around the city with a police radio and claimed to have been one of the first to reach the scene of the Saint Valentine's Day Massacre. Stories about newspaper coverage of the massacre abound, and some are contradictory, but one of the best involves Peebles. According to lore, Peebles and a *Daily News* reporter spirited away three overcoats from the Clark Street murder scene because they contained documents they thought might shed light on the crime. They soon realized that the coats belonged to coroner Herman Bundesen, a police officer, and a reporter for a competing paper. In true *Front Page* tradition, the *CDN Circle* reported, only "Bundesen and the detective got their coats back."

Peebles, like Brown, was remembered for the beauty of his photos. "George Peebles took gorgeous pictures and Clyde Brown was the same way," recalled Jack Mabley, who began work as a *Daily News* reporter in the late 1930s. "They had a weakness for pretty blue skies and cumulus clouds. They were principally artists."

Hartland Klotz started in 1924 at age eighteen, working as a copy boy, picture chaser, and cub reporter for three years before joining the photo staff. He covered the sinking of the pleasure boat *Favorite* off the Oak Street beach in 1927, but his fame came later, during World War II, when he

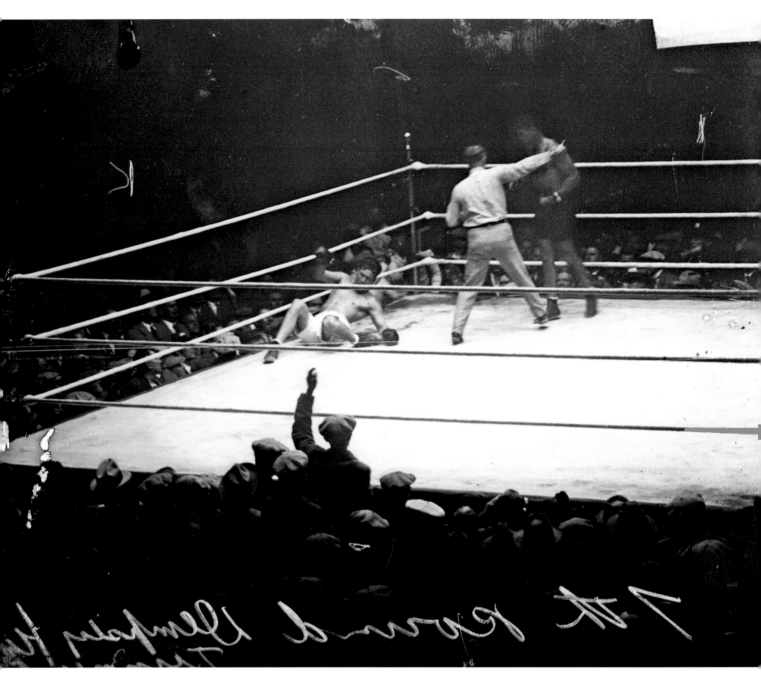

With boxer Gene Tunney on the canvas, referee Dave Barry orders Jack Dempsey to his corner during the "long count" in their 1927 bout at Soldier Field.

took a photo of dour Sewell Avery, president of Montgomery Ward & Company, being carried out of his office by GIs during a bitter confrontation with government officials.

Although every photographer was expected to cover all types of events, many carved out specialties. W. Alden Brown, who began work in 1912 and photographed through the 1950s, loved to shoot baseball. Robert "Smiling Bob" Stiewe, who started in 1928, specialized in crime—from gangsters to judges. Russell Hamm started many days at the Washington Park and Arlington Park horse racing tracks photographing early-morning workouts. The *CDN Circle* noted: "He also specializes in beach beauties." Al Westelin and Joe Marino were assigned to the night shift. Saverio Salerno, who started at the paper in 1913, worked in the darkroom.

On the night of September 22, 1927, the *Daily News* photo staff performed as a well-trained team to cover the heavyweight championship fight between Gene Tunney and Jack Dempsey. Tunney had defeated Dempsey the previous year, and the rematch at Chicago's Soldier Field was attended by more than a hundred thousand fans. It is considered one of the great fights of the century.

Clyde Brown and Miller were stationed in a tower overlooking the ring. At ringside were Alden Brown, Peebles, Hamm, and Cliff Thompson. As soon as the opening bell brought the fighters out of their corners, the photographers began shooting. They passed their exposed negatives to motorcycle couriers, who rushed back to the Daily News Building with sirens blaring. The first negatives reached the paper only thirteen minutes after the fight began. Westelin and Salerno, in the darkroom, quickly developed the photos and be-

gan feeding prints to the art department and picture editors.

Tunney dominated the first six rounds but was floored by two rights from Dempsey in the seventh. A new rule required fighters to head to the far corner of the ring before the count began. Dempsey hesitated, taking about five seconds to reach his corner. The referee delayed his count, and the extra seconds were decisive: Tunney struggled to his feet as the ref reached seven, eight, or nine (accounts vary) and went on to win the bout. One of the *Daily News* photos records the historic "long count." The image, frayed at the edges and displaying crop marks probably made by picture editor Julius Klengel, shows referee Dave Barry motioning Dempsey to retreat while Tunney sits on the mat.

At 9:54 p.m., a mere eight minutes after the decision for Tunney was announced, the *Daily News* hit the streets, claiming that the speedy turnaround constituted a world's record. Its special edition, featuring an article by legendary sportswriter Fred Hayner, pictures by the photo staff, and a complete ten-round blow-by-blow account, sold a hundred thousand copies. Clyde Brown, Alden Brown, and George Peebles spent the night churning out photos for future editions. They slept that night on the floor of the WMAQ radio studio because all the downtown hotel rooms were taken.

While they gained vital experience in the field, newspaper photographers also benefited from two technological developments. In 1912, the Speed Graphic was introduced. Like the Graflex, the new camera could be hand-held or mounted on a tripod, but it was far less bulky. The Speed Graphic—with two shutters, three viewfinders,

a rise-and-fall front, and lateral shifts—looks complicated today, but it was considerably easier to operate than the Graflex and quickly became the workhorse of the *Daily News* photo staff. The camera was retrofitted in the 1920s to use longer, faster lenses. The family of Hartland Klotz still owns the Speed Graphic he was issued in 1928.

Just as important was the development of the flashbulb, which came near the end of the 1920s. "It has given us the opportunity to make pictures that were never thought of in the days of unsatisfactory flash powder," Clyde Brown said. Photographers also found themselves more welcome at indoor events. "Hotels, theaters, mansions, and auditoriums hitherto closed to picture men armed with popping flashlight guns soon will be opening their doors to the gentlemen of the camera, now equipped with flash bulbs, absolutely noiseless and more efficient," the *CDN Circle* reported in 1930.

Daily News photographers primarily covered Chicago and the surrounding area. When they did leave the Midwest, it was most often to follow a major news event or disaster. The staff's most frequent destination was Washington, D.C., where photographers covered presidential inaugurations and such events as the 1906 wedding of Alice Roosevelt to Nicholas Longworth. *Daily News* photographers attended almost all of the national political conventions and often covered out-of-town World Series games and spring training by the Cubs and White Sox. But other trips seemed random. They followed evangelist John Alexander Dowie to New York City in 1903 and traveled to Esopus, New York, to profile Democratic presidential nominee Alton B. Parker in 1904. They covered the building of the Panama

Canal in 1908 and the race riots in East Saint Louis in 1917.

As the photo staff became more productive, its status in the paper grew. "Pictures have become as much a part of the modern newspaper as the stories themselves," proclaimed a 1920s *Daily News* employee manual. "And the *Daily News* pioneered in newspaper photography." A 1926 promotional brochure bragged that the newspaper offered Chicago's first and finest pull-out photogravure section. The weekly insert made its debut on August 11, 1923, featuring pictures printed on high-quality paper using screens that produced a pattern of fine lines instead of the usual halftone dots.

Victor Lawson died in 1925. As much as he cared about the *Daily News*, he made no mention of the newspaper in his will. Walter A. Strong, the paper's business manager, organized a syndicate of investors and bought the paper for $13.7 million. He took over as publisher and ran the paper with Lawson confidants Charles H. Dennis and Henry Justin Smith as his top editors.

In 1929 the *Daily News* moved from its original offices, at Wells and Madison streets, to the new Chicago Daily News Building at 400 West Madison. The three-block move, to a twenty-five-story art deco skyscraper just west of the Chicago River, was a blessing for both the photographers and the photo archive. Built off the newsroom on the sixth floor of the new building were a large photo studio, three darkrooms, two print rooms, and a "cameraman room." The glass negatives, until then stored precariously in the paper's library, one floor beneath the stereotype room, were transported in metal containers designed to protect the fragile plates, then filed in drawers. Decades later, chief librarian Tom Sayers recalled

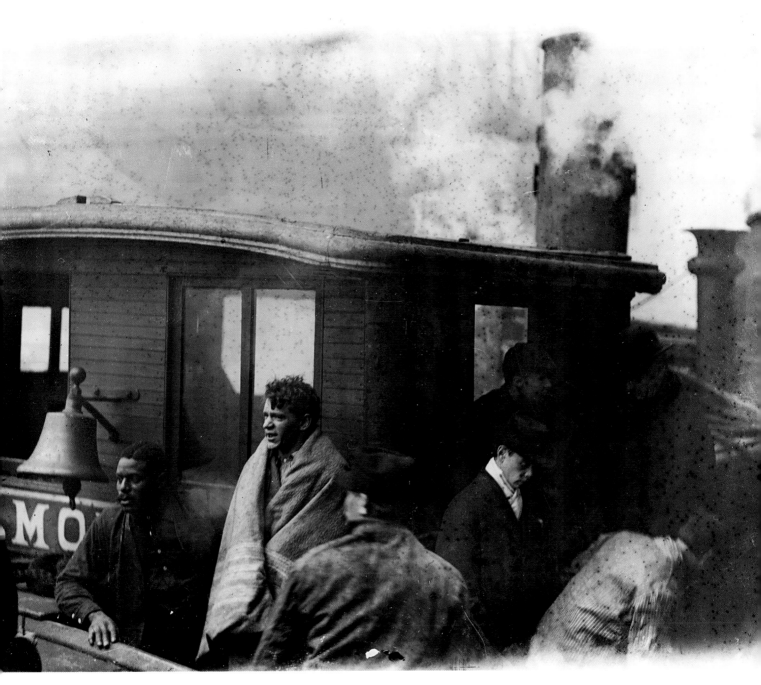

One of the most poignant *Daily News* pictures from the early years of the century depicts a 1909 disaster on Lake Michigan. A temporary wooden crib, built more than a mile out on the lake for workers constructing an intake facility and tunnel to supply drinking water to the South Side, burst into flames. Thirty men were immediately killed, and the rest of the laborers jumped into the frigid water. The final death toll was sixty. The photo shows some of the twenty-five survivors aboard the tugboat *T. T. Morford* as it headed toward shore.

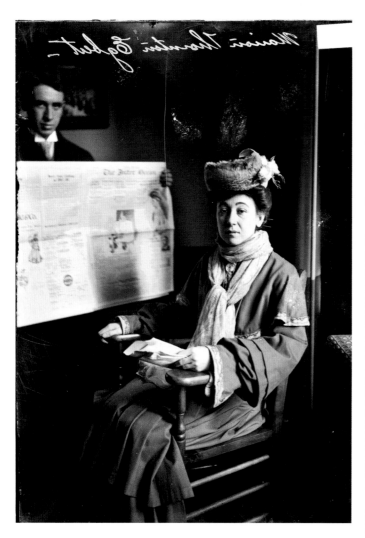

The *Daily News* archive reveals the
techniques of early press photogra-
phy. For a 1906 portrait a man held
a newspaper to reflect light from a
window back on the subject, Marion
Thornton Egbert. Egbert, editor of
a magazine for bachelors, engaged
in years of legal battles with her es-
tranged husband. Their tussles over
divorce and child custody supplied
the newspapers with lurid tales of
her entertaining Kentucky gentlemen
in her "bohemian" studio.

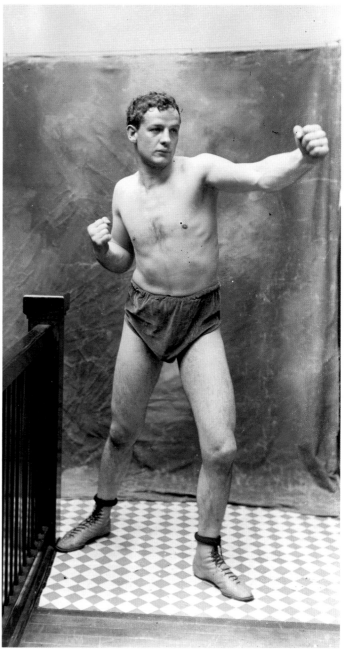

The newspaper did not maintain a
photo studio until the late 1920s. Be-
fore that, most sports portraits, in-
cluding this 1902 shot of boxer Mar-
vin Hart, were taken in the natural
light of a *Daily News* stairwell.

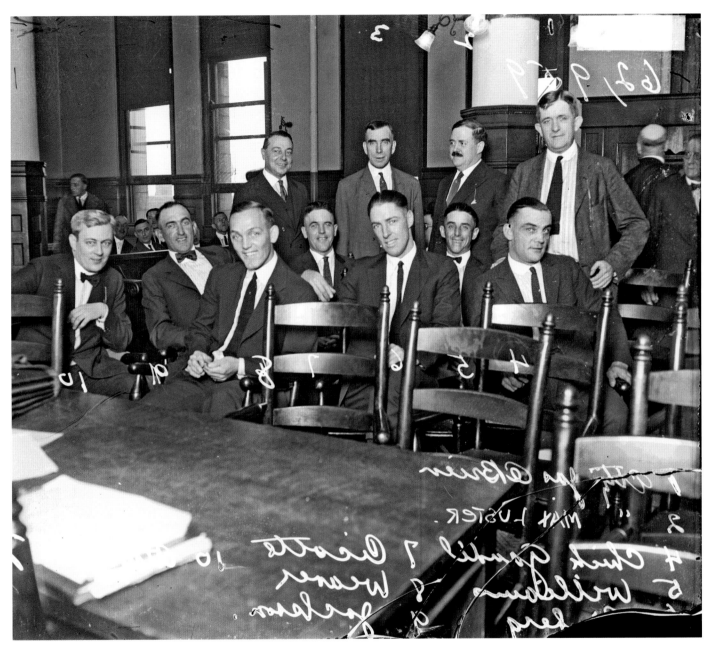

A 1921 picture of the infamous Chicago Black Sox shows how photographers made notes, often identifying the pictures' subjects, directly on the negatives. They wrote on the emulsion side of the glass plates, which is why the writing appears in reverse in prints. When the photograph was reproduced in the newspaper, the art department would either crop the image or airbrush the writing. Shown here are (seated, from left) attorney Thomas Nash and ballplayers "Shoeless Joe" Jackson, George "Buck" Weaver, Eddie Cicotte, Charles "Swede" Risberg, Claude "Lefty" Williams, and Arnold "Chick" Gandil.

the days in the old building when steaming water from stereotypers would seep through the ceiling and bathe the collection. He said he spent much time drying negatives.

"10 TONS OF CHICAGO HISTORY MOVED FROM DAILY NEWS"

Control of the *Daily News* passed to three other owners: Frank Knox (in 1931), Knight Newspapers (1944), and Field Enterprises (1959). In 1960 the *Daily News* moved to a new home at 401 North Wabash Avenue and consolidated its library with its new sister paper, the *Chicago Sun-Times*. Instead of hauling the heavy glass negatives to the new offices, the papers' publisher, Marshall Field IV, decided to donate the collection to the Chicago Historical Society.

On April 27, about one hundred thousand glass-plate negatives were moved two miles north to the historical society, at Clark Street and North Avenue on the Near North Side. A *Daily News* article headlined "10 Tons of Chicago History Moved from Daily News" noted: "The six movers handled their burden as carefully as if it were precious china. In some ways it was more precious—and just as fragile."

The agreement between Field Enterprises and the historical society was remarkably casual. "If we were to relate exactly how it came about we would at best burden our readers with unnecessary detail, and at worst arouse some clucks of disapproval on account of the informal and unconventional character of the negotiations," wrote CHS director Paul M. Angle in the winter 1960 issue of *Chicago History* magazine. The donation, he said, was one of the society's most important acquisitions in years, but not one word had been put on paper. "We distrust superlatives," he wrote, "but if any noncommercial institution has a finer photograph collection than this for the period covered we shall be greatly surprised."

Angle said that his staff spent the summer of 1960 going through the files and tossing out thousands of negatives deemed unworthy of saving. The historical society originally planned to make two sets of prints from ten thousand historically significant negatives. One set would be kept at the society, the other would be given to the *Daily News*. "The procedure is costly but necessary," wrote Angle. "Glass plates 40 and 50 years old are brittle and often break even when handled with the utmost care. Besides, many in this collection are showing signs of deterioration, and if not printed soon, will be beyond recovery."

The glass plates included 243 eight-by-ten-inch negatives, 18,000 five-by-seven-inch negatives and 65,000 four-by-five-inch negatives. (Staff photographers generally stopped using five-by-seven plates in 1922.) In 1998 the Chicago Historical Society was given four hundred thousand dollars by the Andrew W. Mellon Foundation to catalog and digitally scan the *Daily News* glass-plate negatives and to rehouse them in archival envelopes. The collection was a perfect candidate for digitalization. Many of the negatives showed heavy silver mirroring, a metallic sheen on the surface. That is not uncommon with aging newspaper negatives, which often were not washed properly in the rush to publication. Only a few of the glass negatives were found to be broken. Some were stuck together, but most could be separated without damage. The oldest negatives were digitized first. Starting in January 1999, technicians scanned 57,471 images,

about two-thirds of the collection, most of which have also been cataloged and posted online.

The *Daily News* archive may be the earliest large collection of U.S. newspaper photographs still in existence, says Michael L. Carlebach, author of *American Photojournalism Comes of Age.* Glass-plate negatives from most turn-of-the-century publications, he notes, have long since been discarded or otherwise destroyed: "It's remarkable that these photos were saved."

In 1973, Field Enterprises donated more photos to the historical society: about 220,000 nitrate and safety-film negatives dating from the late 1920s to the 1970s. The 11,345 nitrate negatives have been scanned but are not yet online. The safety negatives, which are more stable and less prone to deterioration or combustion, await attention.

The *Daily News* closed in 1978, a victim of "p.m. disease." Afternoon papers nationwide folded as nightly television news gained viewers and consumers' reading habits changed. Many staff members were hired by the *Chicago Sun-Times*, also owned by Field.

It is virtually impossible to determine how many of the images in this archive were printed in the *Daily News.* In the early twentieth century, the paper produced up to ten editions per day, and the few institutions that keep *Daily News* microfilm generally have only one edition per day. About two dozen photographs were published in each edition, with the photographic content varying somewhat, though rarely dramatically.

It is common in newspaper production for many photographs never to see print. Often, only one photograph from an assignment is used with a story. And frequently a story is killed or an editor decides to run it without accompanying art.

It is safe to say that the majority of the photos in this book have never before been published, and many of those that were published appeared only as thumbnail-sized mug shots.

It is also clear that this collection does not include all the photographs taken by the *Daily News* staff during this era. All newspaper photo libraries have suffered from the disappearance of pictures through theft and disinterest. And as newspapers switched to newer photographic methods, preserving glass negatives was sometimes considered more of a chore than a privilege. Now, however, the images that survived are treasured and have become an electronically accessible public resource. Ironically, the photo archive has become the *Daily News'* most prominent legacy.

The Library of Congress, in partnership with the Chicago Historical Society (renamed, in 2006, the Chicago History Museum), has presented the newly cataloged digital images on its American Memory Web site. Museum staff and volunteers have transferred notations made by photographers and *Daily News* clerks to the digital files, along with additional information. The original index cards were often abbreviated and incomplete. (A photograph of Theodore Roosevelt standing with University of Chicago president William Rainey Harper, for instance, is labeled "TR with President Harper.") Researchers first looked to the *Daily News* itself, searching microfilm for such details as subjects' first names, but they also consulted other sources. The city changed its street number system after the turn of the century, and researchers converted addresses to the present system.

Anyone with a computer can now search the archive and so discover ways in which the world has changed. For example, there are 2,046 photos that

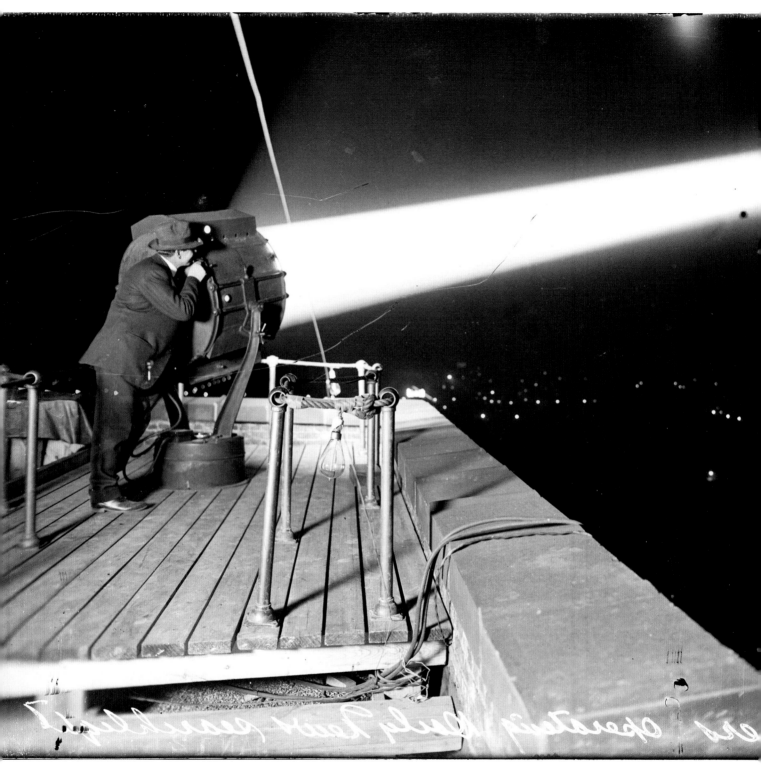

The *Daily News* occasionally went beyond newsprint to report important events. During the World Series, a scoreboard on a downtown street was updated after every play. For at least three presidential elections, the paper's staff used a searchlight to announce the results. The operator, atop one of the city's tallest buildings, would swing the light horizontally for one candidate and vertically for another. This photo is from 1916, when the paper beamed the news of Woodrow Wilson's reelection.

Many of the photographs in this collection focus on the *Daily News* itself. Hundreds of images document the official *Daily News* car, boat, and plane, as well as the newspaper's sanitarium, trips for kids, and Easter egg hunts. Here the composing room staff celebrates its last edition in the paper's first home, on Wells Street. The *Daily News* moved west to its own building on Madison Street in 1929.

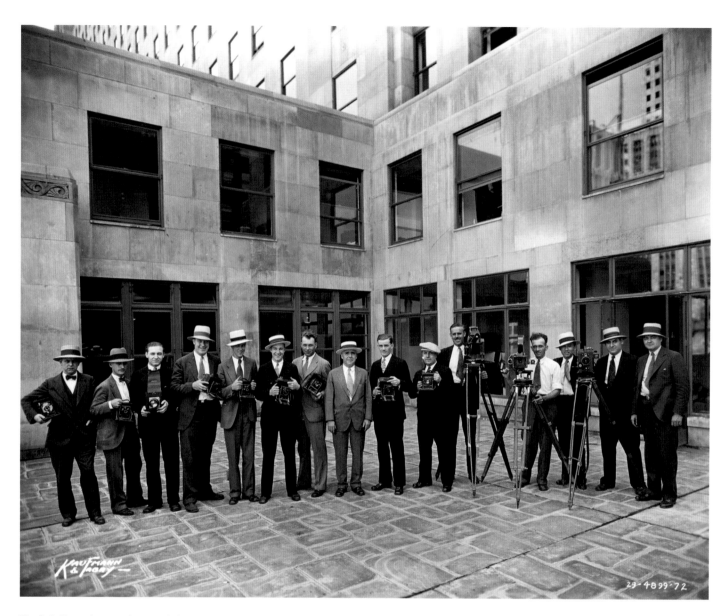

The *Daily News* photography team, led
by Clyde Brown (center, without cam-
era), poses for the Kaufman & Fabry
commercial photography firm at the
new Chicago Daily News Building.

answer to a search for "horse"—a testament to the importance of that beast of burden at the turn of the century. Yet by 1930, the horse had become virtually irrelevant in American urban life. A search for the name "Henrietta" yields seven pictures showing four different women with that name. There are also thirty photos of Chaunceys and sixty-three of Wilburs. While photos of blacksmiths and dirigibles are clearly depictions of another age, the archive also reveals ways in which we have changed hardly at all. Much of what the pictures show is altogether familiar: posturing politicians, awe-inspiring technology, the worship of movie stars—albeit of silent films—and other celebrities.

Of course, the *Daily News* archive is not complete. Missing are such luminaries as Frank Lloyd Wright and his Robie House; the famed Everleigh sisters, madams of the Levee district; Helen Keller; Ida B. Wells; Theodore Dreiser; Edgar Lee Masters; Upton Sinclair; Daniel Burnham; and economist Thorstein Veblen, who studied shoppers at Marshall Field's and came up with the idea of "conspicuous consumption." The *Daily News*, like most mainstream media of the time, was slow to recognize African American contributions to the culture, especially when they did not follow Anglo-Saxon norms. The newspaper's offices were only a few miles north of the nightclubs and recording studios where Louis Armstrong and Jelly Roll Morton were making music history, but those musical greats aren't represented in this archive, nor is any other black jazz or blues musician.

Despite these gaps, the archive preserves the most wide-ranging visual record of the city in the first decades of the twentieth century. The *Daily News* aimed for a wide audience—the bank president, the Italian immigrant, the Irish cop. And it succeeded in a grand and compelling fashion.

The power of these images takes us back to the defining years of Chicago, showing us the city's tumult, its tribes, its touchstones. And in doing so, it takes us back to ourselves.

CHAPTER TWO

WELL-HEELED AND DOWNTRODDEN

By the turn of the twentieth century, huge fortunes had been amassed in Chicago. The city's aristocratic families—the McCormicks, Palmers, and Armours—had established their dynasties and were determined to have their say in the expanding city. Perhaps nothing better symbolized their power than the grandiose Palmer Castle on North Lake Shore Drive, built by Potter and Bertha Honore Palmer to woo the wealthy north from Prairie Avenue, on the South Side, to the new Gold Coast. "Dropping by," however, was discouraged. The gothic mansion had no exterior doorknobs; the only way to enter was to wait for a servant.

But Chicago was also a hotbed of class struggle and social activism. Emma Goldman preached free love, Eugene Debs socialism. And Lucy Parsons, whose husband had been convicted and executed after the Haymarket Affair, joined labor activist Mary Harris "Mother" Jones and dozens of others in establishing the Industrial Workers of the World, a union commonly known as the Wobblies.

The contrast between rich and poor was stark. "Like the frogs in the Egyptian plague, you could not escape from the tramps, go where you would," author William T. Stead wrote in the 1890s. "In the city they wandered through the streets, seeking work and finding none."

To this mix was added a stream of immigrants from Europe and African Americans from the rural South, who flooded the city in search of work, hope, and a new life, filling the factories and saloons and making Chicago a remarkable melting pot.

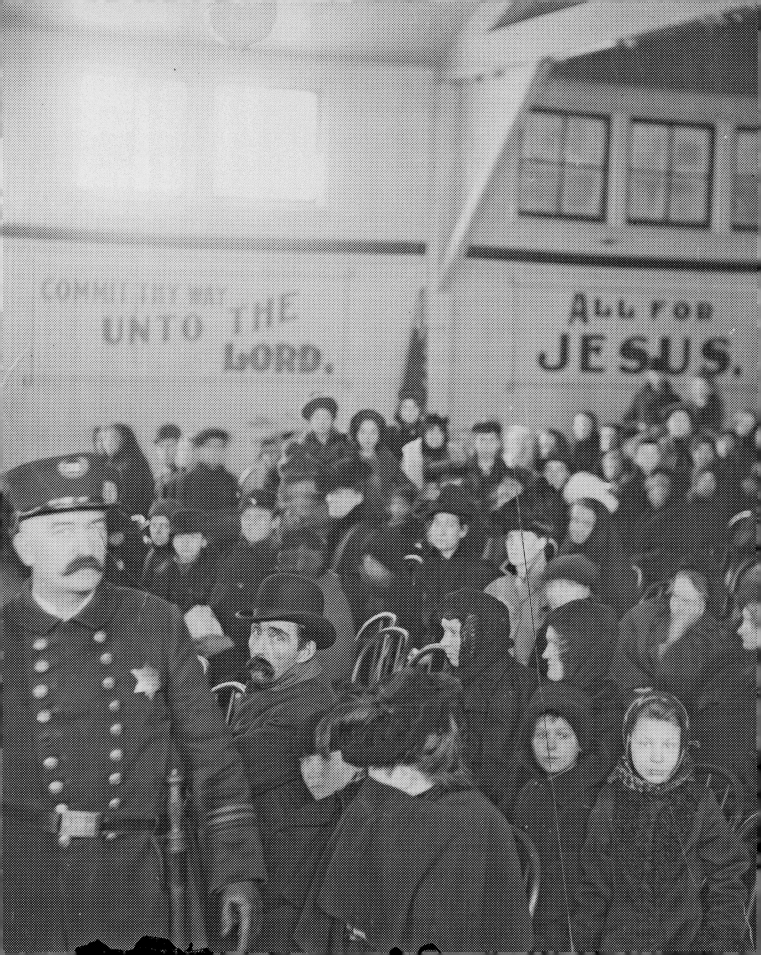

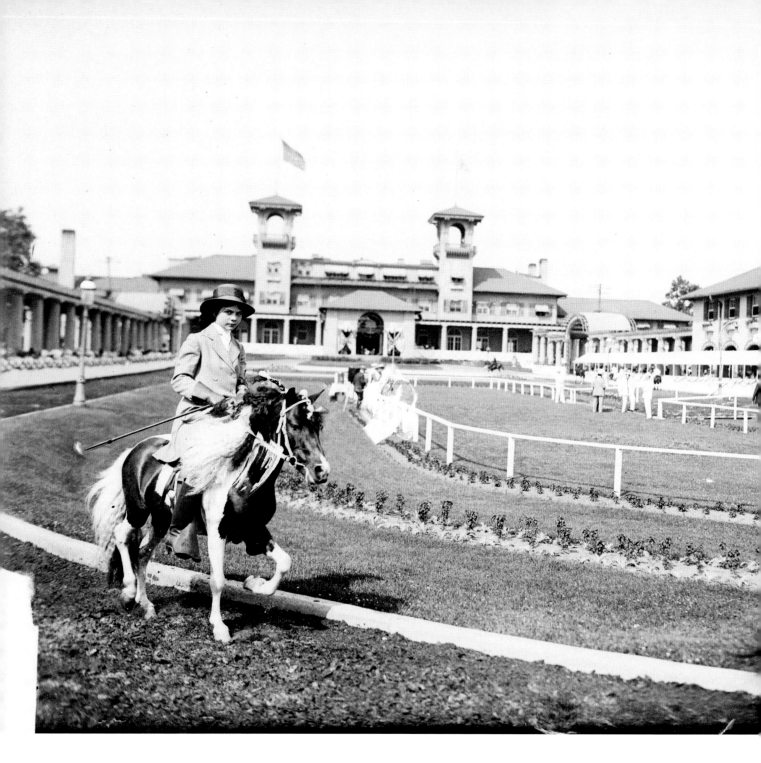

THE RICH

Mildred Reed rides a pony named Spotwood at the South Shore Country Club in 1913. The lavish club was the playground of some of Chicago's most prominent families and was visited by former president William Howard Taft, actress Jean Harlow, and entertainer Will Rogers. Around 1930, the club formally barred Jews from membership. Today it is a Chicago Park District facility serving a mostly African American neighborhood.

Palmer Castle, built in 1882 and razed in 1950, dominated North Lake Shore Drive. In the late nineteenth century, Potter Palmer and his wife, Bertha, were the first family of Chicago society. Potter died in 1902, and Bertha subsequently spent much of her time in Europe and Florida. The relatives of Cyrus McCormick, who invented the mechanical reaper, then gained dominion over the city's social scene.

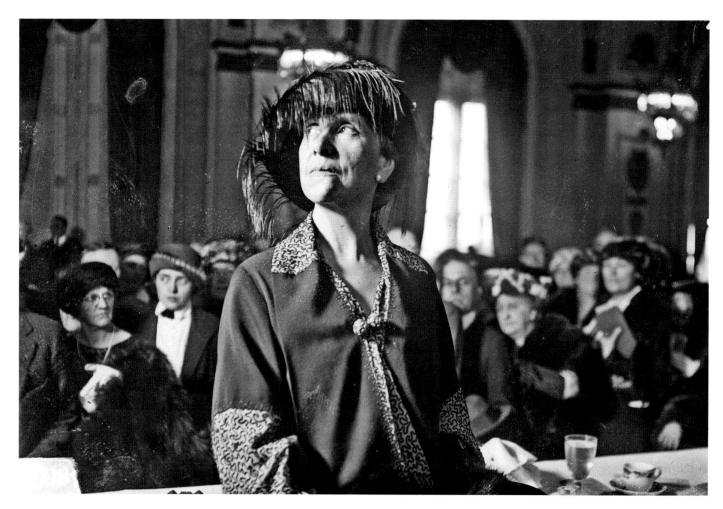

Edith Rockefeller (above), daughter of industrialist John D. Rockefeller, married International Harvester executive Harold McCormick in 1895 and ascended the throne of Chicago society. The couple hosted lavish social events at their 1000 North Lake Shore Drive mansion and gave generously to charities. The marriage fell apart in the 1910s, however, and Harold took up with a charismatic would-be opera singer from Poland named Ganna Walska. Harold's bankroll gave Walska the opportunity to debut with the Chicago Opera Company, but she quit days before the scheduled performance because of a clash with the conductor. The episode may have inspired a plotline in Orson Welles's film *Citizen Kane*. Edith is shown in 1921, the year she divorced her husband, a decree that allowed him to marry Ganna the next year. The new Mr. and Mrs. McCormick (right) are shown in 1929, the year Ganna left Chicago, giving Harold the grounds to divorce her for desertion. Ganna eventually married and divorced six men, retiring on a thirty-seven-acre estate in Montecito, California, named Lotusland. Harold became a virtuoso whistler, performing on the radio and at concerts. Edith McCormick, who once paid twenty-five thousand dollars for a horoscope, lost her fortune in the Depression and died in 1932.

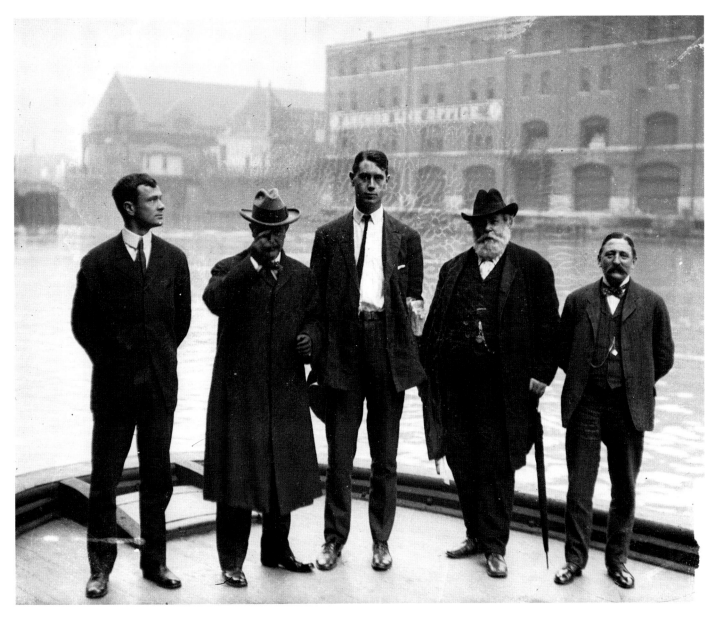

"All the McCormicks are crazy except me," said Harold's cousin, Robert R. McCormick, shown here towering over other civic-minded citizens on a Chicago River inspection tour in 1906. McCormick, also the grandson of *Chicago Tribune* editor and publisher Joseph Medill, was appointed the *Tribune*'s publisher in 1914. After serving as a colonel in World War I, he named his west suburban estate after the site of his greatest victory, Cantigny, and became known as "the Colonel." But he did not long for war and was an ardent isolationist. His newspaper's nameplate included the slogan "Always America First" and the boastful "World's Greatest Newspaper," which inspired the acronym for its radio station, WGN.

William Wrigley Jr., shown piloting a ferry in the Chicago River in 1922, was a natural-born salesman. He used to brag that he could sell "pianos to armless men in Borneo." But instead he sold something then known as chicle and now called chewing gum. Wrigley pioneered modern marketing: In 1915, he sent four free sticks of gum to 1.5 million people whose names were pulled from phone books. As his business prospered, Wrigley took over the Chicago Cubs and renamed the team's ballpark Wrigley Field. In the 1980s, the neighborhood around the ballpark came to be known as Wrigleyville.

Meatpacker J. Ogden Armour inherited the outlook of his father, Philip, who once admitted, "I do not read, I do not take part in politics . . . but in my counting house, I am in my element." Philip Armour died in 1901, and fellow meatpacking czar Gustavus Swift died two years later, leaving the younger Armour to face the music in 1906 when Upton Sinclair's *The Jungle* exposed the abuses of the meatpacking business.

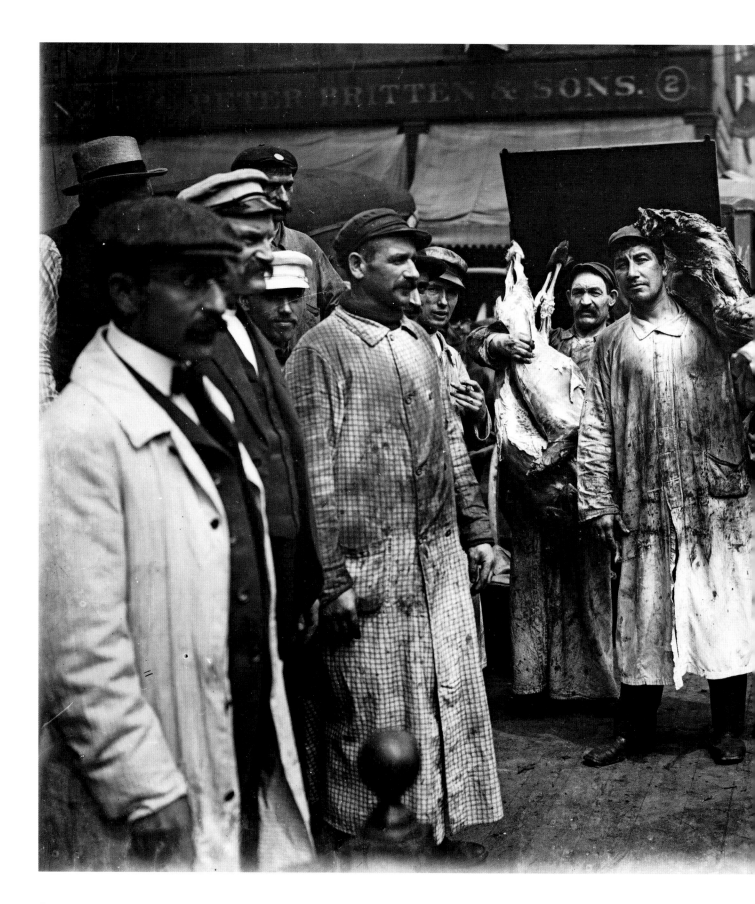

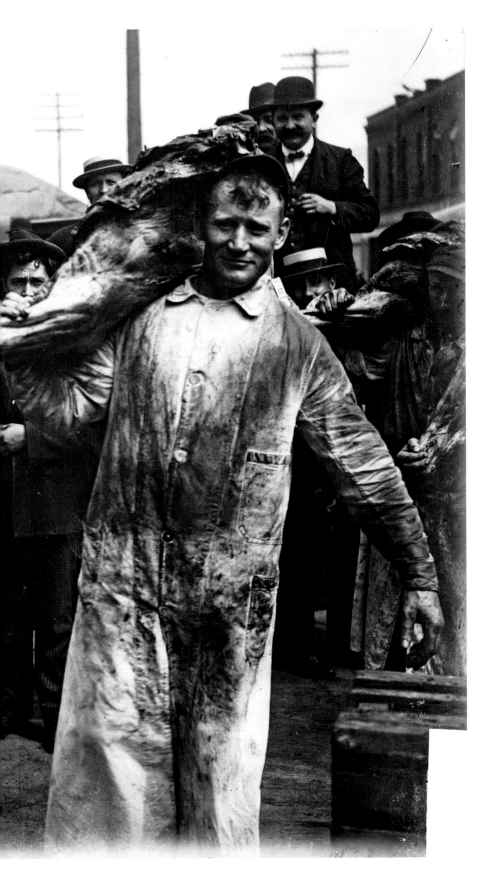

At the stockyards, thousands of workers made a living while a few owners made a killing. These men in butcher's coats, shown in 1904, were part of a Chicago industry that produced more than three-quarters of the meat consumed in America, plus by-products such as lard, glue, fertilizer, gelatin, soap, and even violin strings. People boasted that every bit of the hog was used except the squeal. But the huge capitalist engine known as Packingtown wasn't all that tidy: waste products were dumped into Bubbly Creek, an un-pleasant odor wafted through the air, and labor unrest sometimes spilled into violence.

Chicago's upper class loved to mingle with visiting royalty. Here Prince Wilhelm of Sweden (center) poses in 1927 with one of Chicago's most admired citizens and one of its most reviled. Julius Rosenwald (right), chairman of the board of Sears Roebuck and Company, gave much of his money to build schools in poor black communities in the South. Samuel Insull (left) was a giant of industry, turning the Commonwealth Edison Company into a powerhouse and consolidating the area's rail lines into an imposing network. But when the Great Depression hit in 1929, Insull was badly overextended and his stockholders were left holding the bag. Indicted for embezzlement and mail fraud, he fled to Greece, only to be dragged back to Chicago for trial after a lengthy extradition fight. Though acquitted, he was never vindicated.

In 1906, Paul O. Stensland, the esteemed founder of the Milwaukee Avenue State Bank, fled the country after questions were raised about his diversion of bank funds for land speculation. Word soon spread about the missing money, and depositors besieged the building. Stensland, a Norwegian immigrant who had helped revise the city charter and served as a director of the World's Columbian Exposition of 1893, was tracked down in Morocco and brought back for trial. Convicted of embezzlement and forgery, he did time in Joliet Penitentiary. Depositors eventually got about 70 percent of their money back.

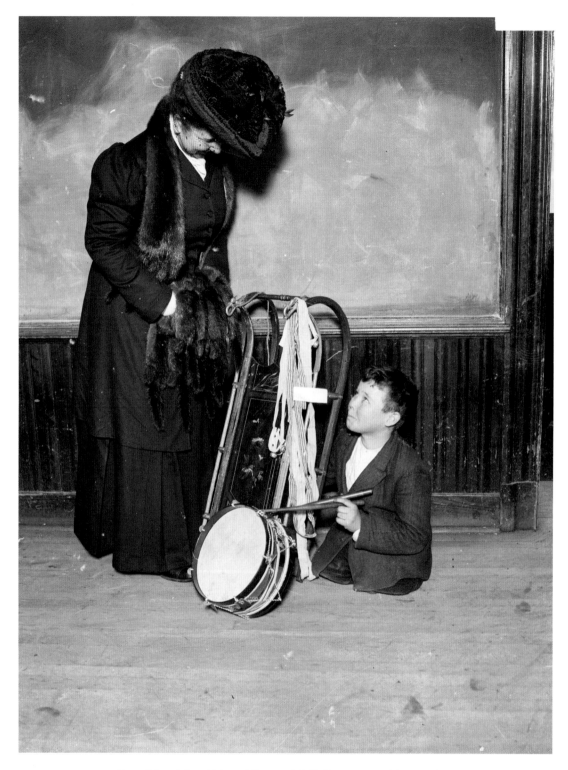

Many of the privileged felt an obligation to give to charity. In 1905, a woman makes a Christmastime visit to a home for the handicapped to deliver sleds, drums, and other gifts.

A *Daily News* account of the event included a description of handicapped children singing carols: "Two of the performers had no legs, but all had voices."

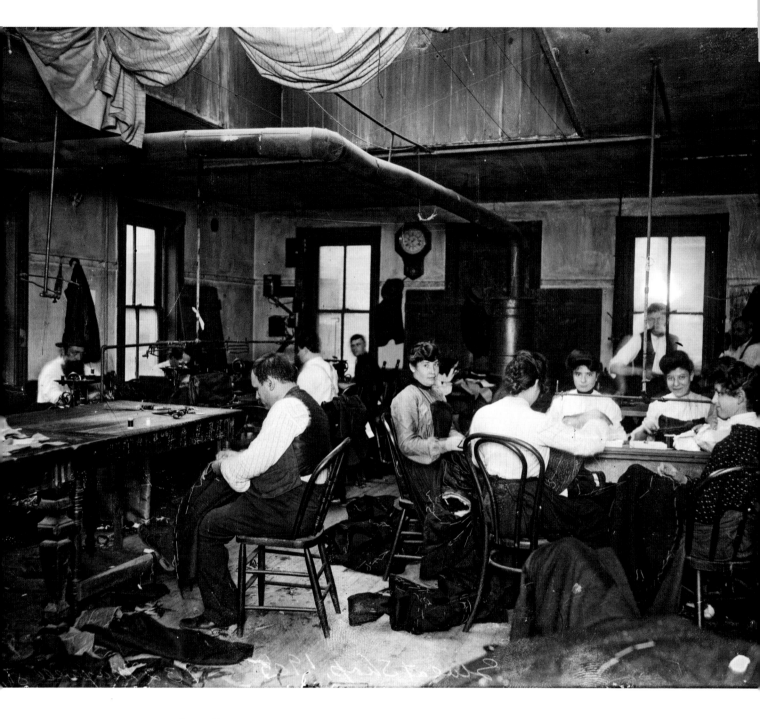

THE POOR

A makeshift clothing factory in the Maxwell Street neighborhood was one of many sweatshops in the city in 1905.
Fourteen-hour days and six-day weeks were common for such work.

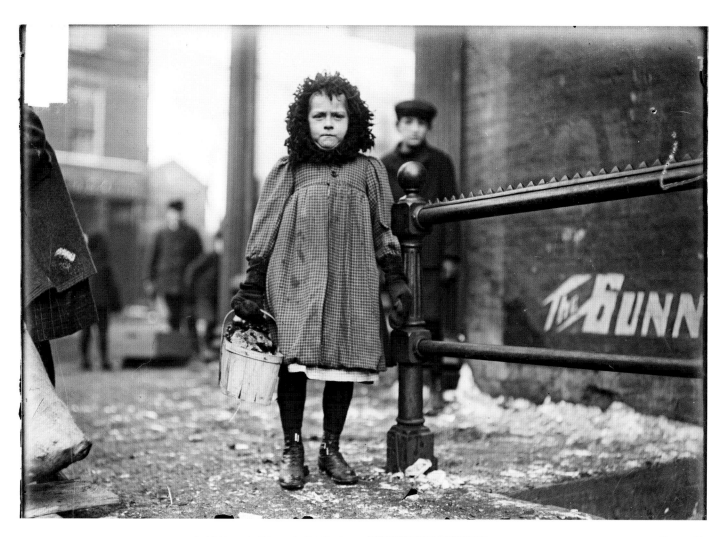

A child born in Chicago in 1900 had only a 75 percent chance of reaching age five. (The figure today is better than 98 percent.) Although some public aid was available, child welfare was often left to private charities such as the Salvation Army, which made discount coal available to the poor, including this young girl in 1903.

With parents working long hours, juvenile delinquency became a major concern. Shown is a boy smoking in 1904.

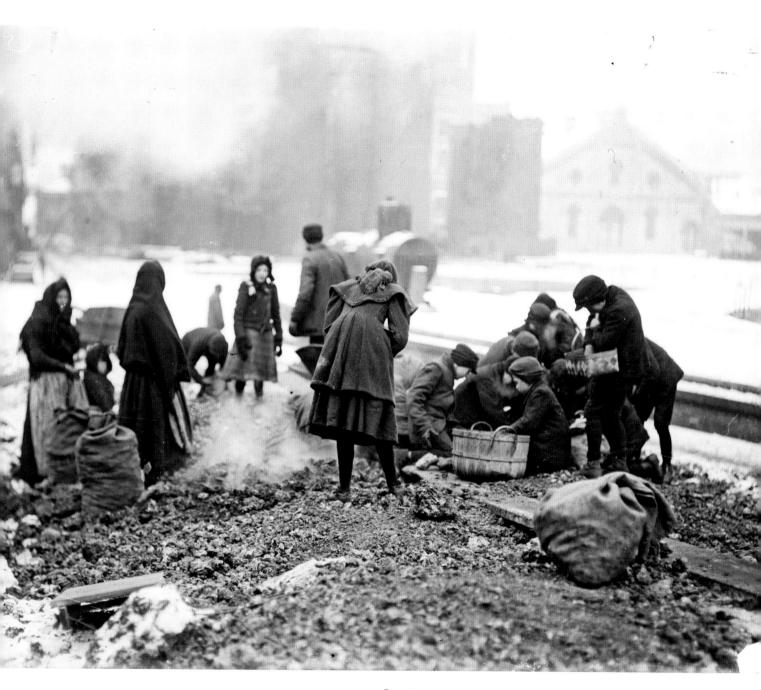

Poverty was condemned as a personal failing, reflecting a deficit of character. Such views didn't fade until the Great Depression, when more than a quarter of Americans were out of work. In the early twentieth century, it was a common sight to see the poor foraging for spilled coal along the railroad tracks. While local governments provided poorhouses and gave some handouts, the federal government didn't get into the welfare business until 1935, when the Social Security Act provided for payments to elderly persons, as well as Aid to Families with Dependent Children.

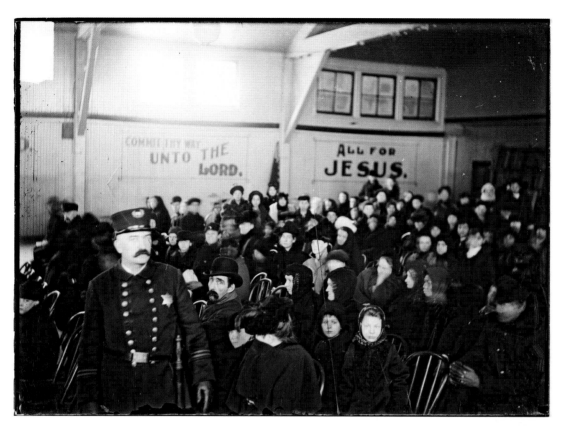

Christmas Eve 1902 at the Salvation
Army.

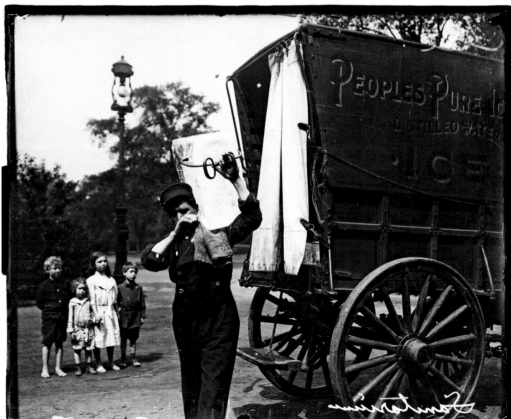

An iceman makes a delivery in 1912
to the *Daily News'* Fresh Air Fund
sanitarium in Lincoln Park, where
needy children received medical
care.

Captain George Wellington Streeter was a champion of the unlanded class and a nuisance to the rich. Streeter, who earned his captain's stripes as a teenager in the Civil War, was piloting a fishing schooner in 1886 when it ran aground on a sand bar off the end of Chicago's Superior Street. He decided to stay where he had landed and make the most of it. He charged building developers for the right to dump waste around his schooner, collected rent from other squatters, and sold off lots, declaring the landfill area he created to be an entity separate from Chicago. Thus began a decades-long dispute between Streeter and municipal authorities, who objected to his squatting and his unregulated sale of beer and whiskey. They attempted to evict him, sometimes at gunpoint. Streeter, shown here with wife Elma in 1915, was eventually forced off the land, but he had his vindication. There's no section of town called Palmertown or McCormickville or Fieldland, but one of Chicago's most fashionable neighborhoods, in the place where he staked his claim, is now known as Streeterville.

"I'm not a humanitarian. I'm a hell-raiser," said Mary Harris "Mother" Jones, shown here in 1915. The daughter of an Irish rebel, Jones and her family immigrated to Canada, and she later came south as a teacher. In 1867 her husband and all four of their children died within a week in a yellow fever epidemic in Memphis. She moved to Chicago, where she lost all her belongings four years later in the Great Fire. Mother Jones became an impassioned advocate of worker rights. Known as "the Miners' Angel," she was a founding member of the Industrial Workers of the World, or Wobblies, established in Chicago in 1905. Arrested at the age of eighty-two for speaking in public without a permit, she remained active in the labor movement until her death at age ninety-three in 1930.

Part Creek Indian, part African American, and part Mexican, Lucy Parsons grew up in Texas and fell in love with a former Confederate soldier named Albert Parsons. They became man and wife—though interracial marriage was illegal—and began working in Texas to register black voters. After Albert was shot and threatened with lynching, they fled north to Chicago, where they organized unions. When eight police officers were killed in the Haymarket Riot in 1886, Albert was arrested and charged with murder even though he had not attended the rally where the bombing and shootings occurred. He was executed the next year. Lucy Parsons was a founding member of the Industrial Workers of the World and joined the American Communist Party in 1939. When Parsons died three years later in a house fire, the FBI seized her fifteen thousand books and all her papers. This photo was taken in 1915, following her arrest for leading an unemployment protest.

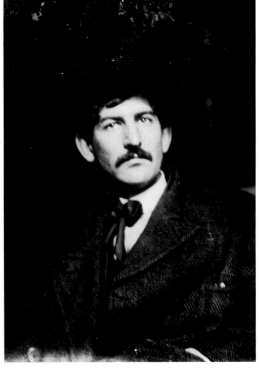

Ben Reitman, a Chicago physician shown here in 1908, once got a letter from his lover that read: "You have opened up the prison gates of my womanhood." That woman was Emma Goldman, who knew something about prison gates. Reitman helped manage Goldman's incendiary speaking tours and advocated for the homeless—known back then as "hobos." He was a doctor to the down-and-out, treating prostitutes' venereal disease and advocating what would now be known as "safe sex."

Emma Goldman, born in Russia, refused to marry her father's choice of husband and immigrated to the United States, where she became a radical activist, drawing inspiration from the "Haymarket martyrs." But Goldman clashed with Haymarket widow Lucy Parsons: While Parsons supported traditional marriage, Goldman was an advocate of free love. Goldman, shown here in 1906, was arrested several times, for advocating birth control and draft resistance, and was deported in 1919. "Red Emma," as she was known in the press, returned to Russia after the revolution there but became disaffected with the Bolsheviks and took British citizenship. After she died in Canada in 1940, her body was transported to Waldheim Cemetery in Forest Park, Illinois, for burial near the Haymarket monument.

Not all union activists were selfless stalwarts willing to go to jail for their principles. A labor racketeer named "Umbrella Mike" Boyle instead went to jail for his principal ally, corrupt Illinois governor Len Small. Boyle, an officer in the International Brotherhood of Electrical Workers, refused to cooperate with an investigation of whether jurors were bribed when they acquitted the governor of embezzlement. Jailed for contempt of court in 1923, Boyle's sentence was quickly commuted by— who else?—Governor Small. Boyle twice called strikes that left Chicago in the dark, and he was linked to the intimidation of businessmen by thugs known as "Chicagorillas." Boyle, shown here in 1917, later denied the legend that he was called "Umbrella Mike" because people would drop bribes into his folded umbrella when he propped it in the corner of his office or hung it from a restaurant coat rack.

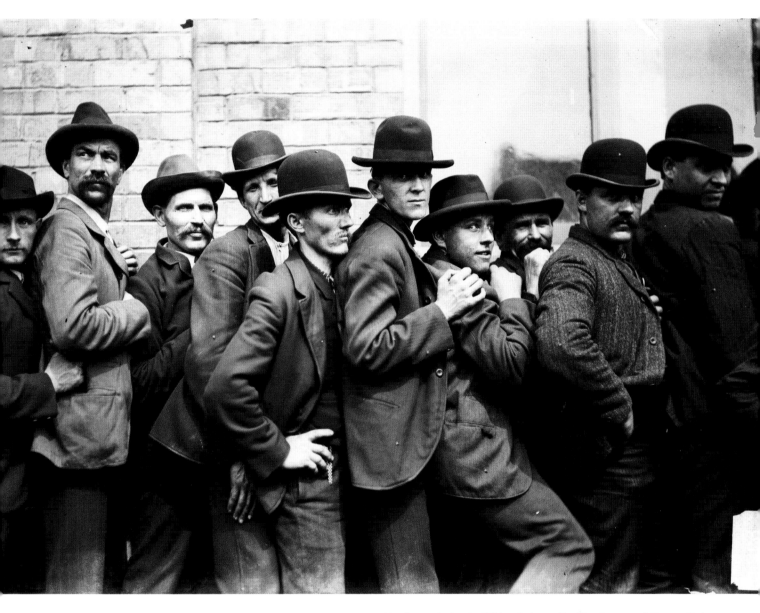

Men line up during the 1904 strike in Chicago's stockyards, a walkout doomed to failure because so many people were eager for a job. The meatpacking barons, known as the Beef Trust, successfully recruited African American strikebreakers from the South, increasing whites' resentment toward blacks in Chicago.

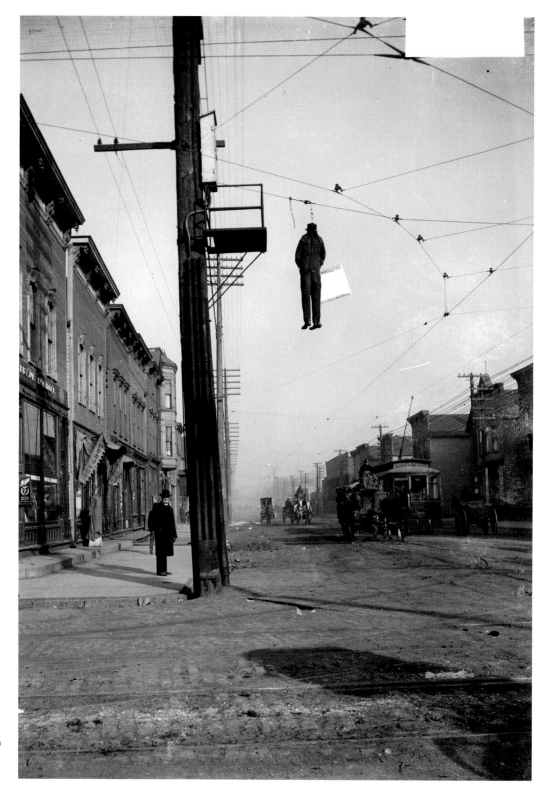

During the Chicago City Railway strike in 1903, an effigy of strike-breaker Frank Curry was hung from a trolley wire at Forty-second and Wentworth streets. Curry was the first motorman to take his car back into service and was rewarded with a promotion to division superintendent when the strike ended.

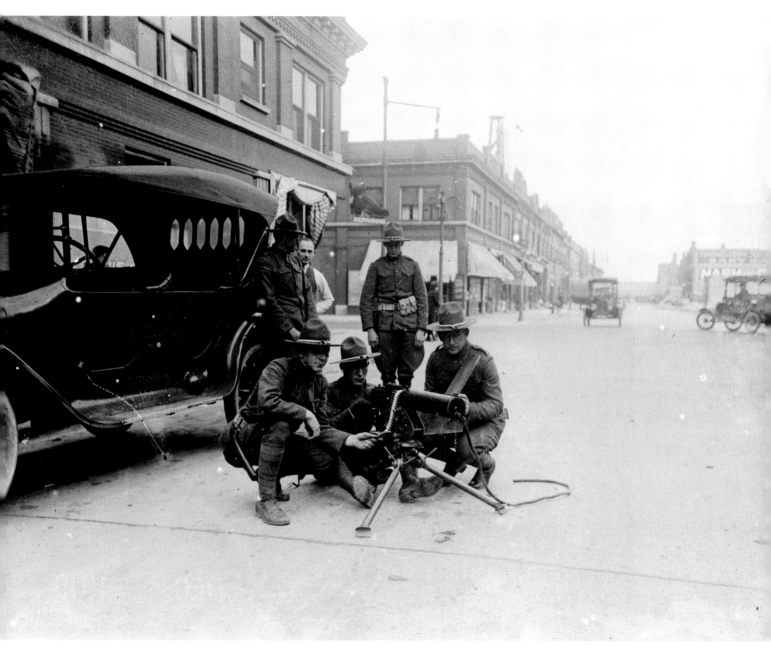

When a walkout swept the steel industry in September 1919, the federal government sent in troops to guard major thoroughfares near steel plants in Gary, Indiana, and other cities. It was common during labor disputes for business groups to donate machine guns and other armaments to the military. By today's standards, the workers' demands were reasonable: no more seven-day workweeks, no more twelve-hour shifts—and no more back-to-back shifts, in which workers might be on duty for twenty-four hours straight. An estimated 350,000 steelworkers, more than half of the industry's workforce, struck nationwide. But management held firm, led by U.S. Steel executive Elbert Gary, for whom the Indiana city was named. By the end of November, the strikers drifted back to work. The labor movement suffered many defeats in this era, but its political influence grew. With the coming of Franklin D. Roosevelt's New Deal in the 1930s, more and more industrial products came to bear the union label.

NEWCOMERS

A railroad worker examines a document as a woman relaxes in the immigrant section of the new Northwestern train station in 1911. The station, at Madison and Canal streets, boasted special accommodations to protect immigrants from the homegrown charlatans waiting to greet them. Chicago's chief newcomers of the nineteenth century—Germans, Irish, and English—were well established by the turn of the century, but new ingredients were being added to the city's stew all the time. In 1909, at least fourteen languages were in common use by ten thousand or more Chicagoans.

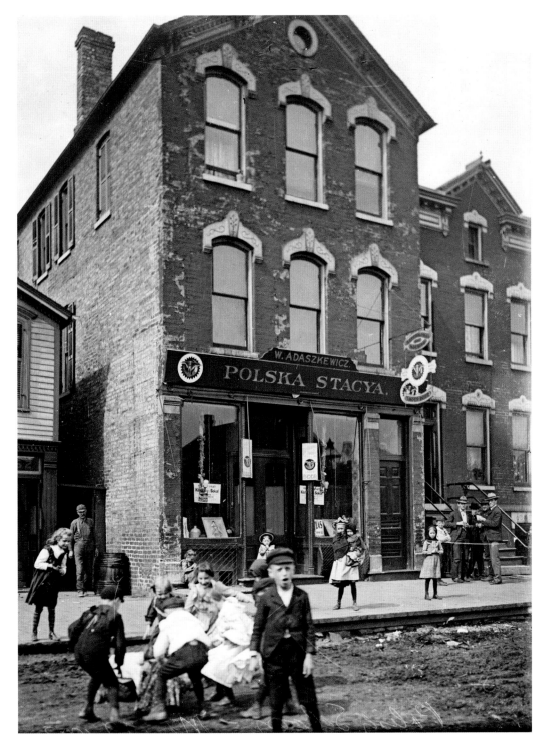

Children play outside the Polska Stacya, a Polish saloon, in 1903. By 1920, 350,000 Poles had settled in Chicago—the largest Polish population in any city except Warsaw. Much of Polonia lived along Milwaukee Avenue on the Northwest Side, where traces of it exist today, although the Polish *sklep komputerowy* (computer store) now shares the street with the Mexican *panaderia* (bakery).

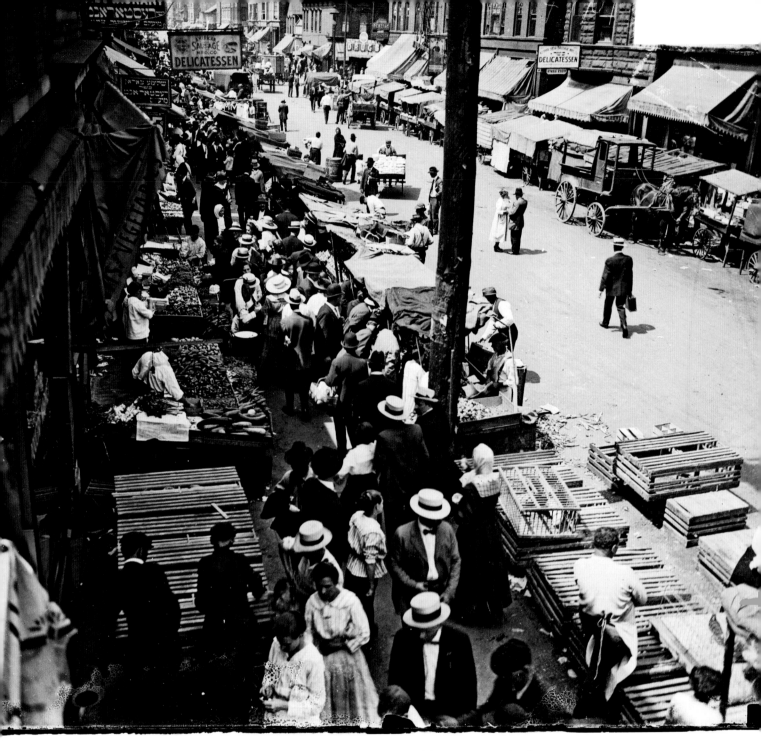

From 1880 to 1920, one-third of the Jewish population of Eastern Europe emigrated because of pogroms and poverty, and many made it across the ocean to America. In Chicago, the Maxwell Street market on the Near West Side was the prime gathering place for Jewish immigrants, a center of old-world haggling and American free enterprise. One merchant posted a sign reading, "We Cheat You Fair." The market survived until the turn of the next century, when the University of Illinois at Chicago took over the land for a campus expansion. The vast majority of the Jewish population had left the area decades earlier.

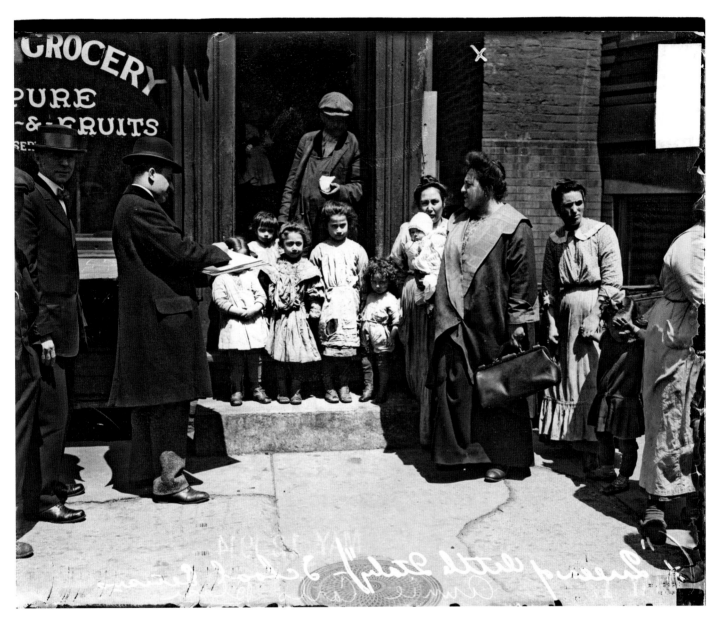

Annie Carlo-Blasi (with satchel), an activist known as the Queen of Little Italy, accompanies census taker Philip D'Andrea on his rounds in 1914. As Italian immigration to Chicago dramatically increased in the early 1900s, Carlo-Blasi and others demanded a share of political power from the Irish bosses running her ward. She was known for handing out naturalization papers, and she made the front page of the *Chicago Tribune* when she delivered a sickly man to the polls on a cot. Although America was "discovered" by one Italian and named after another, Italian Americans represented less than one-tenth of 1 percent of the U.S. population in 1880. But more than two million Italians immigrated between 1900 and 1910—and today Italian Americans represent 6 percent of the population.

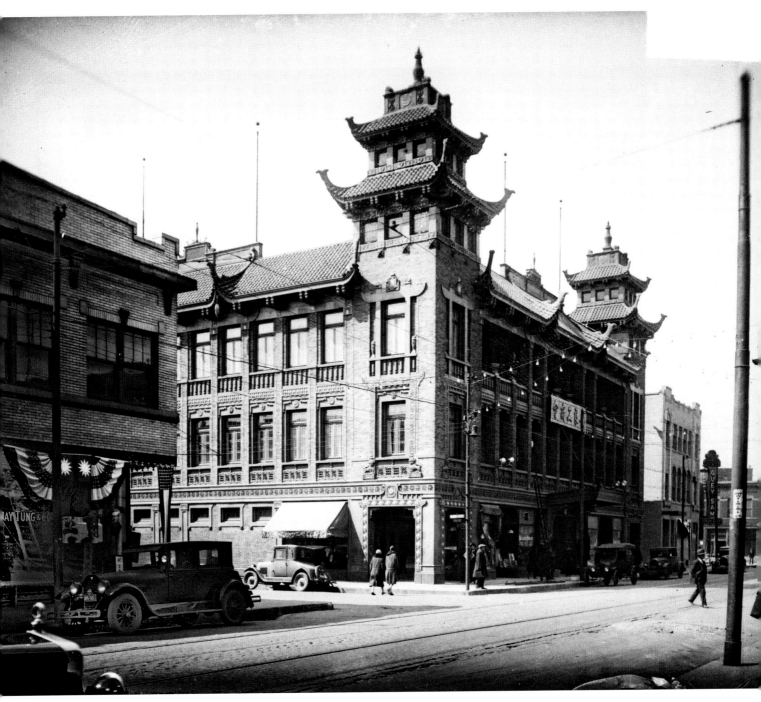

The Chinese arrived in Chicago beginning in the 1870s, many fleeing discrimination on the West Coast, such as laws that banned them from testifying against white men in court. They didn't find themselves entirely welcome in Chicago either, but eventually a Chinatown took shape in a former Italian and Croatian neighborhood around Twenty-second Street (now Cermak Avenue) and Wentworth Avenue on the South Side. The Chinese created their own economic niche, running 430 laundries and 167 restaurants in the early years, but the federal Chinese Exclusion Act, first enacted in 1882, prevented a significant increase in the city's Chinese population. The On Leong Merchants Association Building, shown here, was designed by Norwegian American architects and opened in 1928 as Chinatown's "city hall." It is now the Pui Tak Center, a community center owned by the Chinese Christian Union Church.

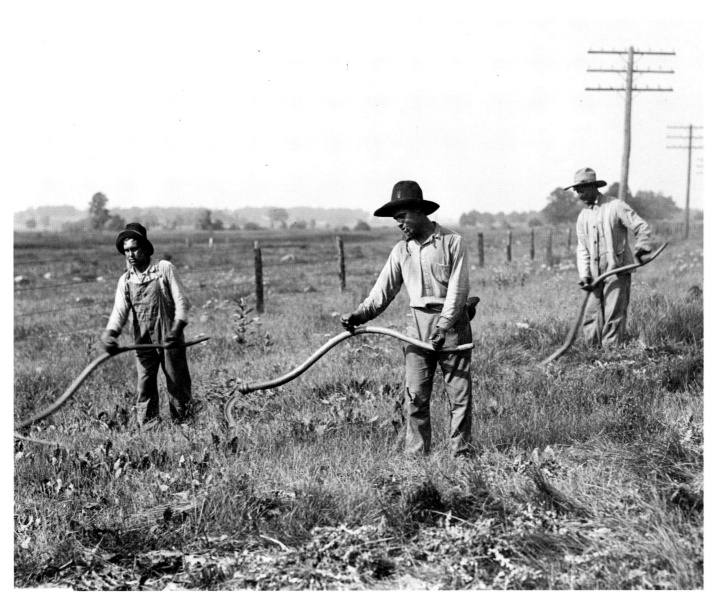

Mexicans cut weeds in Willow Springs, Illinois, outside Chicago in 1917. That year, the immigrant-wary *Chicago Tribune* reported that there were twelve thousand Mexicans within 120 miles of Chicago and that their "dark-skinned visages have been appearing in noticeably large numbers" in the city. In fact, Mexican immigration wouldn't have a major impact in Chicago for another half century. But what an impact it had after that: By the year 2000, at least one in six Chicagoans was of Mexican descent.

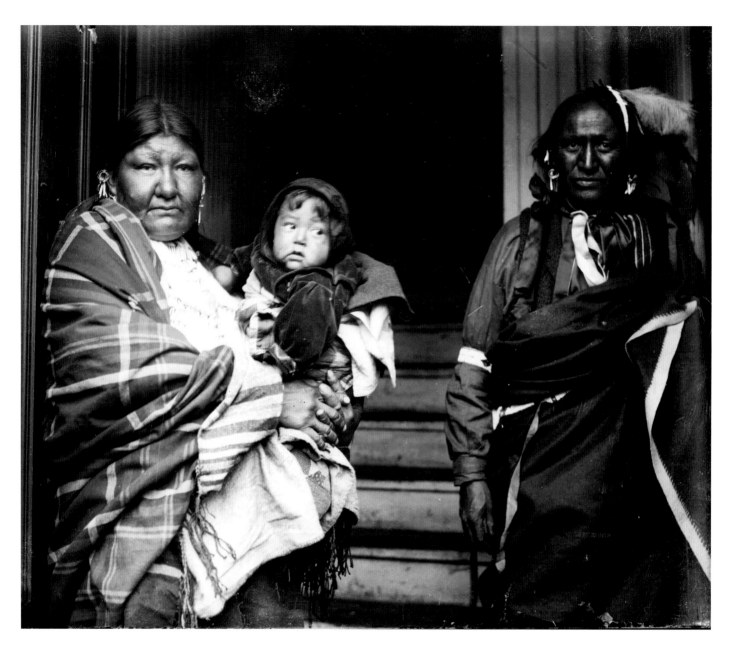

The area's first residents were Native Americans, and Chicago's name was derived from an American Indian word meaning "wild onion" or "garlic" or "skunk" or "powerful." But the Indians were pushed out of Chicago by white settlers who bought their land for two cents an acre and sent them west in the 1830s. By the time this photo was taken in 1907, Indians were a curiosity in Chicago, sometimes serving as attractions at carnivals and archery contests. These visitors were from the Pine Ridge reservation in South Dakota.

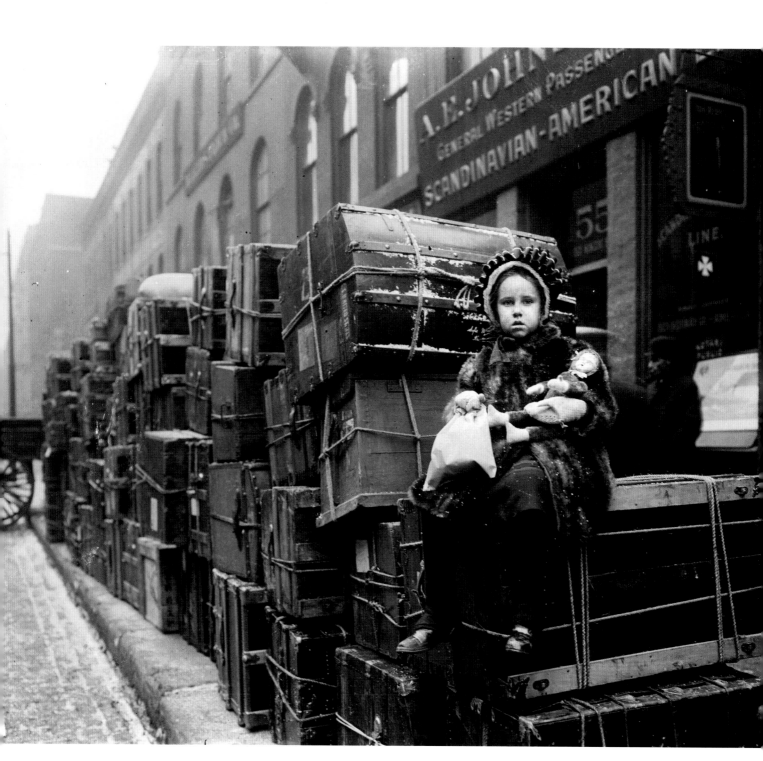

A girl waits outside a travel agency on Kinzie Street downtown in 1910 for a trip back to Norway. A *Daily News* article in 1906 reported that five hundred "Norsemen" were going home for a Christmas visit, their "pockets jingling with American gold and tongues impatient with stories of the wonders of their adopted country." An enduring myth of American immigration is that almost all new arrivals found their niche in this country.

It's true that the United States welcomed eighteen million new residents between 1890 and 1920, but it also waved good-bye to millions who either didn't like what they saw or were here only temporarily to make money. A 1921 law limited European immigration for the first time, and the flood was over. In 1931, some forty-three thousand people arrived in this country—and eighty-seven thousand left.

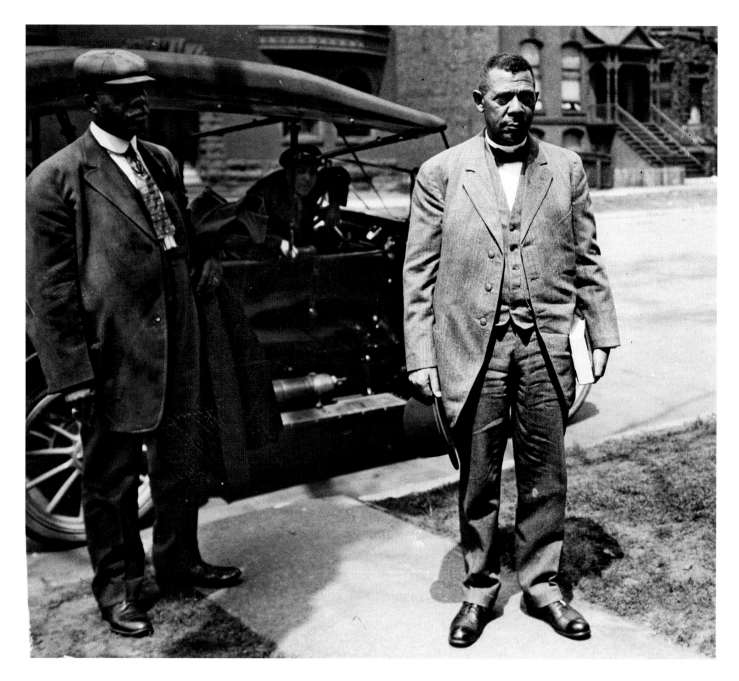

THE GREAT MIGRATION

Booker T. Washington, the most prominent African American of his day, is shown during a 1911 visit to Chicago. Washington, who was born into slavery and turned Alabama's Tuskegee Institute into a widely re-spected institution, urged blacks to strive for economic progress and to avoid confrontation on civil rights issues. That approach earned him the respect of presidents, access to business leaders, and vilification by less patient black leaders. African Americans' stake in Chicago started early: the city's first permanent set-tler was a black man, Jean Baptiste Pointe DuSable. But in 1910, the city's population was only 2 percent black. Local blacks found that there was spotty enforcement of the state's ban on discrimination in most public accommodations. Few blacks were allowed to stay at downtown hotels, but a well-known person like Wash-ington had no trouble getting a room at the Palmer House. Within a few years of Washington's visit, the Great Migration dramatically increased both the black population of Chicago and white hostility.

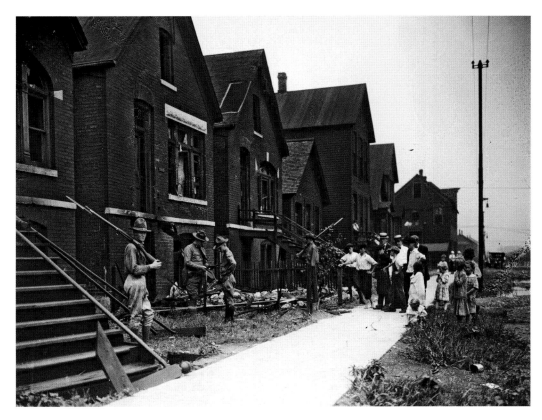

Soldiers guard a vandalized block of homes during the race riot that wracked Chicago's South Side in 1919. World War I had created a labor vacuum, and southern blacks rushed north to fill it. Black-white tensions came to a head with the death of a seventeen-year-old black youth near the Twenty-ninth Street Beach. Eugene Williams, who had floated over to a white section of the lakefront, was attacked by stone-throwing whites and drowned. Blacks demanded that a white man be arrested. When the police refused and instead arrested one of the black protesters, another black man pulled a gun and wounded a policeman. The assailant was fatally shot by a black policeman. From there, things only got worse. Rumors and rocks flew during six days of mayhem that killed 38 people, injured 537, and left a thousand black families homeless.

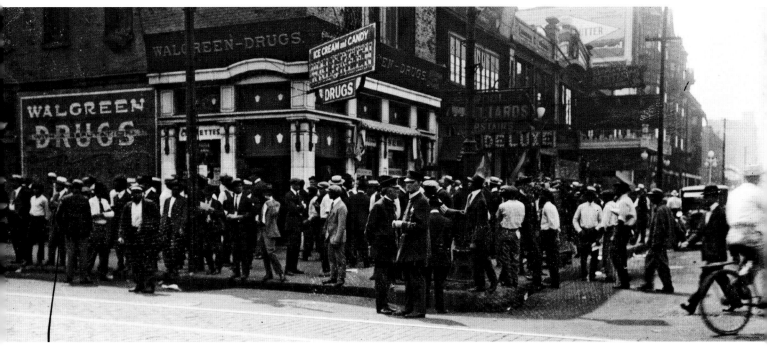

A *Daily News* bulletin early in the riot stated, "Three hundred negroes were reported at a late hour this afternoon to have congregated at South State and Thirty-fifth streets [where this photo was taken]. Many of them are armed and it is believed that they intend to start an immediate attack on whites of the neighborhood."

BLACKFACE

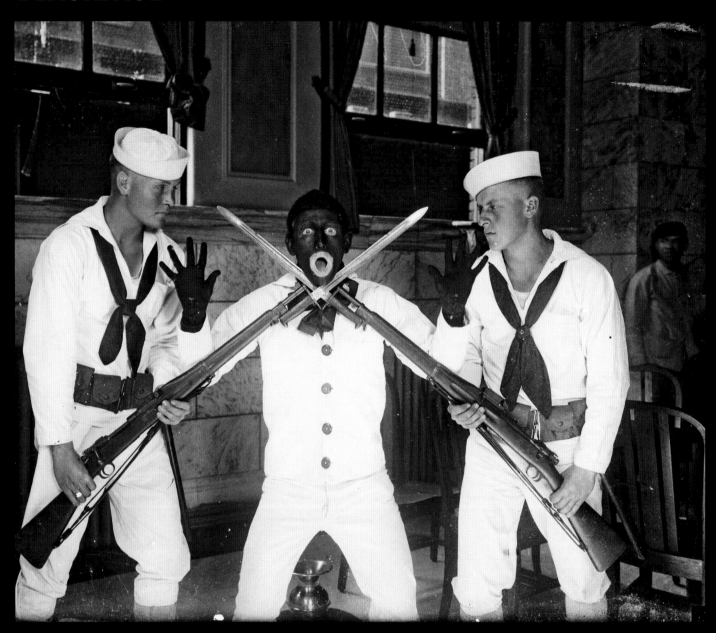

As African Americans struggled to overcome prejudice and improve their social standing, they found their public image hijacked by whites who depicted them as childlike. This scene advertised a minstrel show at the Great Lakes Naval Training Center in 1917.

Two white performers who became famous by portraying black people were Freeman Gosden (left) and Charles Correll, who produced minstrel shows and had a 1925 hit song called "Kinky Kids Parade." In 1926, they started a radio show entitled *Sam and Henry* on WGN, playing two lovable black friends. They moved from the *Tribune*'s station to the *Daily News*–owned WMAQ in 1928, renaming their program *Amos 'n' Andy*. The show was about two Georgia farmhands who had gone north and founded the Fresh Air Taxicab Company of America. The program, broadcast nationwide, was a sensation. Movie theaters would stop their features and pipe in the fifteen-minute show, broadcast six days a week. The Williamson Candy Company of Chicago sold Amos 'n' Andy candy—vanilla honeycomb wrapped in chocolate—with a label that read, "Um Um. Ain't Dat Sumpin'!"

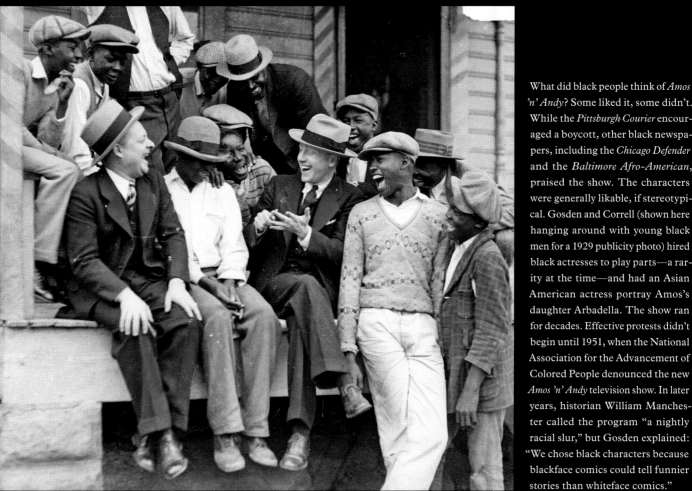

What did black people think of *Amos 'n' Andy*? Some liked it, some didn't. While the *Pittsburgh Courier* encouraged a boycott, other black newspapers, including the *Chicago Defender* and the *Baltimore Afro-American*, praised the show. The characters were generally likable, if stereotypical. Gosden and Correll (shown here hanging around with young black men for a 1929 publicity photo) hired black actresses to play parts—a rarity at the time—and had an Asian American actress portray Amos's daughter Arbadella. The show ran for decades. Effective protests didn't begin until 1951, when the National Association for the Advancement of Colored People denounced the new *Amos 'n' Andy* television show. In later years, historian William Manchester called the program "a nightly racial slur," but Gosden explained: "We chose black characters because blackface comics could tell funnier stories than whiteface comics."

CHAPTER THREE

HOOCH AND HOMICIDE

Chicago is still trying to put away Al Capone. For all the city's architectural wonders, for all its innovative theater and world-class museums, its international reputation remains defined by the brazen violence of "Scarface" and other gangsters more than eight decades ago.

The enactment of the National Prohibition Act in 1920 set the stage. The law, which banned the sale and manufacture of intoxicating liquors, led to a thriving black market of speakeasies, bathtub gin, and rumrunners.

Chicago was perfectly situated to become a crime capital. Its politicians stood with open palms, eager for bribes. Its police were trained to look the other way. But even corrupt officials were shocked by the carnage. Battles between rival gangs killed hundreds—and not just in the shadows. Bullets flew on crowded downtown corners at midday. Gunfire chipped the facade of Holy Name Cathedral. Gangsters owned the streets. "They did not evade the law," wrote Fletcher Dobyns, a crusading attorney of the era. "They were superior to it."

Some Chicago journalists portrayed Capone as a Robin Hood out to help the common man. But not the *Daily News*. Editor Henry Justin Smith refused to sensationalize or romanticize gangsters' crimes. Instead he published their names and addresses and instructed his staff to call Capone and his colleagues "small-time hoodlums." There was likely no greater insult.

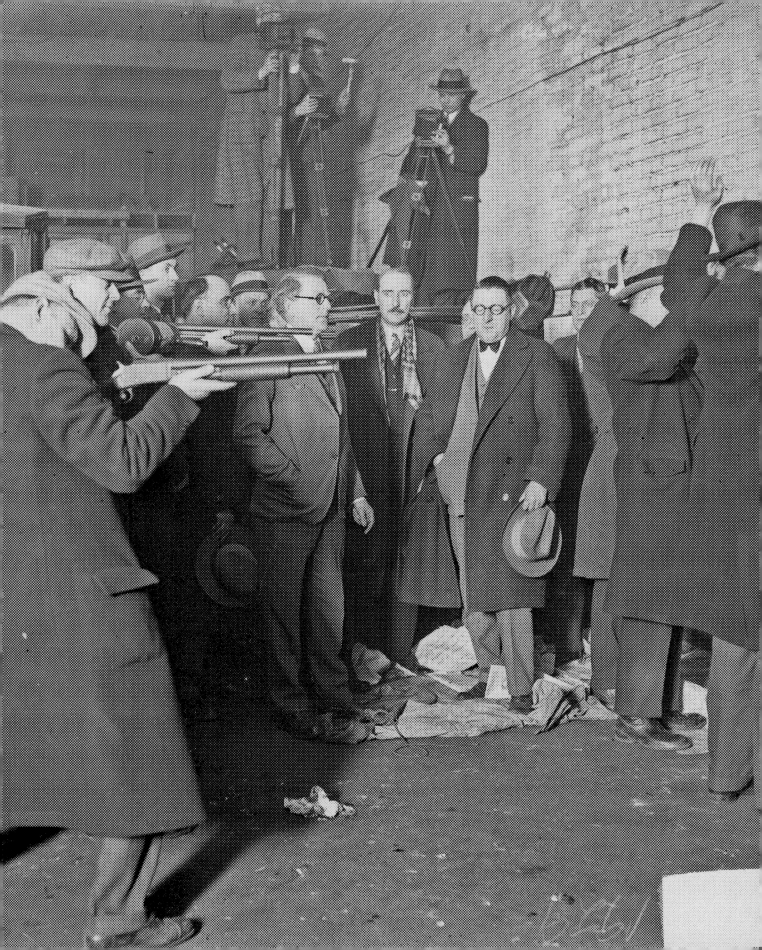

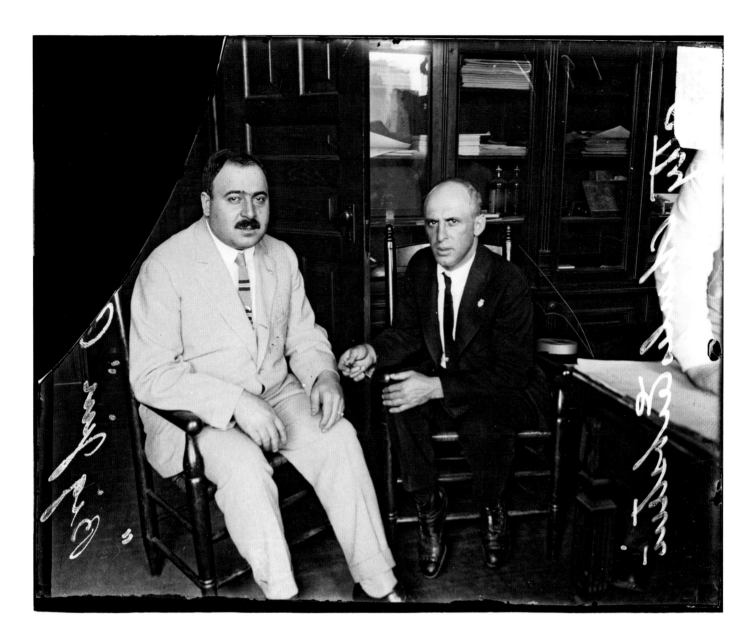

GANGLAND

"Big Jim" Colosimo (left, with lawyer Charles E. Erbstein) started out as a pickpocket and pimp, and became the millionaire head of organized crime in Chicago in the 1910s. He played host to crooked aldermen, stars of show business, and adventurous socialites at his elegant nightclub, Colosimo's Cafe on South Wabash Avenue. His big mistake was inviting members of New York's Five Points Gang to come west and serve as his henchmen. Big Jim was uninterested in branching out into bootlegging during Prohibition, telling his aides that "we stick with the whores." The more ambitious Five Points boys arranged his fatal shooting in the vestibule of his cafe. That killing, on May 11, 1920, ushered in a violent era of gangsterism. The shooter was never arrested, but among the suspects was a Brooklyn-born thug named Al Capone.

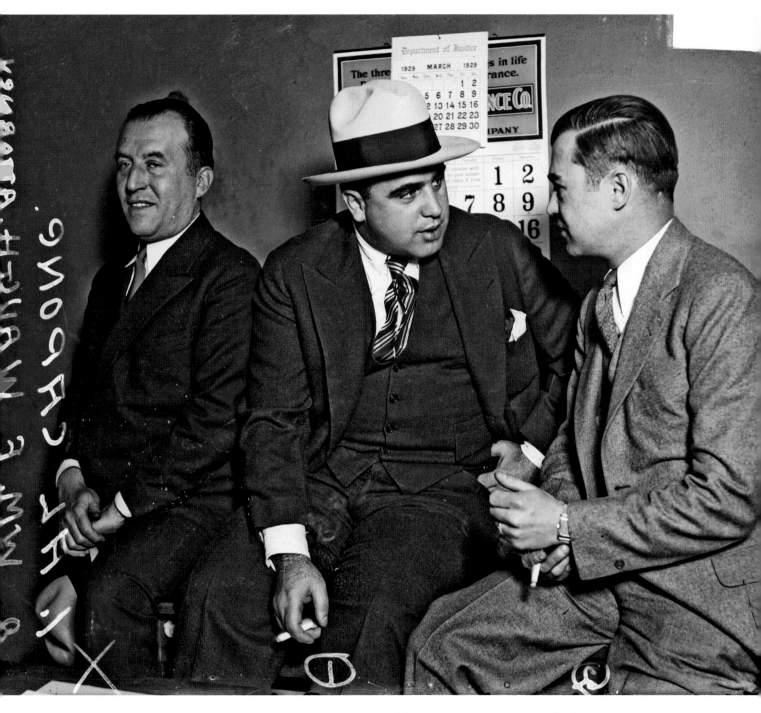

He carried business cards that read "Alphonse Capone, Second Hand Furniture Dealer, 2222 S. Wabash," but Chicagoans knew him—and the world still knows him—as the most brutal and shameless gangster in American history. "You can get much further with a kind word and a gun than you can with a kind word alone," quipped Capone (center), shown talking to attorney William F. Waugh in 1929. Scarface was arrested at various times for disorderly conduct, drunken driving, being a suspicious person, vagrancy, bootlegging, and even suspicion of murder, but through bribery and intimidation he managed to stay a step ahead of the law. In 1931, however, Capone ran out of sympathetic judges and jurors. Convicted of income tax evasion, he spent the next eight years in prison. In 1947, eight years after his release, the syphilis-ravaged gangster died of a natural cause—a heart attack.

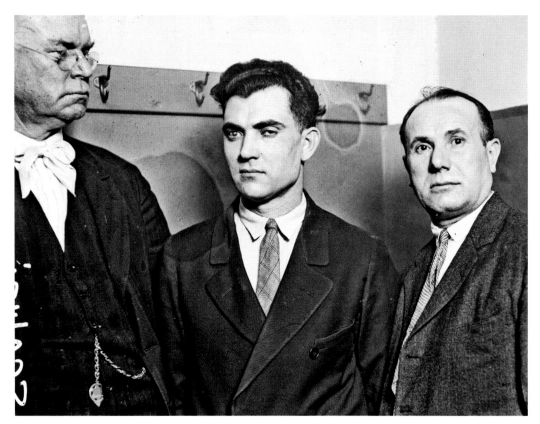

John Scalise (center) and Alberto Anselmi (right), shown with attorney Patrick O'Donnell in 1927, fled murder charges in Sicily and brought their unique criminal techniques to America. They coated their bullets with garlic, thinking erroneously that if the shot didn't kill the victim immediately, the garlic would give him a fatal case of gangrene. They also perfected the "handshake murder," in which one of them greeted the intended victim and the other sneaked up from behind and shot him in the back of the head. Allied with Capone, they committed one of the biggest gang hits of the era, the murder of North Side crime boss Dion O'Banion in his flower shop in 1924. But Scalise and Anselmi didn't stay on Capone's good side. Scarface hosted a dinner in their honor at an Indiana roadhouse in 1929 and surprised his guests by pulling out a baseball bat and beating them to death.

Frankie Lake (left) and Terry Druggan were heads of the only Irish gang to side with Capone. When their bootlegging operation was busted in 1924, both were sentenced to a year in the Cook County Jail, but they had in-out privileges, paid for with a twenty-thousand-dollar gratuity to Sheriff Peter Hoffman. One day a reporter visited the jail, seeking to interview Druggan. "Mr. Druggan isn't in right now," a jail employee told him. The reporter requested an interview with Lake instead. "Mr. Lake is also out . . . an appointment downtown. They'll return after dinner." Hoffman was later fined and himself sentenced to jail.

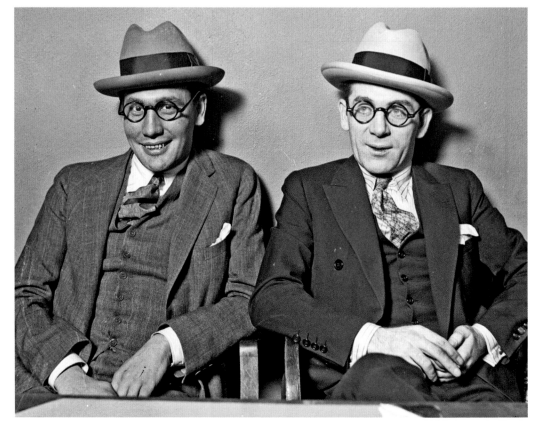

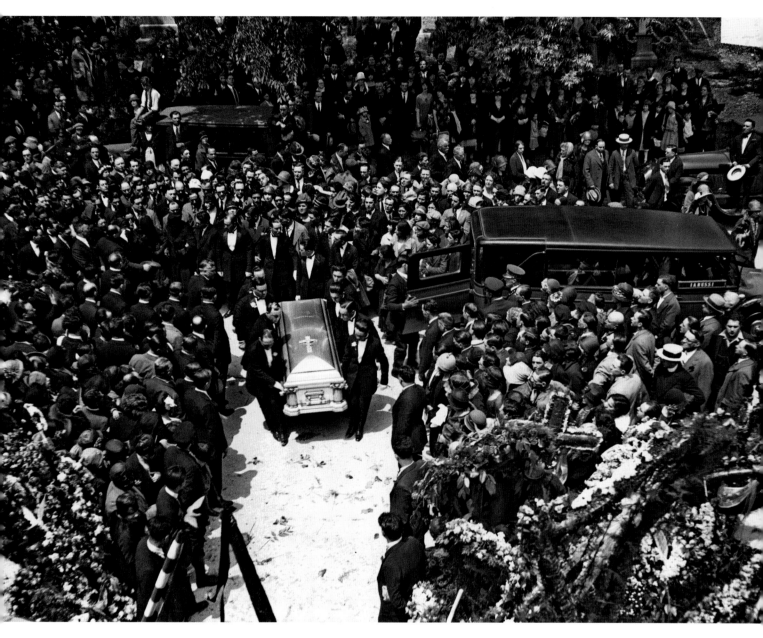

"Bloody Angelo" Genna's funeral in 1925 featured a ten-thousand-dollar bronze casket and twenty-five thousand dollars' worth of flowers. Genna, head of a Near West Side crime family allied with Capone, was ambushed by North Siders Earl "Hymie" Weiss, George "Bugs" Moran, and Vincent "Schemer" Drucci, who were incensed over Dion O'Banion's murder by Genna's gang. Genna was driving alone in his roadster when the North Siders began chasing him. He speeded up, lost control of his car, and slammed into a lamppost. The crash left him trapped behind the wheel as his pursuers coasted past with guns blazing. When Genna was put to rest at Mount Carmel Cemetery in the western suburb of Hillside, a police sergeant noted that his grave was only yards away from O'Banion's: "When Judgment Day comes and them graves are open, there'll be hell to pay in this cemetery."

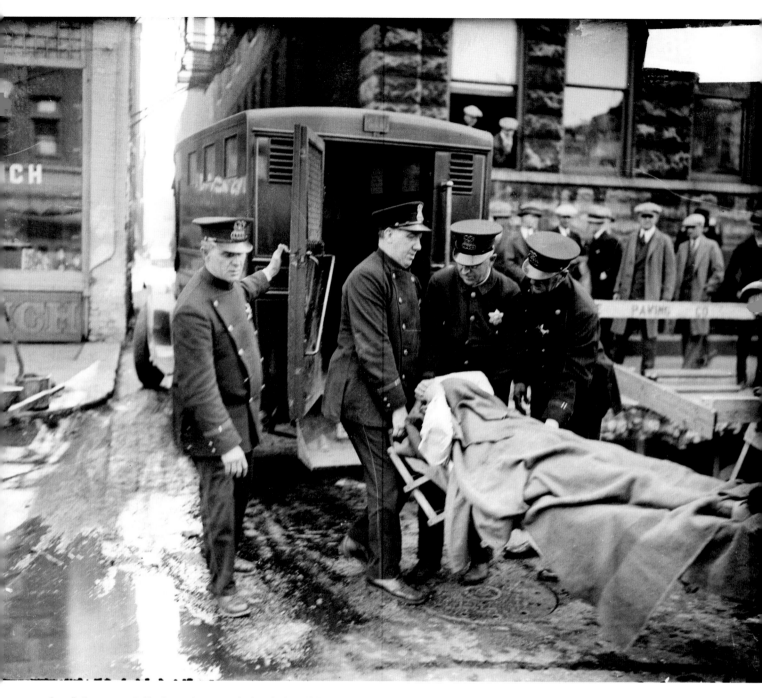

Sam Peller, a wounded bodyguard
for gangster Hymie Weiss, is covered
and carried on a stretcher as police
take him to court for an inquest into
Weiss's assassination by Capone's
gang in 1926. Peller was shot in the
groin during the ambush, which
took place in the middle of North
State Street in front of Holy Name
Cathedral. Bullets smashed into the
cornerstone of the church, blasting
an inscription that read, "At the name
of Jesus every knee should bow in
heaven and on earth."

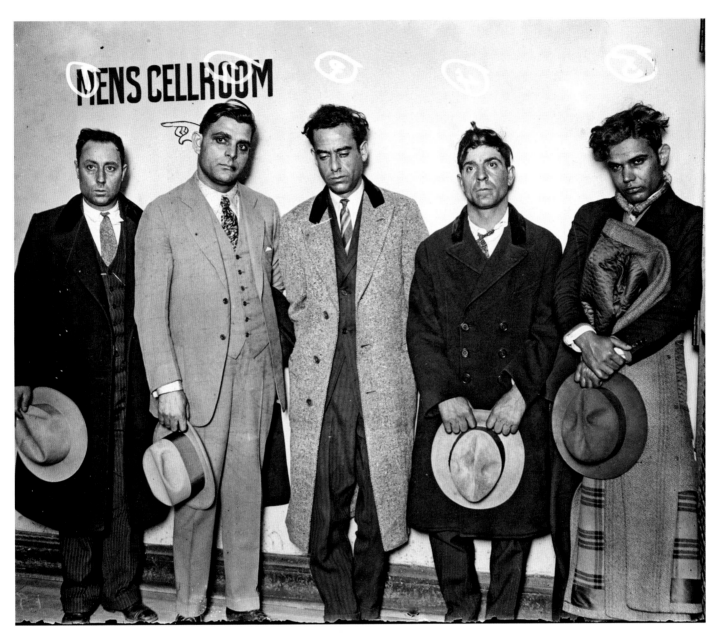

A hood named Joe Aiello (second from left) made a concerted effort to kill Al Capone. He recruited out-of-town thugs who tried and failed to ambush Scarface outside his favorite cigar store. Aiello also offered ten thousand dollars to a chef if he would poison Capone's soup. Instead, the chef told Capone. Aiello got his just deserts: In 1930, his body was riddled with at least a hundred bullets.

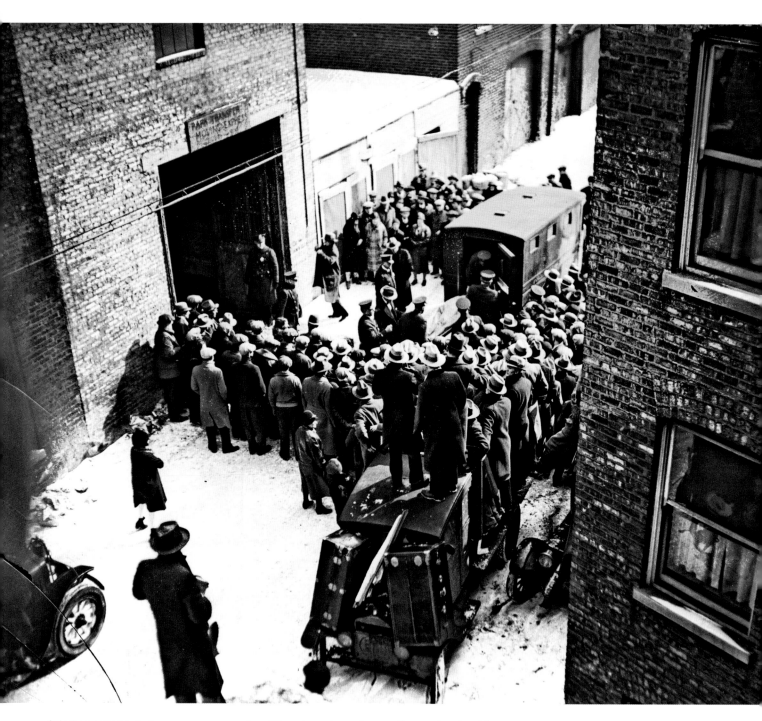

Onlookers gather as bodies are removed from the S. M. C. Cartage Company garage at 2122 North Clark Street. This was the signature event of Chicago's gangland murder spree, the Saint Valentine's Day Massacre in 1929. Five suspected Capone gunmen, two of them dressed as policemen, walked into the garage, a headquarters for the Moran gang, and ordered seven people inside to line up against a brick wall. They killed them all with sawed-off shotguns and Thompson submachine guns. Moran, who missed the massacre because he was late arriving at the garage, proclaimed, "Only Capone kills like that." The attack made Capone the undisputed crime boss of Chicago and was a turning point in public outrage at the carnage.

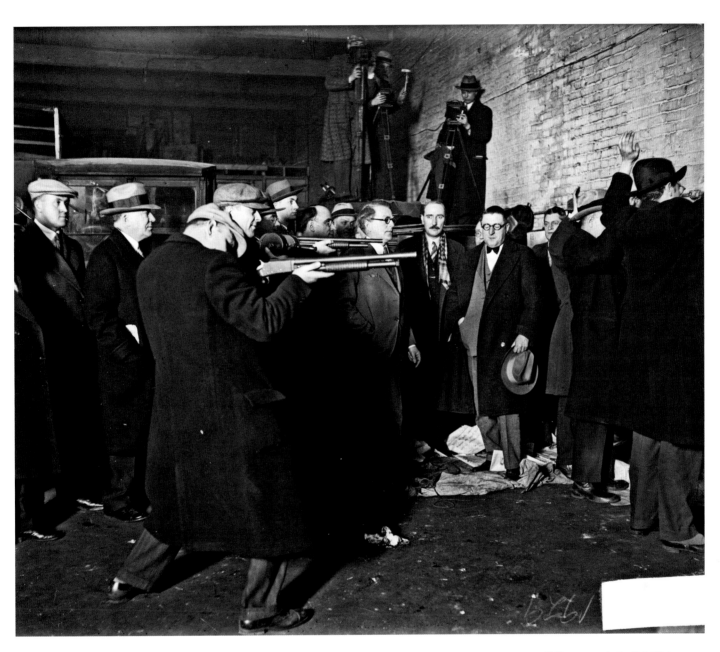

Police re-create the Saint Valen-
tine's Day Massacre a day after the
murders.

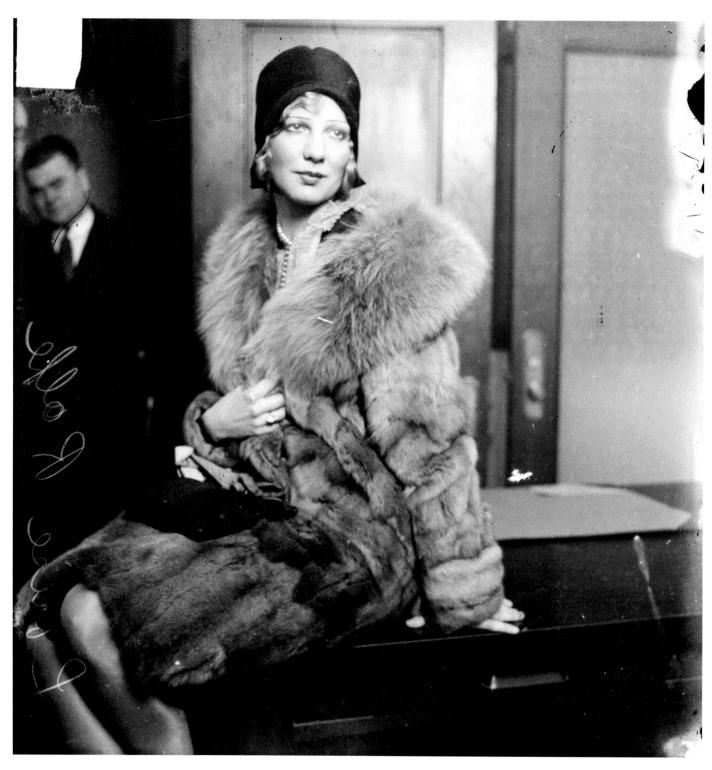

Chicago showgirl Louise Rolfe was the ultimate gangster moll, nick-named the "Blonde Alibi." When her boyfriend, "Machine Gun" Jack McGurn, was arrested on suspicion of being involved in the Saint Valentine's Day Massacre in 1929, Rolfe insisted that he'd been with her the whole time. Then she married him so she couldn't be forced to testify against him. The attention ruined McGurn's career as a hit man, so he began managing nightclubs. When he failed as a businessman during the Depression, Rolfe left him. On Valentine's Day 1936, McGurn was shot to death in a bowling alley by rival gangsters.

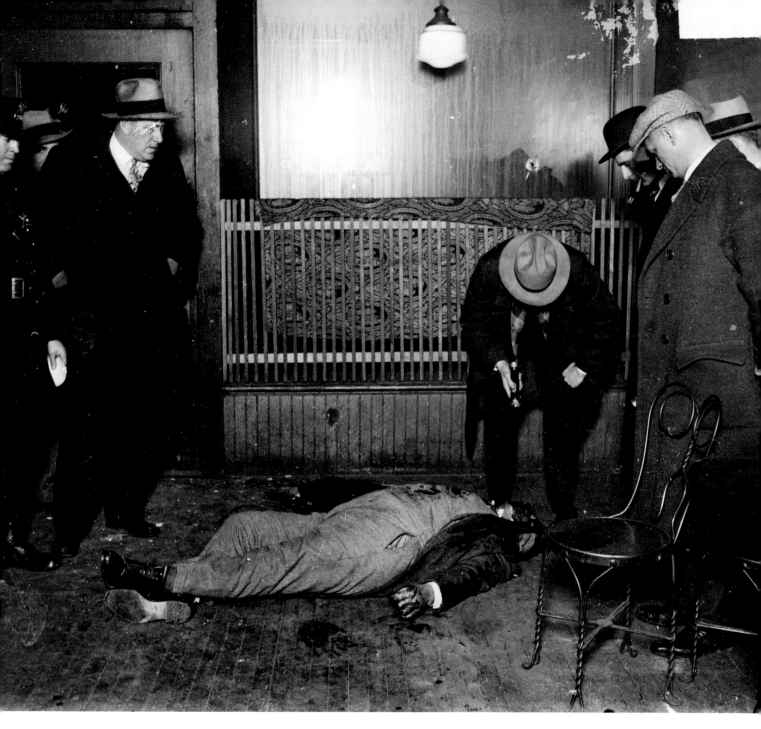

Little Italy neighborhoods throughout the country were plagued by extortion gangs known as the Black Hand. In Chicago, the corner of Oak Street and Milton Avenue (now Cleveland Avenue) was called "Death Corner." In a fifteen-month period beginning in 1910, thirty-eight people were killed there by the Black Hand. Pictured here is the body of an Italian immigrant known as Ole Scully (his given name was believed to be Olympio Scalzetti). When he agreed to testify against the Black Hand in a 1928 kidnapping, men with sawed-off shotguns burst into a tavern at 1421 West Taylor Street and shot him to death. The kidnapping defendants were convicted anyway.

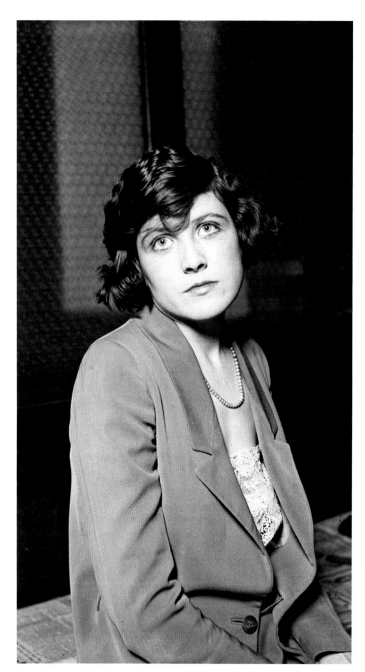
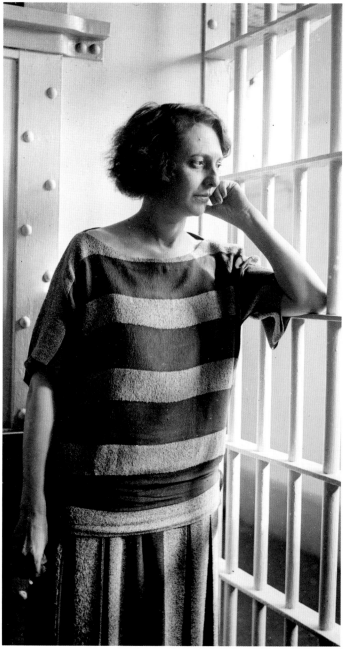

MURDER UNINCORPORATED

The main characters in the play and movie *Chicago* were based on two inmates on Cook County Jail's "Murderess Row" in 1924. *Tribune* reporter Maurine Dallas Watkins, who covered the cases, quit the newspaper to write the play. One suspect, a married woman named Beulah Annan **(left)**, shot her lover when he tried to break off their relationship. As he died, she played the song "Hula Lou" on the phonograph. Her legal mouthpiece, W. W. O'Brien, played the press with a series of revelations, including her purported pregnancy and the story that both suspect and victim had grabbed for the gun. She was acquitted. The second woman, a twice-divorced cabaret singer named Belva Gaertner **(right)**, was also accused of killing her lover. After the shooting, police discovered the gun in her possession and his blood on her clothes. She explained that she had been too drunk on gin to remember what happened, and she too was acquitted.

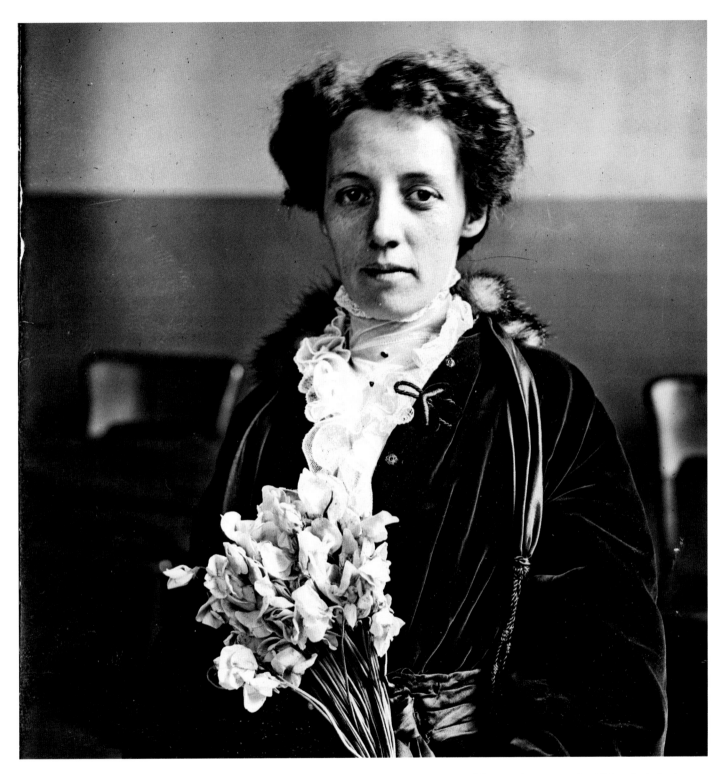

Divorcee Nellie Higgs was found not guilty of murder in 1914 despite clear evidence that she had boarded an Illinois Central train and shot her married paramour, train conductor William Walter Willis, in the back. After consulting her attorney, Higgs declared, "My mind is a blank." She was the seventeenth woman in Cook County acquitted of murder in a decade, prompting a call for an end to all-male juries. "Any kind of a woman can kill at her pleasure," Assistant State's Attorney Stephen A. Malato complained. "She can go into court after killing, shed a few tears and cast a few wistful glances at the jury, and she will be acquitted."

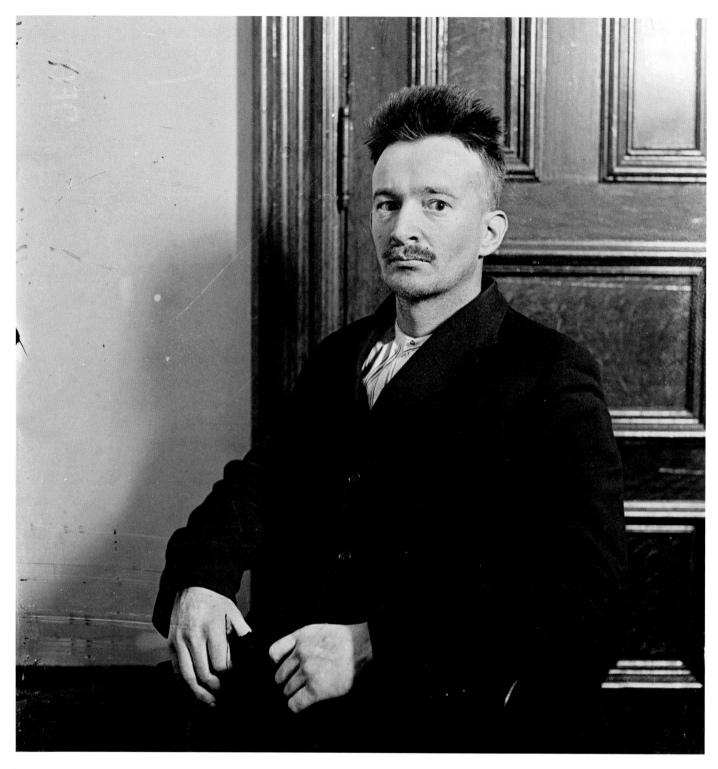

"Terrible" Tommy O'Connor, convicted of killing a police officer in 1921, was awaiting the hangman in the Criminal Courts Building. But in a scene later fictionalized in Ben Hecht and Charles MacArthur's play *The Front Page*, Tommy somehow got a gun, held up a guard, sneaked down a freight elevator, and climbed over a nine-foot wall, seizing two vehicles in the course of his escape. "O'Connor will not be taken alive!" declared Detective Chief Michael Hughes. He was right: O'Connor wasn't taken at all. As late as 1977, a wooden gallows was kept in a jail basement in case O'Connor was captured, but he never was.

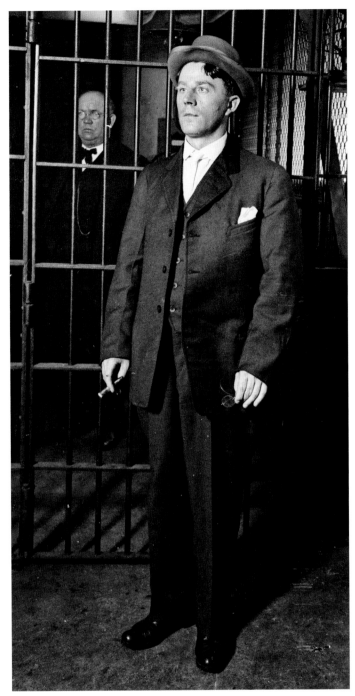

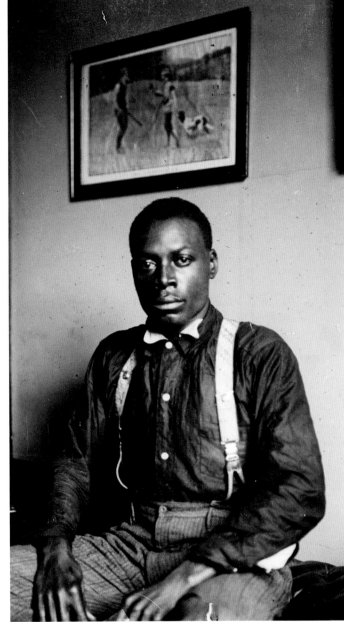

Henry Spencer almost got away with bilking and murdering a "spinster," Allison Rexroat, in the western suburb of Wheaton in 1913. First he persuaded her to put her savings in his name. Then he took her for a picnic and bashed her head with a hammer. He withdrew the money from the bank and was waiting for a train out of town when he was arrested. *Daily News* reporter Ben Hecht covered the hanging in August 1914. As he was writing the story, he got a wire from his editor: "Omit all gruesome details. . . . The world has just gone to war." Hecht wired back: "Will try to make hanging as cheerful and optimistic as possible."

While burglarizing a house in Chicago in 1910, Thomas Jennings killed a home owner who confronted him. But he left something behind—his fingerprints on a freshly painted railing outside the house. Jennings, the first American convicted of murder based on fingerprint evidence, was hanged.

LEOPOLD AND LOEB

It was called "the crime of the century," and the *Daily News* helped solve it. Fourteen-year-old Bobby Franks was kidnapped in the upper-class Kenwood neighborhood after school on May 21, 1924. A phone caller demanded a ransom, but before Franks's family could pursue payment, the boy's body was discovered in a drain pipe on the southern edge of the city. Police also found a pair of eyeglasses and initially assumed they belonged to the boy. They did not. Of unusual design, the glasses were traceable to Nathan Leopold, son of a wealthy businessman who lived in Franks's South Side neighborhood. Leopold, a nineteen-year-old genius attending law school at the University of Chicago, told police he'd lost his glasses while bird-watching.

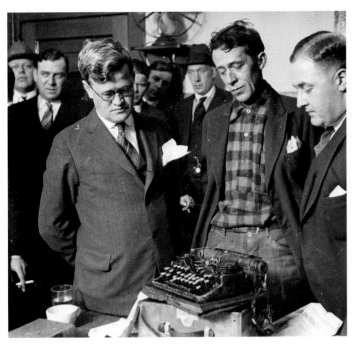

Leopold had an alibi for the day of the murder—he'd been driving around with a friend, graduate student Richard Loeb, an eighteen-year-old who also was from a wealthy family. The two, interrogated separately, eventually gave differing accounts, and other evidence further raised police suspicions. Two *Daily News* reporters, James W. Mulroy and Alvin H. Goldstein, found study notes typed by Leopold that matched the type found on a ransom note. Leopold's chauffeur told police that he'd spent the entire day of the murder fixing the family's Willys-Knight—the car that the two young men said they had been using. Confronted with these facts, the suspects cracked. They confessed that they'd killed Franks and that their real motive wasn't ransom money. What they wanted was a thrill, a "perfect crime" to relieve their boredom.

The wantonness of the crime prompted calls for the death penalty, but the suspects (Leopold at left center, Loeb at right center) had the best defense lawyer in the business, Clarence Darrow (right). The attorney persuaded both of them to plead guilty—avoiding a jury trial—and then set about saving their lives. He gave the judge a recitation about how these sons of privilege were really emotionally deprived. And he made an eloquent twelve-hour argument against capital punishment. The judge gave the defendants life plus ninety-nine years. The *Daily News* reporters who had helped crack the case received a Pulitzer Prize, the first of thirteen won by the newspaper.

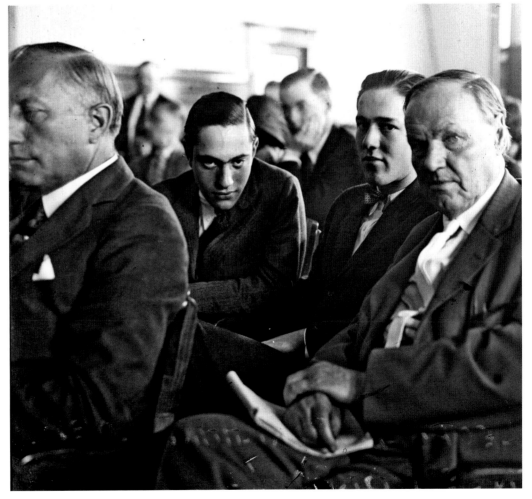

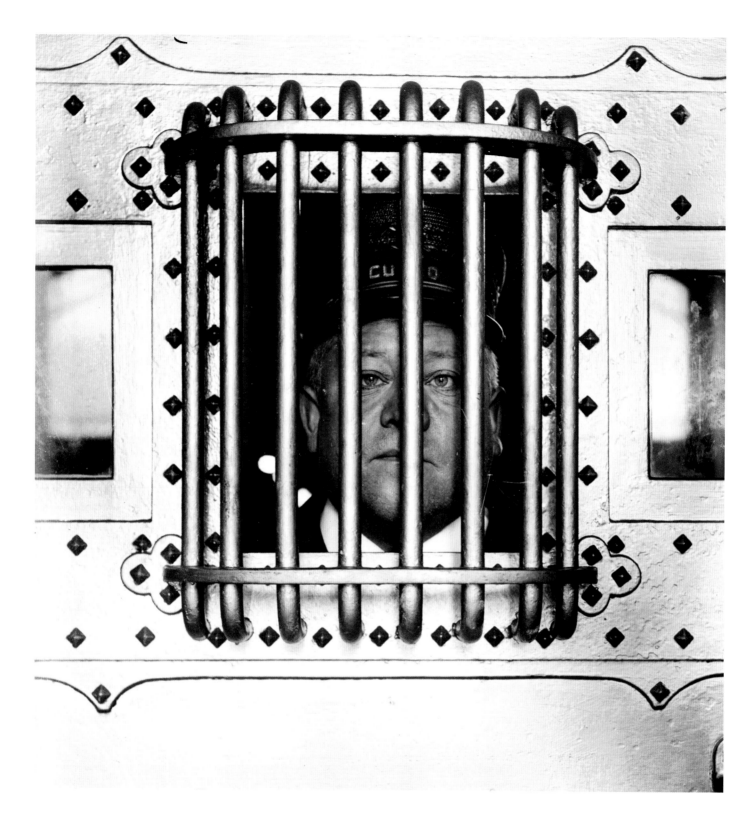

AUTHORITY FIGURES

A guard stands watch at the Cook County Jail in 1908.

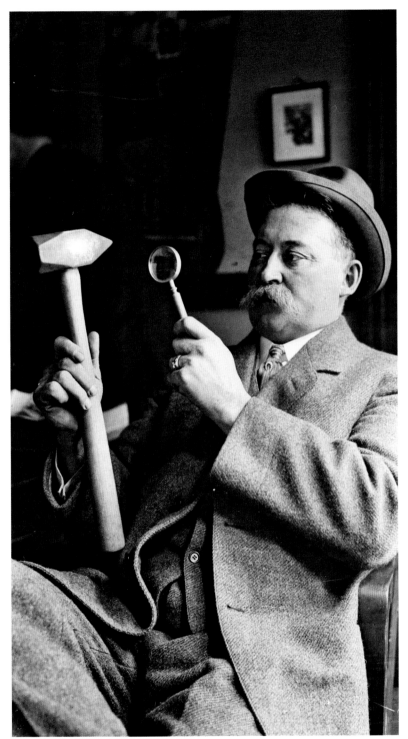

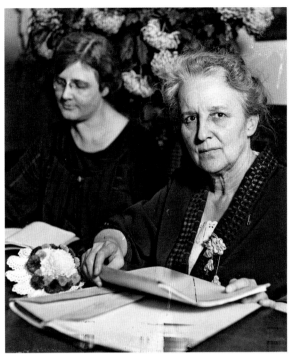

Mary Margaret Bartelme, a Northwestern law school graduate, served sixteen years as Cook County public guardian and in 1923 became a circuit court judge, the first woman elected to that post in Illinois. This photo was taken the following year. Bartelme earned the nickname "Suitcase Mary" for leading fundraising drives to give suitcases filled with clothes to underprivileged girls. By the time she retired in 1933, her charity had filled more than ninety-three thousand pieces of luggage.

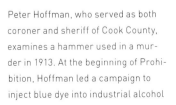

Peter Hoffman, who served as both coroner and sheriff of Cook County, examines a hammer used in a murder in 1913. At the beginning of Prohibition, Hoffman led a campaign to inject blue dye into industrial alcohol to prevent the sale of the lethal rot-gut known as "coroner's cocktail." Hoffman was not morally opposed to bootlegging: He took bribes to let hooch merchants Frankie Lake and Terry Druggan out of jail.

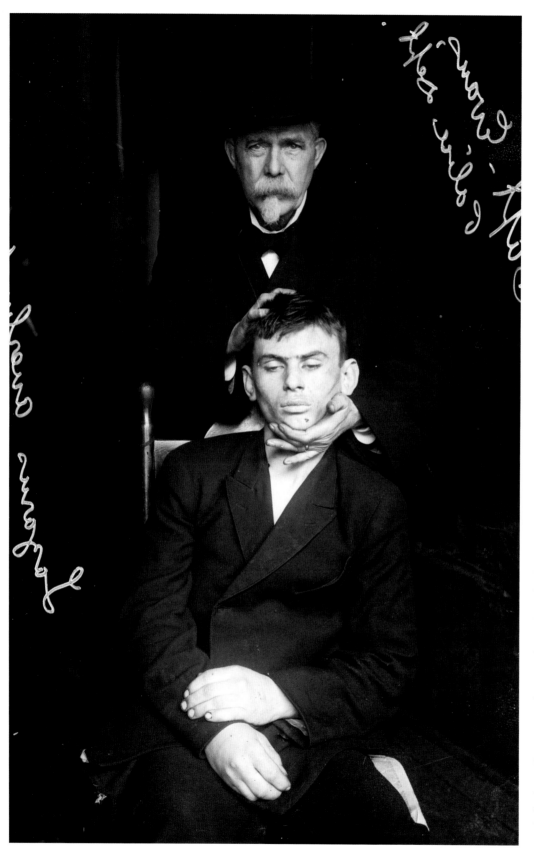

The body of Lazarus Averbuch is held up by police captain Michael Evans in 1908 after a deadly struggle at police chief George Shippy's house. Averbuch, a nineteen-year-old Russian immigrant, knocked on the chief's door on a March morning and handed him an envelope with Shippy's name and address on it, and only a blank piece of paper inside. Shippy thought Averbuch looked suspicious and jumped him. As they wrestled, Averbuch allegedly stabbed Shippy and shot Shippy's son Harry and Shippy's bodyguard, James Foley. All three survived, but not Averbuch, who was fatally shot by Shippy and Foley. The newspapers accepted the police account that Averbuch was an anarchist bent on assassinating the chief, but there were other theories. The young man may have offered Shippy the envelope because it was traditional in Averbuch's native Russia to get the police chief to sign a statement attesting to one's good character before seeking employment. The shooting remains a mystery.

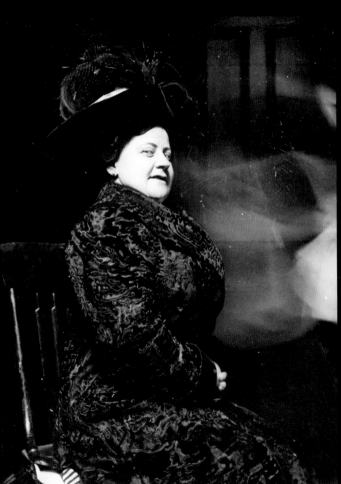

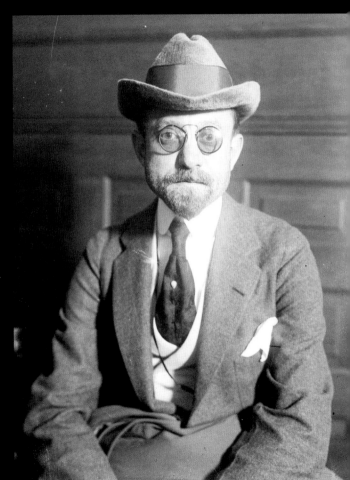

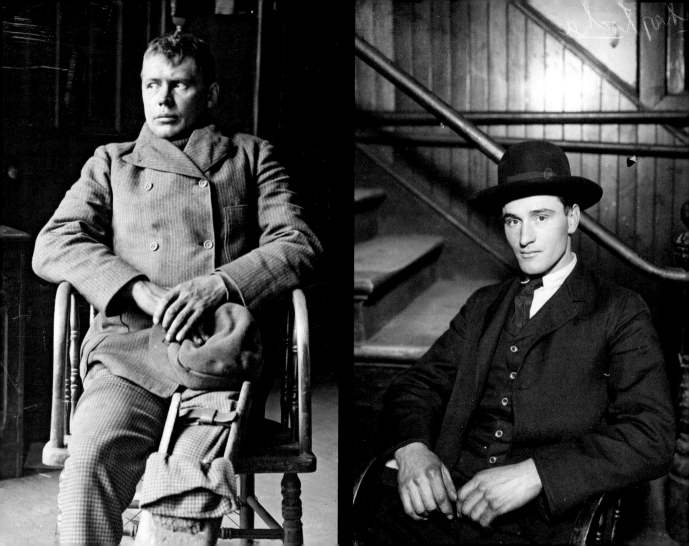

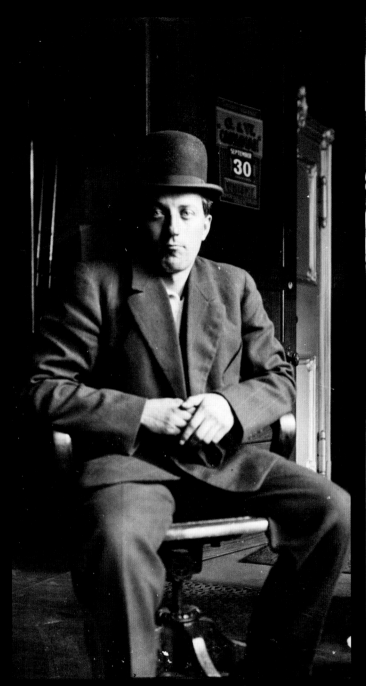

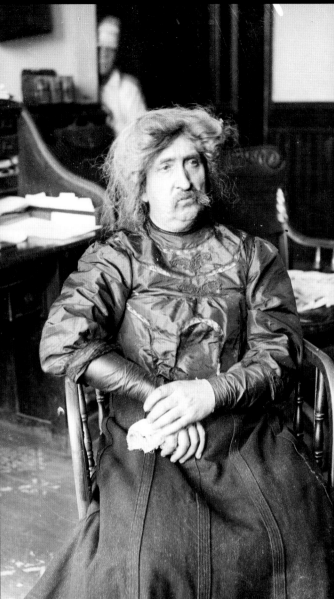

Julius Duc, cross-dresser, 1906.

Fred Wahlenmeyer, bomb maker, 1910. He claimed to have found and defused explosives outside the Palmer mansion, but police said it was all part of a "demented" attempt to become famous.

CHAPTER FOUR

VAMPS AND VAUDEVILLIANS

H. L. Mencken, America's literary czar, declared Chicago the champion of culture during the first decades of the twentieth century. "Find me a writer who is indubitably an American and who has something new and interesting to say, and who says it with an air, and nine times out of ten I will show you that he has some sort of connection with the abattoir by the lake," Mencken wrote in 1917.

Chicago's realistic, naturalistic style was fashioned in part by Carl Sandburg and fellow *Daily News* writer Ben Hecht. It found its way into other arts, making Chicago the nation's preeminent city for poetry, painting, playwriting, music, and architecture, according to Mencken. "In Chicago originality still appears to be put above conformity," he wrote. "The idea out there is not to do what others do, but to do something they can't do."

The city also seemed a perfect location for moviemaking. In the heart of America, it boasted large numbers of theater actors and the skilled technicians needed to produce silent films. During the first decades of the century, the Selig movie company and Essanay Studios produced hundreds of one-reelers. From the start, the *Daily News* sensed the importance of this new industry and appointed young Sandburg as one of the nation's first film critics.

But Chicago's weather was not well-cast for the movie business. Hollywood beckoned. Meanwhile, many of Chicago's writers and poets felt the pull of New York. While the moviemakers went west, the literati went east.

TUNES

The Alexander sisters were popular "songbirds" in 1925, performing at such downtown theaters as the McVickers and RKO Palace.

John Philip Sousa, the composer and bandleader known as the "March King," was a frequent visitor to Chicago, performing at the 1893 World's Columbian Exposition and leading bands at the Great Lakes Naval Training Center north of the city during World War I. Sousa wrote "Semper Fidelis" (the Marine Corps anthem), the "Washington Post March," and "Stars and Stripes Forever." To spark interest when Sousa toured England, his publicity manager made up a tale that the bandleader was really an English immigrant named Sam Ogden whose luggage was marked "S. O., U.S.A." In truth, Sousa, shown in 1914, was born in Washington, D.C., to parents of Bavarian and Portuguese descent.

Enrico Caruso's fame as an operatic tenor was bolstered by the growing popularity of the phonograph. When the Italian star visited Chicago in 1920, the *Daily News* quoted a Congress Hotel bellboy who complained: "That guy in K 26 has been singing his head off all morning. Talk about a racket!"

STAGE

Will Rogers, shown with his son Will Jr., traveled the vaudeville circuit and told jokes, but calling him a stand-up comic would be like calling Picasso a sketch artist. Rogers was the quintessential American of his era—smart, with a keen sense of humor, and somehow cynical and optimistic at the same time. The part-Cherokee from Oklahoma performed rope tricks, spoke at banquets, appeared on radio, acted in movies, and wrote a newspaper column and six books. Rogers's disdain for war and politics was noteworthy considering that his son became a war hero and a congressman. Among the quips of the "Cowboy Philosopher": "I never yet met a man that I didn't like" and "Never miss a good chance to shut up."

The Cube Theatre in the Hyde Park neighborhood on Chicago's South Side was a rarity of the late 1920s: a racially integrated theater company. Among the performers at the Cube was famed dancer Katherine Dunham. The theater was founded by her brother Albert and Nicholas Matsoukas, and was visited by such African American luminaries as poet Langston Hughes, musicians Louis Armstrong and W. C. Handy, and actor Paul Robeson.

Irene Castle revolutionized popular dancing and modern dress. A New York debutante, she married British actor and nightclub magician Vernon Castle, and the two became the most celebrated ballroom dance team of the age. The Castles popularized the fox-trot, performing in nightclubs, rooftop gardens, and Broadway shows. They also became fashion idols: Irene inspired a generation of women to bob their hair and the shed their corsets. During World War I, Vernon joined the British Royal Flying Corps, surviving 150 combat missions. Back in the United States to teach student pilots in Texas, he was killed in a 1918 plane crash caused by a trainee. Irene Castle, shown here in 1922, tried other dance partners, with limited success, and remarried three times. Her third husband, Major Frederic McLaughlin, built the Chicago Blackhawks hockey team and helped her found the Orphans of the Storm animal shelter in Chicago's north suburbs.

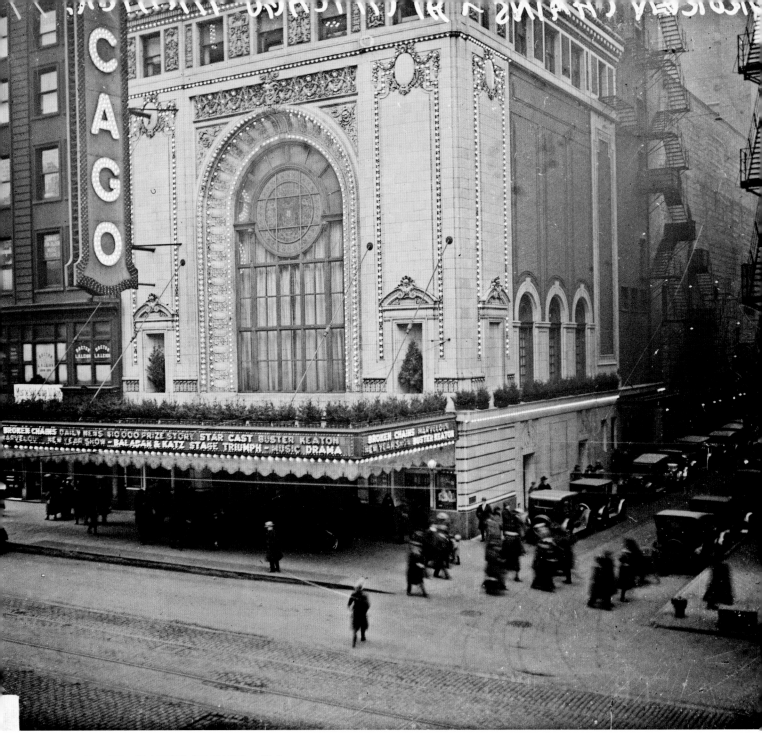

FLICKERS

The city was a huge market for motion pictures: The Chicago Theatre opened in 1921, offering five thousand seats for both road shows and movies. "The Wonder Theatre of the World" is shown in 1923, when it featured *Broken Chains*, made from a screenplay that won a *Daily News* contest.

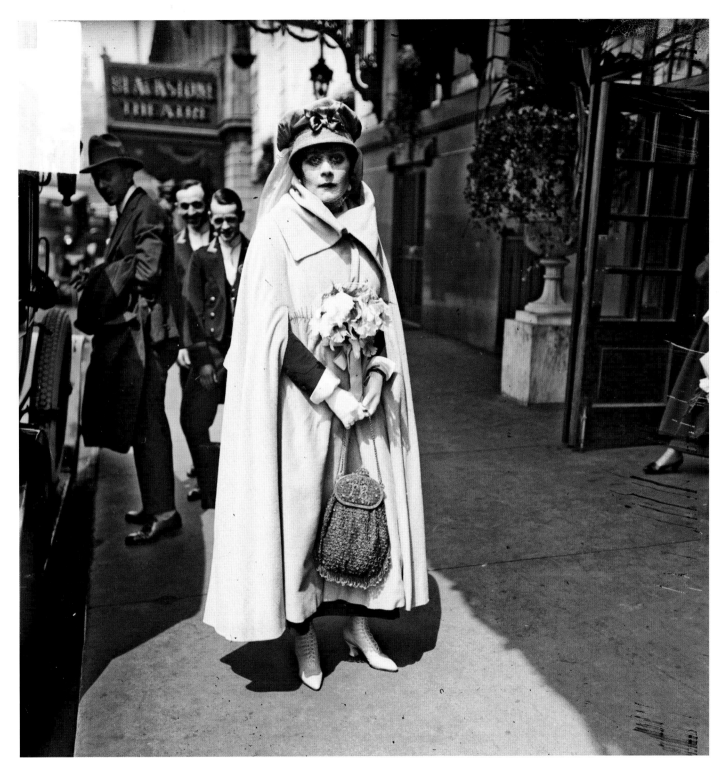

Theda Bara, photographed in front of the Blackstone Theater in 1917, created her own exotic persona when she starred as "the vampire" in the 1915 film *A Fool There Was*. She de- picted a man-devouring femme fatale and popularized the word *vamp*. *Daily News* movie critic Carl Sandburg called her a "she-devil." The studio claimed that her name was an anagram for "Arab Death" and that she was "born in the shadow of the sphinx" with a French artist father and Arab princess mother. In fact, she was Theodosia Goodman, a middle-class Jewish girl from Cincinnati. Bara's haunting eyes are remembered today in the logo for the Chicago International Film Festival.

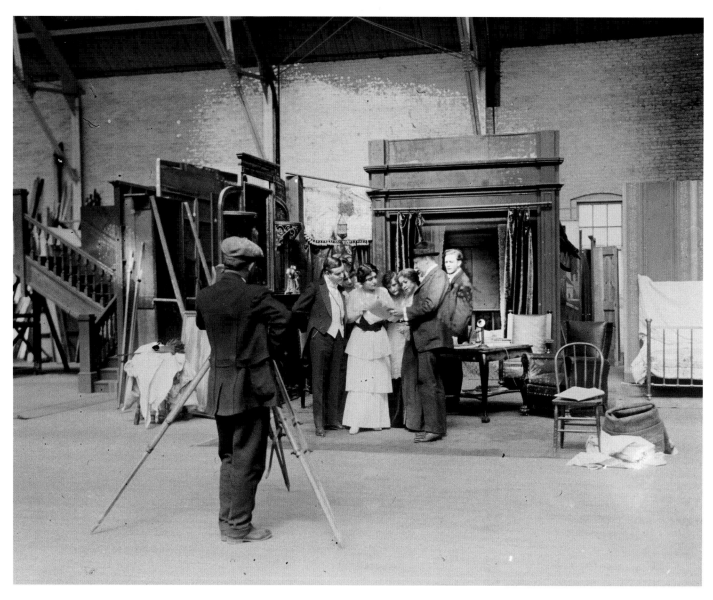

Chicago's Selig movie company, at Western Avenue and Irving Park Road, was a pioneer in both the technology and the art of the "flickers," as movies were once known. In 1909, founder William N. Selig tried to persuade former president Theodore Roosevelt to allow a movie crew to accompany him on a hunting safari in Africa. Roosevelt said no, so

Selig brought Africa to Chicago. He purchased an elderly lion, found an actor who looked like Roosevelt, and hired black Chicagoans to portray African tribesmen. The film, *Hunting Big Game in Africa*, was a hit. Selig set up Hollywood's first movie studio in 1909. The production shown in this 1914 photo is not known.

Facing page: To some modern-day observers, silent films may seem primitive, but before the arrival of "talkies," they were sophisticated entertainment—a social force that defined and reflected moral values, ideals of sexual beauty, and public fashion. Fans were shocked when Mary Pickford, "the Girl with the Golden Hair," lost her curls in 1928 in favor of a modern bob. Pickford got her hair cut in New York, then took

the curls with her on the train to Chicago and re-created the earthshaking event for the *Daily News* and other interested observers. Hollywood's first millionaire and the biggest female star of her time, Pickford was married to swashbuckling star Douglas Fairbanks. In 1919 the couple had formed their own movie studio, United Artists, with Charlie Chaplin and director D. W. Griffith.

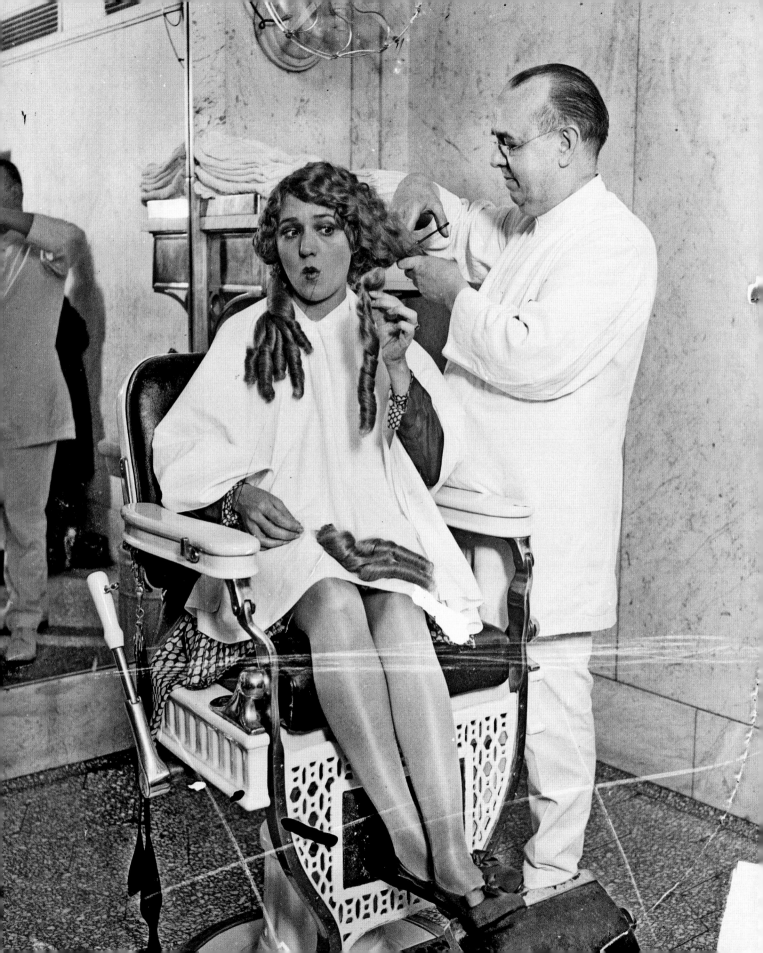

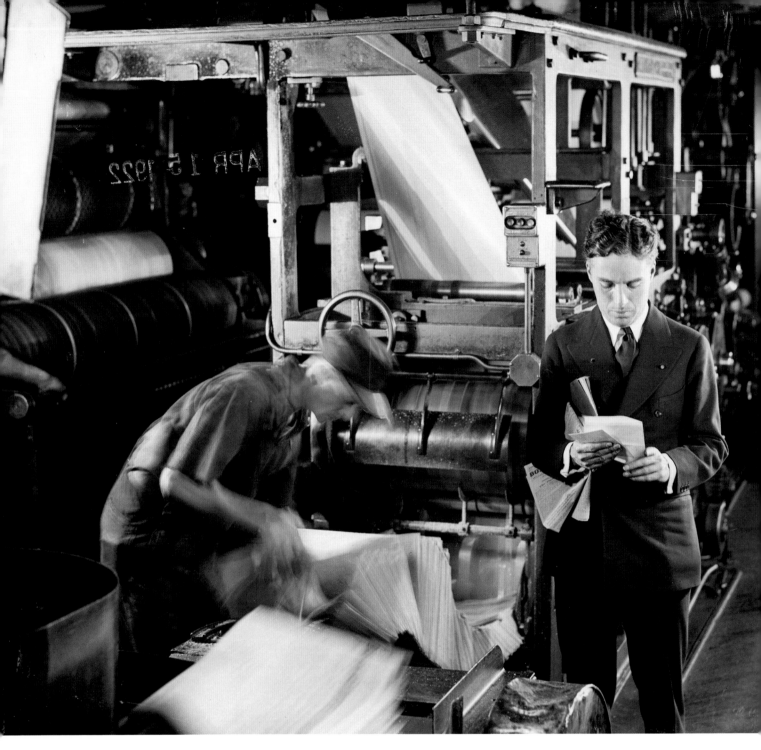

Charlie Chaplin, the most famous actor of his era, poses in the *Daily News* press room in 1922. Chaplin had worked for Essanay Studios in 1915 and part of 1916, during which time his "little tramp" character became known around the world. Upon arrival at Essanay, based at 1333 West Argyle Street, Chaplin was told where to pick up his script. He responded: "I don't use other people's scripts. I write my own." In 1916, Chaplin defected to Mutual Studios, which built him a studio in Santa Barbara, California. It was time to roll the credits on Chicago moviemaking.

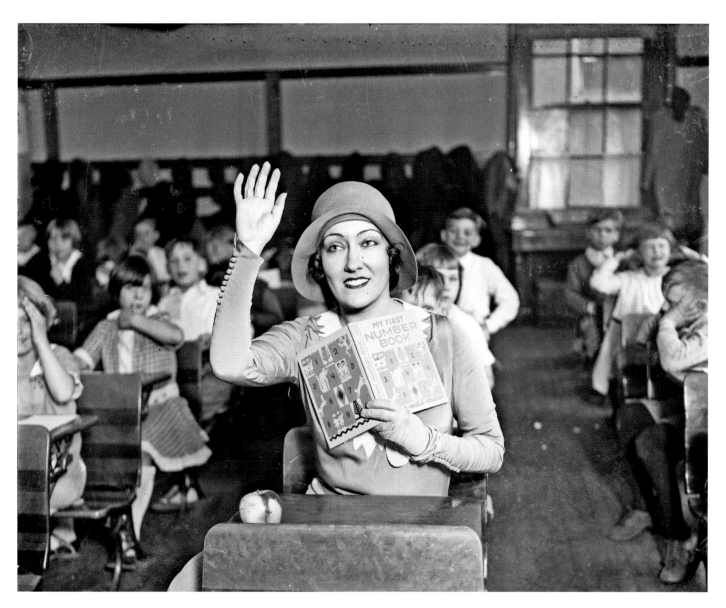

Actress Gloria Swanson visits her old second-grade classroom at Hawthorne School on Chicago's North Side in 1929. She was born in the North Center neighborhood and as a child pushed her doll buggy through Lincoln Park. At age fifteen, she visited Essanay Studios for a tour with her aunt. She was instantly discovered. An actor she didn't know named Chaplin tried to get her to help him in a comedy routine at Essanay, but she brushed him off because she felt better suited to drama. A career that banked on her beauty and style tailed off dramatically as she aged. She is best known today as the washed-up actress in *Sunset Boulevard*.

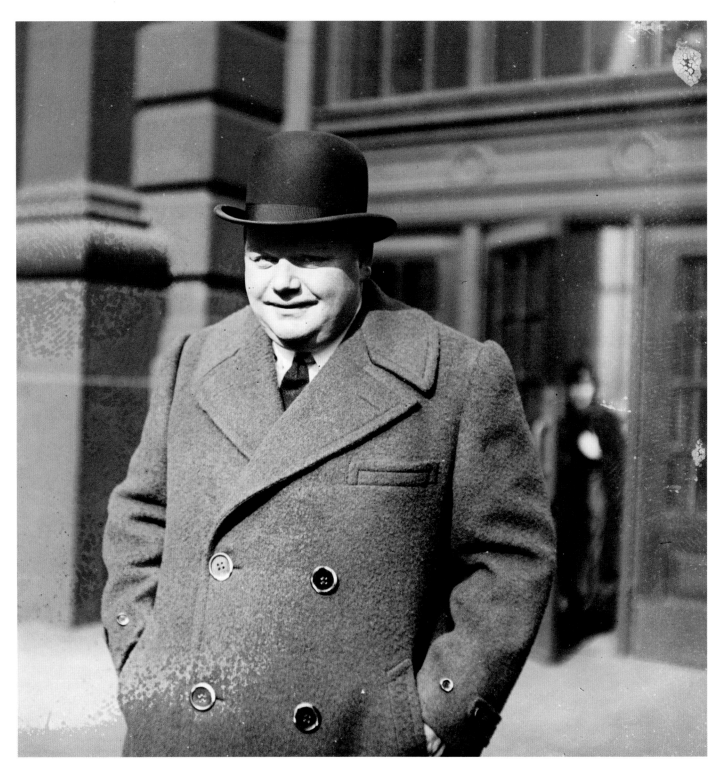

Comedian Roscoe "Fatty" Arbuckle visited Chicago in 1920, a year before a scandal destroyed his career. At a wild party at the Saint Francis Hotel in San Francisco, a young actress, Virginia Rappe, suffered a ruptured bladder and later died, amid reports that Arbuckle had raped her. His girth was part of his cinematic appeal—he was nicknamed "the Prince of Whales"—but it was also used to support a theory that the crush of Arbuckle's weight had killed Rappe. He went through three manslaughter trials. Two ended in hung juries, and he was acquitted in the third. But his reputation and career could not be rescued. He died in 1933.

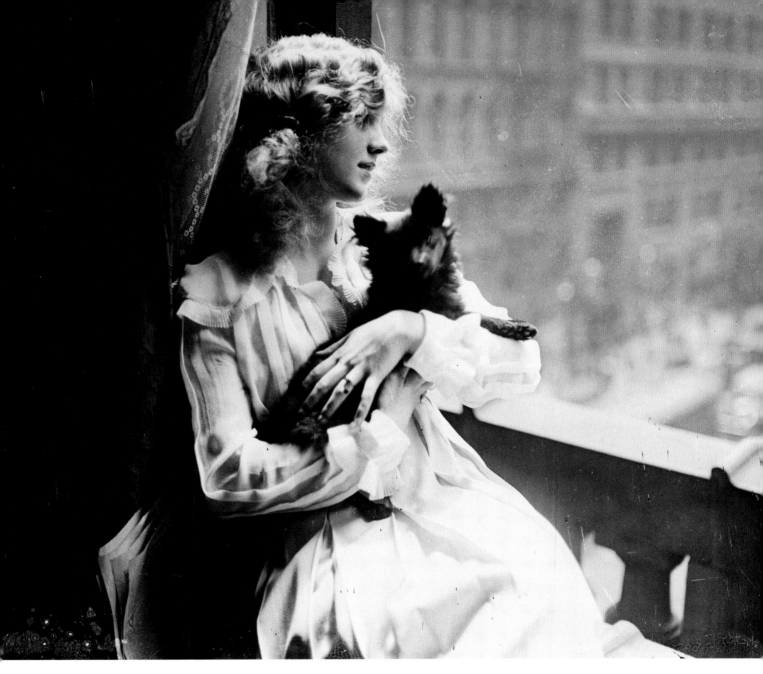

In 1918, when a loaf of bread cost ten cents, a teenage actress named Mary Miles Minter signed a five-year movie contract for $1.3 million. Today, she is virtually forgotten, and her most famous film, *Anne of Green Gables*, does not exist in any form. The director was William Desmond Taylor, a debonair Irishman who was mysteriously murdered in Los Angeles in 1922. Everyone who was close to him came under suspicion, including nineteen-year-old Mary and her forty-four-year-old mother—both of whom were rumored to have had love affairs with the forty-nine-year-old director. Coming on the heels of the Fatty Arbuckle scandal, the murder turned Minter into box-office poison. Taylor's killer was never found, and even today the case is a parlor game for conspiracy buffs. In 1923 Minter walked out of Paramount Studios with a $350,000 check; the studio had bought out her contract, and she never made another film.

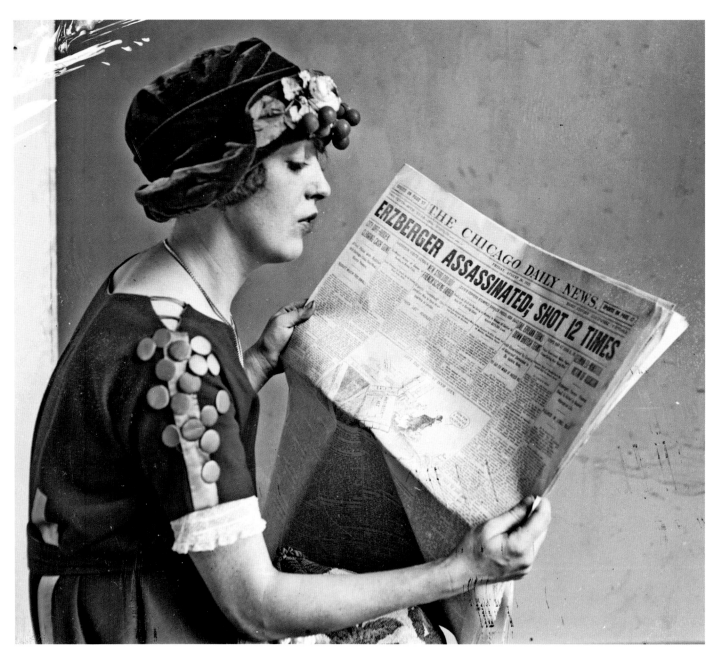

Comic actress Mabel Normand reads a 1921 edition of the *Daily News* with a lead story reporting the assassination of German politician Matthias Erzberger. *Daily News* movie critic Carl Sandburg praised Normand as a female version of Charlie Chaplin. Normand, however, was Chaplin's superior at times, serving as writer and director for some of his early films. Nicknamed the "I-Don't-Care Girl," Normand was as crass as she was creative, earning a reputation for drunkenness and drug abuse. Along with Mary Miles Minter, Normand was a suspect in the murder of William Desmond Taylor, and her career was dragged down by the scandal. She died of tuberculosis in 1930 at age thirty-seven.

Facing page: Joseph Frank Keaton, born to a vaudeville family, received the nickname "Buster" when, at six months of age, he fell down a flight of stairs but was unhurt. "That's some buster your baby took," said an observer. Beginning at age three, Keaton joined his parents in an act in which they would toss him around the stage and watch him take pratfalls. At age twenty-one, he got his first movie break with Fatty Arbuckle.

Keaton's main movie gimmick was his lack of reaction to shocking events. Though he was nicknamed "the Great Stone Face," it was a publicity-department myth that his contract forbade him to smile on camera. Keaton is shown here in 1922 at a Chicago railroad station with his wife, Natalie Talmadge, and son Joseph.

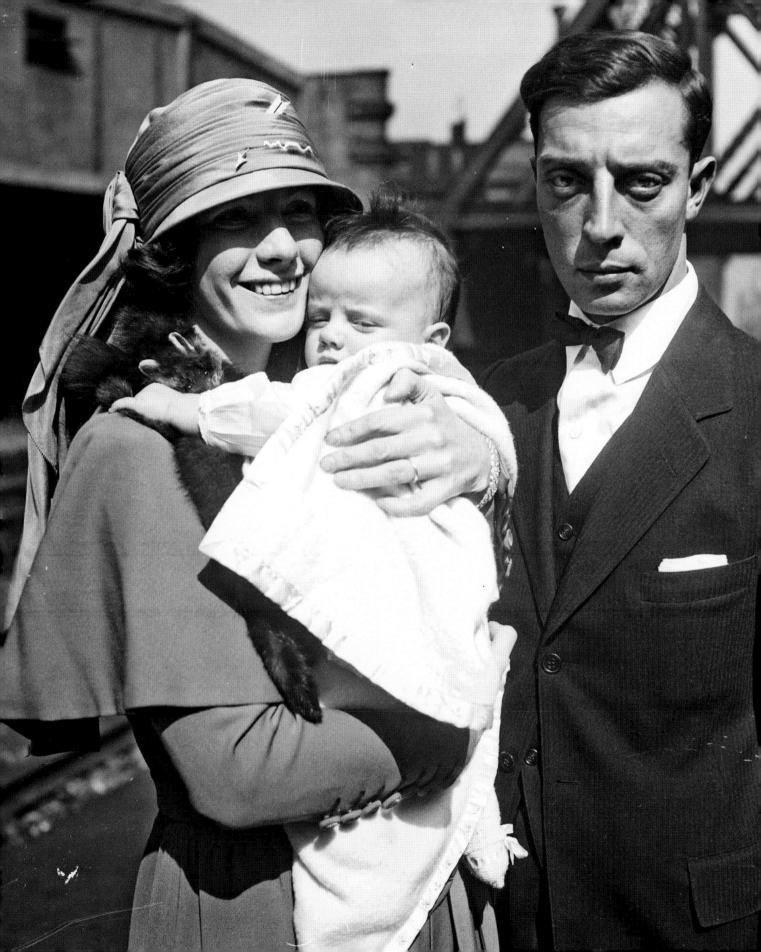

Ernie "Sunshine Sammy" Morrison's winning smile made him a star of the silent era. After playing a featured role in a Harold Lloyd comedy, he starred in his own movie, unfortunately titled *The Pickaninny*, in 1921. Morrison, shown here in 1925, became a founding cast member of the Little Rascals but left after twenty-four episodes for a lucrative vaudeville contract. Later, he was one of the East Side Kids (also known as the Bowery Boys) in their comedy series.

Actor Tom Mix (left), visiting with Chicago mayor William E. Dever in 1925, got his start in 1909 when he was hired by the Selig studio to round up cattle for a film and ended up with a small part. Before long, his name was synonymous with the word "cowboy." Mix made 336 feature films, the vast majority of them silent. Carl Sandburg praised Mix for "radiating the human stuff that gives his pictures a cleaner and more wholesome quality." Studio publicity writers made up a story that he had graduated from Virginia Military Institute, not mentioning the truth—that he was an army deserter.

Lee Duncan and Rin Tin Tin were war buddies. Duncan, a gunner in the U.S. Army Air Corps, found the German shepherd in a bombed-out kennel in France and brought him back to Los Angeles, where the dog embarked on a successful film career. "Rinty" made twenty-six films for Warner Brothers and was the studio's main source of income in the late 1920s. The original Rin Tin Tin died in 1932, in the arms of actress Jean Harlow.

Maria Guadalupe Velez de Villalobos, shown aboard a Santa Fe Railroad train from California to Chicago in 1929, was born in Mexico, raised in a San Antonio convent, and cast in the movies because of her sprightly personality and sparkling beauty. Known as Lupe Velez, "the Mexican Spitfire," she married and divorced Johnny "Tarzan" Weissmuller, dated Gary Cooper, and had affairs with a succession of cowboys, stuntmen, and actors. In debt, pregnant, and rejected by her lover at age thirty-six, she took a fatal dose of Seconal in 1944. "Lupe didn't wait for life to pass her by," wrote gossip columnist Hedda Hopper. "She took herself by the hand and went out on the full tide."

HIGH ARTS

Sculptor Lorado Taft, a native of Elmwood, Illinois, who studied at the Ecole des Beaux Arts in Paris and came back to teach at the Art Institute of Chicago, works in his Hyde Park studio on one of the figures for *Fountain of the Great Lakes* in 1913. The sculpture now sits in the Art Institute's south garden, at Michigan Avenue and Jackson Boulevard. Taft, known as "the Michelangelo of the Midwest," used to give a lecture called "Clay Talk," in which, as he spoke, he modeled clay into the head of a young woman who gradually aged.

No one brought more great visual art to Chicago than Bertha Honore Palmer, shown here in 1906. The wife of businessman Potter Palmer, she reigned over Chicago society and traveled the world. In England, she was Edward VII's bridge partner. In France, she bought paintings by a number of then-controversial Impressionist artists: the work of Monet, Renoir, Pisarro, and Sisley filled the Palmers' mansion at 1350 North Lake Shore Drive. When Potter Palmer died in 1902, he left an eight-million-dollar estate. When Bertha Palmer died sixteen years later, her shrewd investments had increased the estate to twenty million. She bequeathed fifty of her best paintings to the Art Institute of Chicago, forming the bedrock of one of the most formidable collections of Impressionist art in the world.

Some of the most important literature of the century came across Harriet Monroe's desk. *Poetry* magazine, the Chicago-based literary journal that she founded, published early works by T. S. Eliot, Ezra Pound, Carl Sandburg, Wallace Stevens, William Carlos Williams, Edna St. Vincent Millay, and Marianne Moore. Monroe is shown here in 1922, a decade after the magazine's birth. Today, her magazine is still in Chicago and going strong, billing itself as "the oldest monthly devoted to verse in the English-speaking world."

Ben Hecht had three brilliant careers—as a Chicago journalist, a Broadway playwright, and a Hollywood screenwriter. Here he's shown on horseback during an assignment for the *Daily News* in 1915. Hecht covered murders, operas, and bank scandals for the paper but was fired in 1922 after he wrote *Fantazius Mallare*, a racy novel that was banned by postal authorities. Hecht had cards printed that read: "There are no obscene words. There are only obscene readers." He moved to New York to write plays and became part of the witty Algonquin Round Table. His screenplays included adaptations of *A Farewell to Arms* and *Wuthering Heights* and such Alfred Hitchcock suspense films as *Spellbound* and *Notorious*. He served as script doctor for *Gone with the Wind* and directed at least seven films. But he didn't worship Hollywood. When his script for *Underworld* won the first Academy Award for screenwriting, he used the statuette as a doorstop.

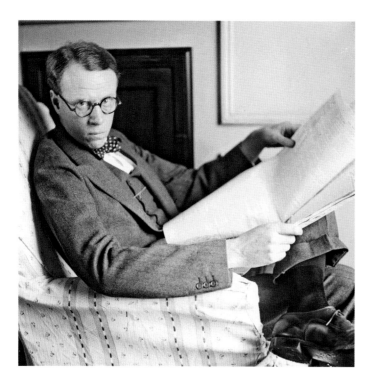

Sinclair Lewis [above], a Minnesota native who in 1930 became the first American awarded the Nobel Prize for Literature, made a career out of exposing hypocrisy. Many of his targets were Midwesterners, including businessmen (*Babbitt*), doctors (*Arrowsmith*) and ministers (*Elmer Gantry*). His condemnations extended to writers too: "We have the power to bore people long after we are dead."

Sherwood Anderson [right], shown in 1922, quit his job managing a paint factory in Ohio and moved to Chicago to write. His 1919 novel *Winesburg, Ohio*, an intimate look at the lives of small-town Midwesterners, made him famous, and soon he was hobnobbing with Gertrude Stein in Paris, sharing an apartment with William Faulkner in New Orleans, and enjoying the life of an internationally famous writer. At a cocktail party in 1941, Anderson swallowed part of a toothpick along with an hors d'oeuvre and died of peritonitis.

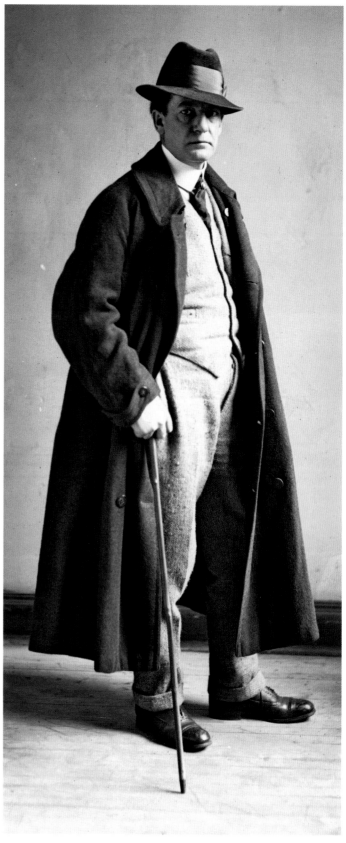

CARL SANDBURG'S CHICAGO

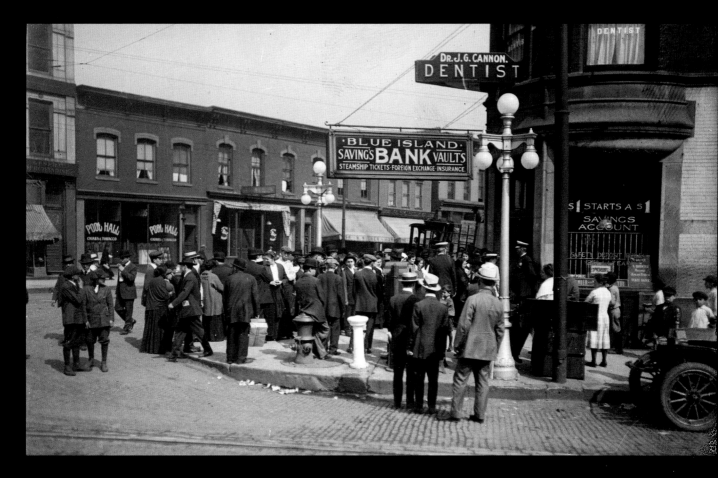

The people and wagons come and go, out and in.
Triangles of banks and drug stores watch.

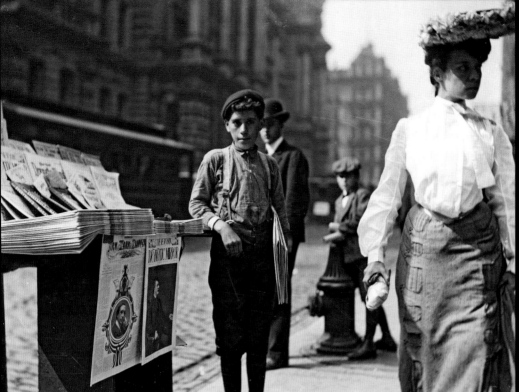

Passers-by,
I remember lean ones among you,
Throats in the clutch of a hope,
Lips written over with strivings,
Mouths that kiss only for love,
Records of great wishes slept with,
Held long
And prayed and toiled for . . .

—From "Passers-by"

A woman walks past a newsboy near City Hall in 1904.

I sit in a chair and read the newspapers.
Millions of men go to war, acres of them are buried, guns
and ships broken, cities burned, villages sent up in smoke,
and children where cows are killed off amid hoarse barbe-
cues vanish like finger-rings of smoke in a north wind.
I sit in a chair and read the newspapers.

—"Smoke"

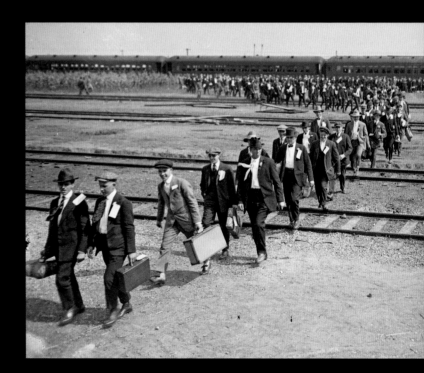

Newly enlisted men from Chicago arrive at Camp Grant in Rockford, Illinois, in 1917.

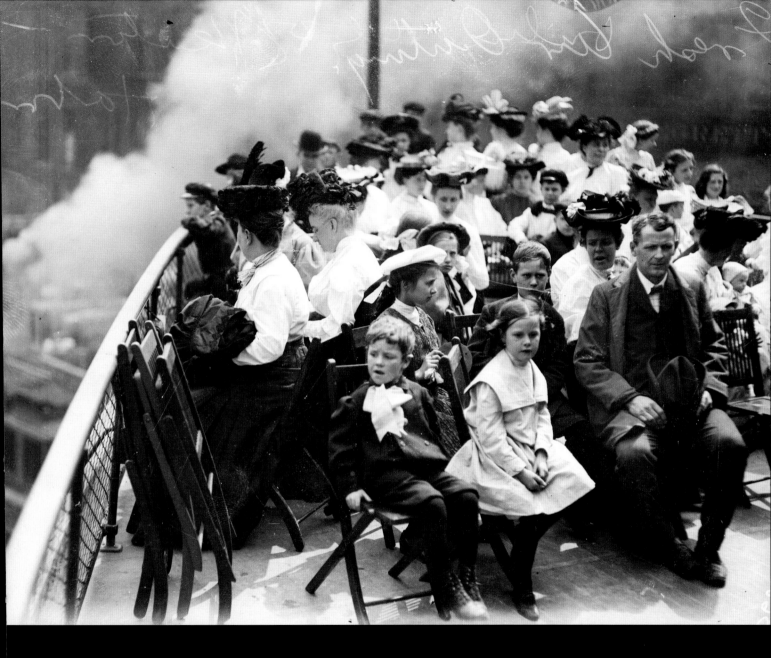

Sunday night and the park policemen tell each other it is dark as a stack of black cats on Lake Michigan.
A big picnic boat comes home to Chicago from the peach farms of Saugatuck.

—From "Picnic Boat"

CHAPTER FIVE

CARNAGE AND CALAMITY

Chicago was traumatized by a disaster—the Great Fire in 1871—and was thereafter obsessed with ensuring public safety. When the Iroquois Theater opened downtown in 1903, it was advertised as "absolutely fireproof." When the steamer *Eastland* took on passengers on the Chicago River in 1915, it had recently been fitted with extra lifeboats.

In both cases, promises of safety proved illusory. A flash fire at the Iroquois killed more than six hundred people. It was the single worst disaster in Chicago history until the next decade, when the *Eastland* flipped on its side only a few feet from its dock, leaving more than eight hundred dead.

Such tragedies were the stock-in-trade of major metropolitan newspapers such as the *Daily News*. Photographers were not able to catch much of the grim drama of the Iroquois Theater fire, which was over quickly. The *Eastland* accident, however, was highly visible, and the rescue of survivors—and recovery of corpses—was a prolonged spectacle captured in many photographs.

Less dramatic was the homefront during the Great War. The glass-negative files of the *Daily News* include about 240 photos from Camp Grant, the largest training facility for troops in the Midwest. Photos of the camp, in nearby Rockford, Illinois, were taken for the *Daily News* and for a special Camp Grant newspaper it published. Although the paper did not send photographers to the European battles, it did purchase photographs from the front lines and produced a series of popular war postcards.

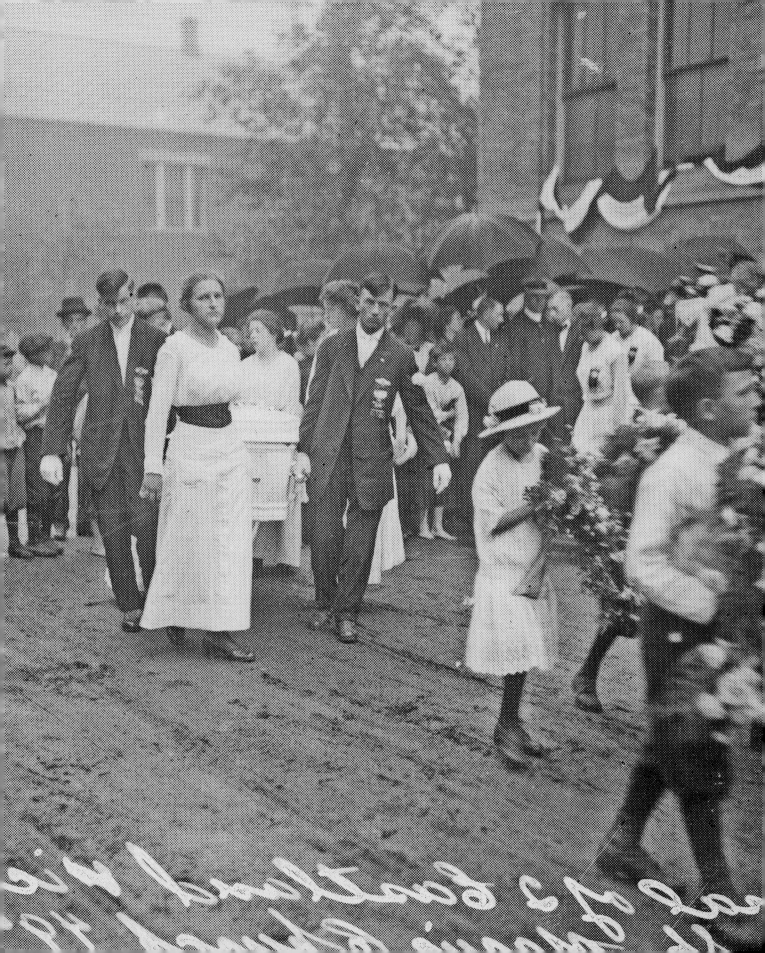

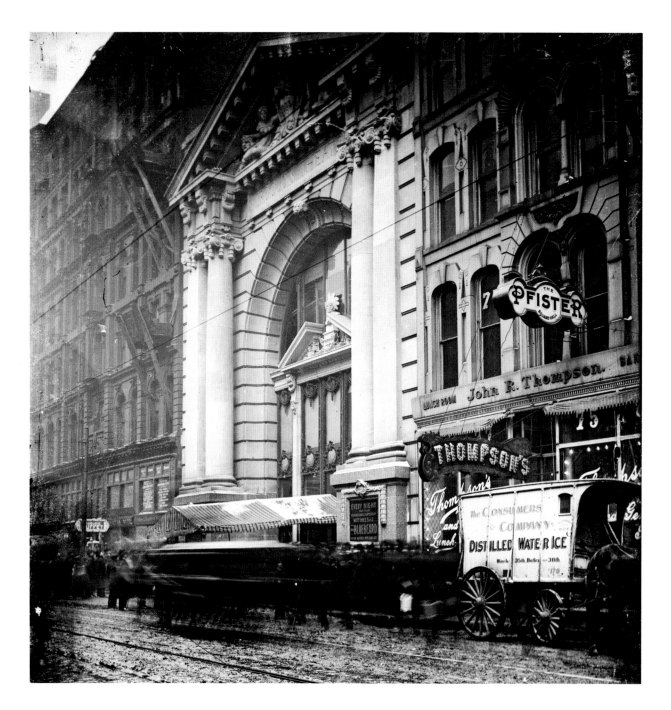

THE IROQUOIS

No theater anywhere is handsomer than the Iroquois," Amy Leslie wrote in the *Daily News* when the venue opened. But five weeks later, on December 30, 1903, no theater was deadlier. The blaze began during the second act of the musical comedy *Mr. Bluebeard*, being performed for a matinee crowd composed mostly of women and children. The theater was packed, with more than sixteen hundred people in seats and at least two hundred more standing along the walls or sitting in the aisles, in violation of safety regulations. An arc light set fire to drapes beside the stage, and the backstage staff was unable to extinguish it. A fire curtain failed to drop properly to protect the audience. And when the cast and crew opened the doors behind the stage to flee, the cold winter wind acted like the air pump on a blowtorch, sending smoke and flame into the audience. Burning scenery and rigging collapsed onto the electrical switchboard, plunging the theatergoers into darkness. The death toll was 602.

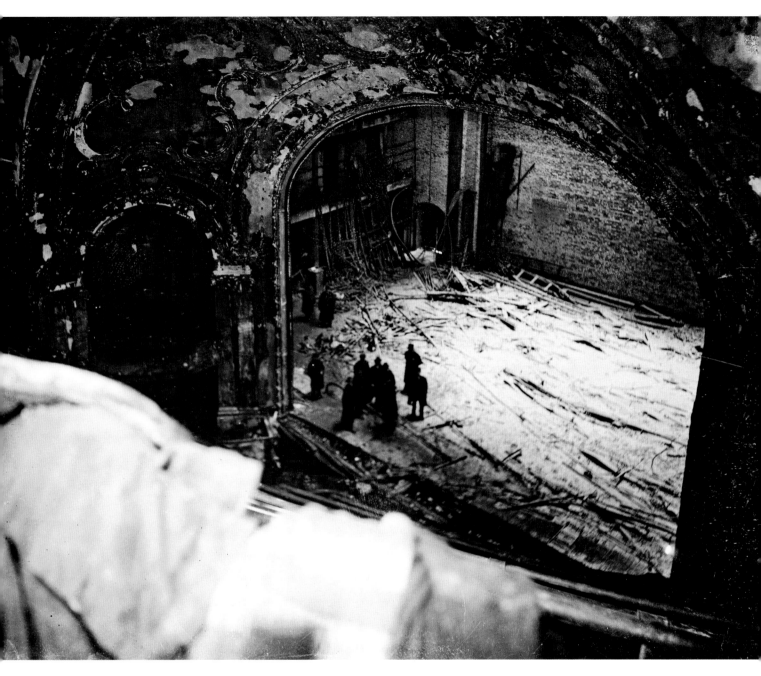

After the tragedy, Chicagoans were outraged to learn that virtually all of the Iroquois's doors opened in, not out, and that some of them had been locked to keep people in the cheaper seats from sneaking closer to the stage. Also, the new theater had no alarm system to notify the fire department. The theater operators weren't the only people tagged as villains—some policemen were spotted looting the dead. The press took its own advantage: Walter Howey, a City Press Association reporter who was one of the first newsmen on the scene, rushed to a nearby saloon and paid a bookie twenty dollars for exclusive use of his phone. Then he paid a child to stick straight pins into the wires of all public phones in the area, rendering them inoperative for other reporters. Howey, who was later city editor of the *Chicago Tribune*, served as the model for the character Walter Burns, an editor in *The Front Page*. Today, another theater stands on the site of the Iroquois: the Ford Center for the Performing Arts, Oriental Theatre.

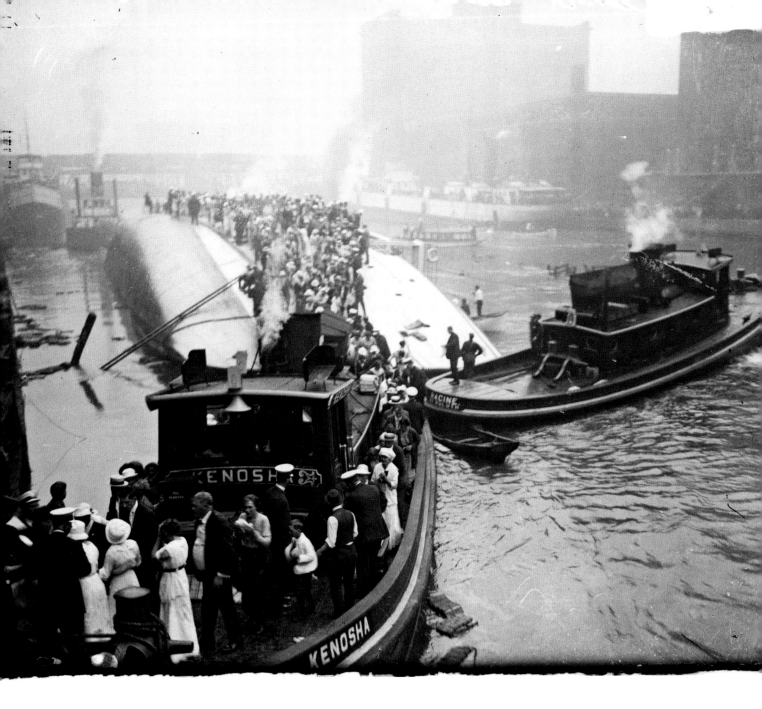

THE EASTLAND

On a Saturday morning in July 1915, Western Electric employees and their families boarded the excursion ship *Eastland*, docked on the south bank of the Chicago River between LaSalle and Clark streets. Plans called for a trip across Lake Michigan and then a company picnic in Michigan City, Indiana. Soon after the twenty-five hundred passengers had boarded, the ship began listing to port at an increasingly alarming angle. Dishes fell off shelves in the pantry and a piano slid across the promenade deck. Seconds later the ship overturned with hardly a splash. Lucky passengers were tossed into the river; the unlucky were trapped underwater. Vendors from the nearby South Water Street produce market tossed wooden crates and chicken coops into the water as lifesavers. The tugboat *Kenosha* served as a bridge that allowed survivors to walk from the overturned *Eastland* to the dock. But 844 others died. It was the deadliest disaster in Chicago history.

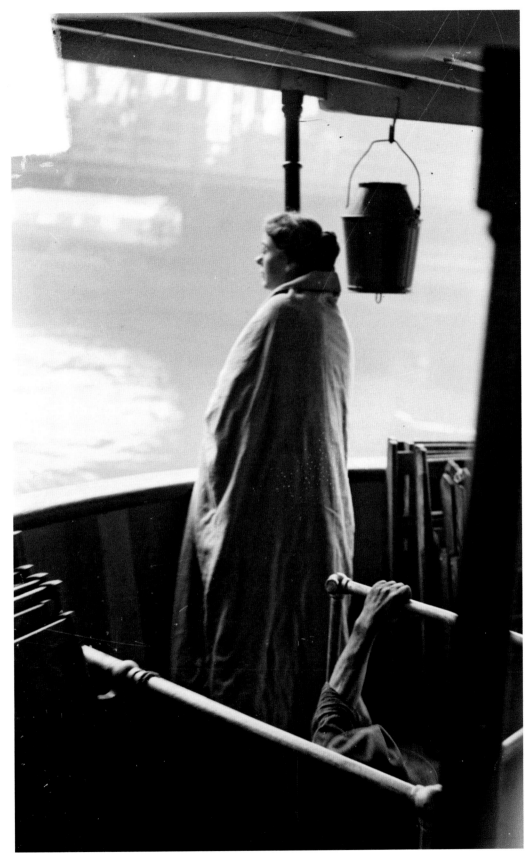

A survivor takes a moment alone in a rescue vessel. Twenty-two entire families were lost in the disaster, including eight members of one family. Most of the victims were working-class Czechs, Hungarians, and Poles, and 70 percent of them were between the ages of fifteen and thirty. A Western Electric janitor named John Salak survived but was so distraught at the death of his wife, Fannie, that he committed suicide in order to be buried with her. George Halas, a Western Electric worker who later helped found the Chicago Bears and the National Football League, missed boarding the *Eastland* because he showed up late.

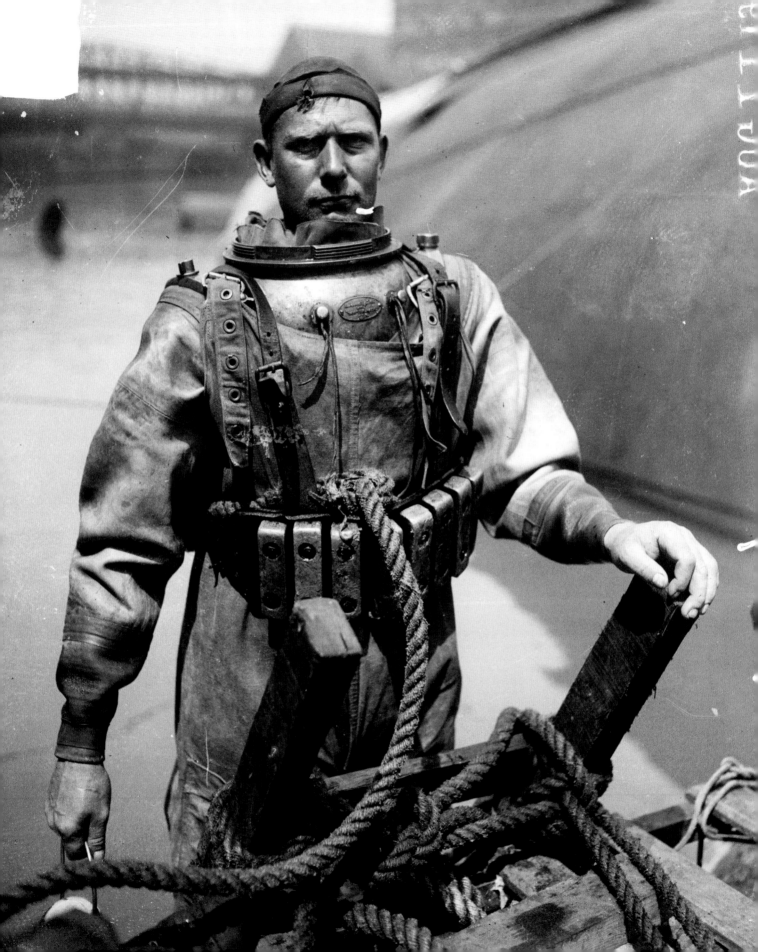

The funeral for fifteen-year-old Florian Nowak and his nineteen-year-old sister, Frances, victims of the *Eastland* disaster.

Facing page: Harry Halvorsen was among the divers who worked for days to recover bodies and then raise the *Eastland*. Wire nets were strung across the river to keep bodies from floating down its South Branch. The janitor of a nearby building let gawkers, who paid ten cents apiece, climb to the roof to watch the search. The *Eastland* was subsequently renamed the *Wilmette* and served as a naval training vessel until it was dismantled for scrap in 1947. The cause of the disaster remains in dispute, but investigations found that the ship had been made top-heavy by a series of renovations—including the addition of lifeboats.

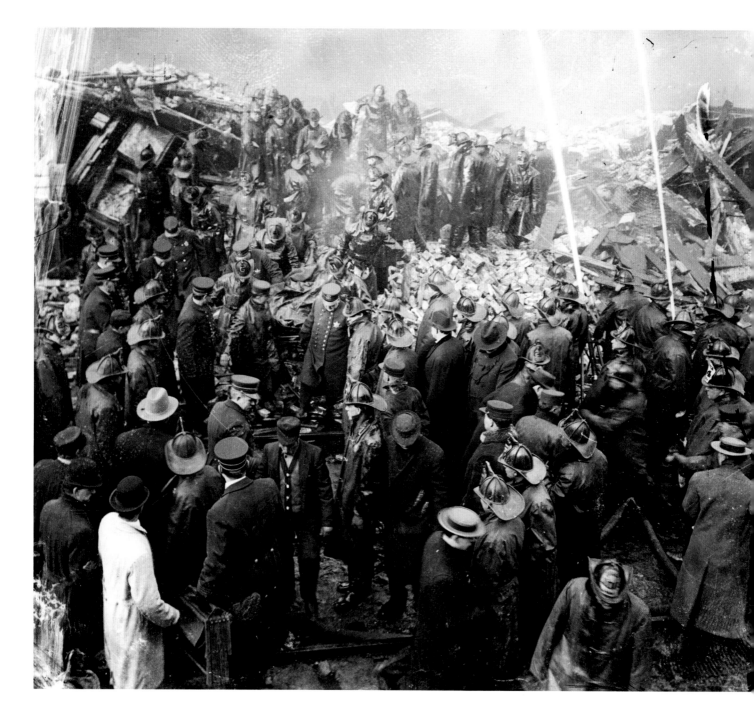

PERILOUS TIMES

One of Chicago's worst fires of the era occurred at the Nelson Morris and Company stockyards three days before Christmas in 1910. The four hundred thousand dollars' worth of damage was nothing compared to the human toll: twenty-one firefighters, including the fire marshal, died when a wall collapsed. It was the largest loss of life ever for the department and is believed to have been the deadliest disaster for American firefighters until the World Trade Center attack on September 11, 2001.

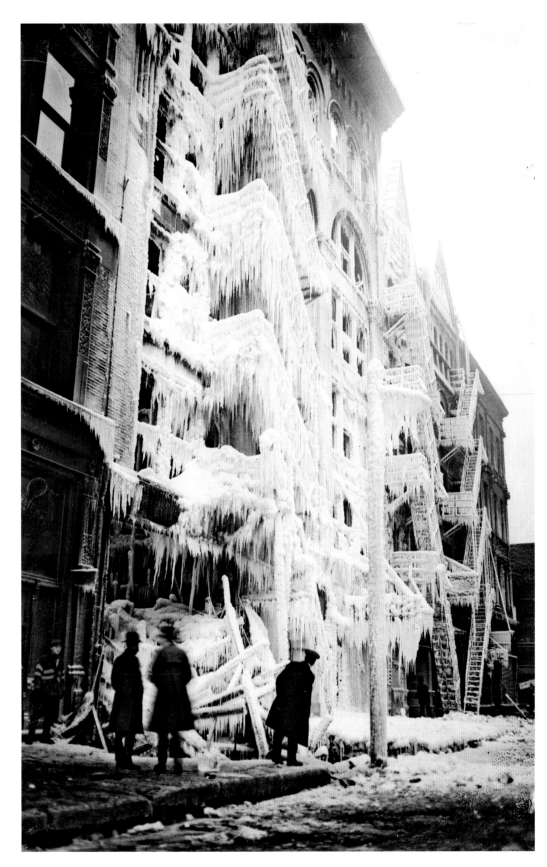

Sometimes fires resulted in beauty, such as this ice sculpture created by a blaze on West Madison Street in 1920.

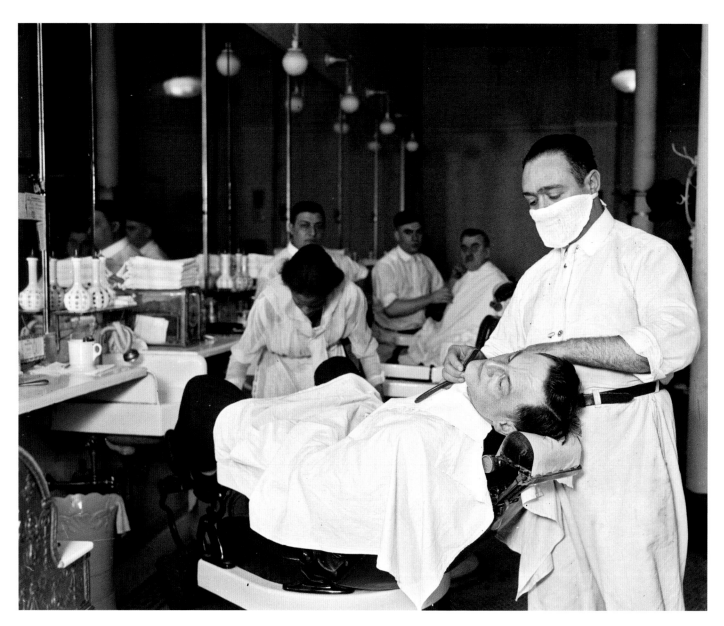

The Spanish influenza of 1918–1919
was the biggest disaster of the age,
a pandemic that killed between
thirty million and forty million peo-
ple—more than died in World War I.
One-fourth of Americans were in-
fected, and one-fifth of all the world's
human beings. In Chicago, barbers
and other service workers wore face
masks, a measure that was of limited
use. Theaters and dance halls were
encouraged to close, hotel lobbies
were swept of loiterers, and attend-
ance at wakes was limited to ten
people at a time. Even so, eighty-five
hundred people died in Chicago.

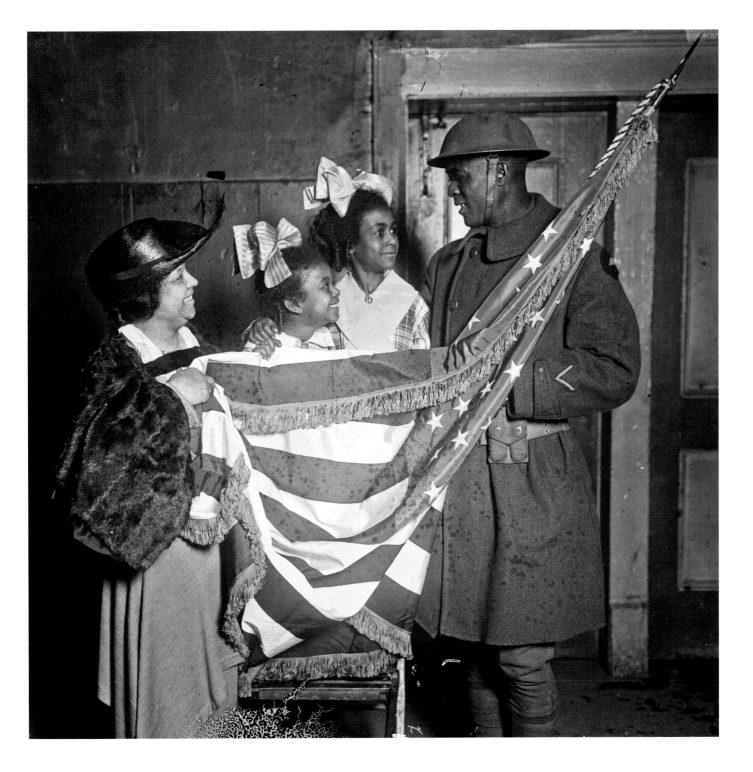

THE GREAT WAR

Sergeant John Edmondson and his family pose with the Stars and Stripes in 1919. Because of racism in the United States Army, Edmondson's "Fighting 8th" regiment and other African American units fought under French command in World War I.

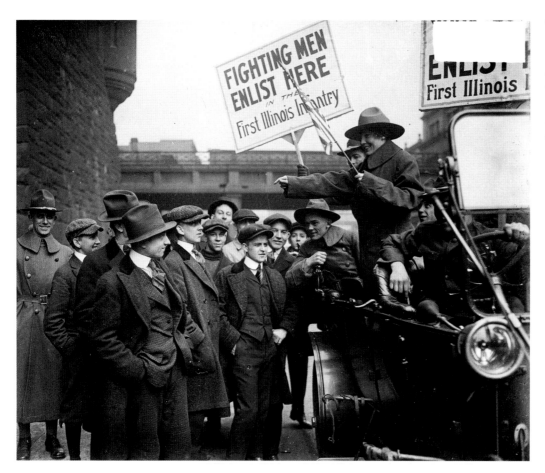

Vivian Boswell was an army recruiter in 1917, when American enthusiasm bolstered the efforts of the British and French, who had already been fighting a draining, futile war for three years. Illinois contributed 322,812 soldiers and 28,341 sailors during World War I.

German Americans were forced to choose between being German and being American, and they faced a systematic sanitizing of their culture. Bismarck Gardens became Marigold Gardens, the Kaiserhof Hotel was renamed the Atlantic Hotel, frankfurters were called hot dogs, and sauerkraut became "liberty cabbage."

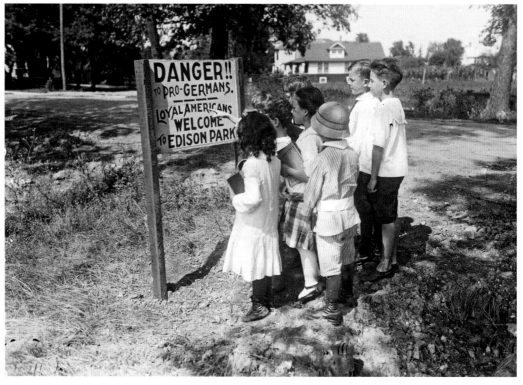

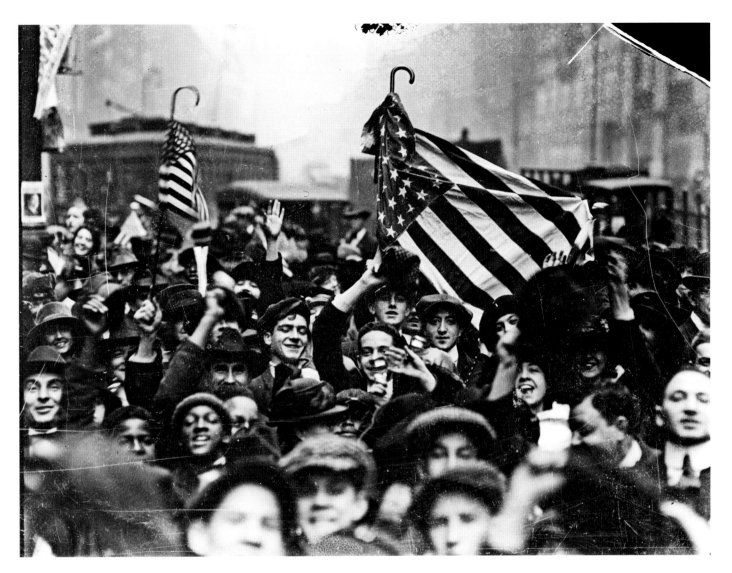

After the Great War came a greater peace: Armistice Day in Chicago, November 11, 1918. News of the peace treaty spread to Chicago via telephone in the early morning hours. Within minutes, sirens blared from atop buildings and from fireboats. Downtown soon took on the look of a New Year's Eve celebration as people from throughout the city congregated in the Loop.

LIGHTNING STRIKES TWICE

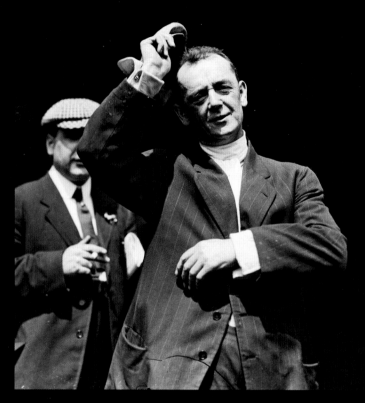

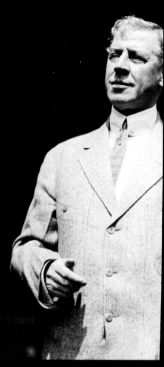

As a young man, actor Eddie Foy survived Chicago's Great Fire by fleeing to the lake's edge. Three decades later, he encountered another withering blaze. At the Iroquois Theater, Foy helped his young son escape the fire, then rushed to the stage to calm the audience. Dressed in drag for his role as an ugly woman in *Mr. Bluebeard*, he at first urged people to stay in their seats. The orchestra played soothing music. Chorus girls fainted and were dragged from the fiery stage. As the situation deteriorated, Foy finally told the audience, "Get out—get out slowly," then he escaped backstage. The photo shown here was taken in 1909.

Ida Sophia Fischer Hippach (right) lost two sons in the Iroquois Theater fire. Nine years later, she and daughter Jean Hippach (left) were sleeping in first class aboard the ocean liner *Titanic* when it hit an iceberg. They decided to go on deck to see what an iceberg looked like. An officer told them, "Ladies, go back to bed. You'll catch cold." Eventually the two Chicago women were ordered into Lifeboat No. 4, which was lowered into the chilly Atlantic even though it wasn't close to being full. When the big ship sank, the lifeboat returned and picked up eight more people. They were rescued the next morning.

Chicago debutante Charlotte Plamondon (center) was with other young ladies of means in a box at the Iroquois Theater when the 1903 fire broke out. She leaped over the box railing and into the arms of a helpful man, and fought her way to the lobby. The theater fire began a trail of disaster for the Plamondon family. Charlotte's father and mother were among the 1,198 people killed in the sinking of the ocean liner *Lusitania* off the Irish coast in May 1915. Two months later, a member of her cousin's family was killed when the *Eastland* capsized.

CHAPTER SIX

SLUGGERS AND SOUTHPAWS

Sports came of age in America and in Chicago during the early 1900s.

Baseball's first World Series took place in 1903, and the Cubs and White Sox reached the series a total of nine times in the first three decades of the century. The only major blemish for Chicago baseball—and it was quite a blemish—was the gambling scandal of 1919, which turned the White Sox into Black Sox.

College football, established before the turn of the century, became a national sensation during these years, and professional football was born. Boxing was enormously popular, with the 1927 Dempsey-Tunney bout at Soldier Field providing one of the most memorable matches in the sport's history.

Some new games made less of a splash, including an indoor version of baseball and a sport called "pushball." Basketball's best years were still to come.

The *Daily News* photographers captured sports in its infancy—the wooden bleachers that surrounded baseball diamonds and the rugged, chewed-up fields where football was played.

Newspapers were star makers, inventing players' nicknames, recording their exploits, and making their faces famous. Sports pictures from this era were often posed, taken before or after the game. Glass negatives and early film required longer exposures than more modern film, so action was difficult to capture.

The newspapers and sports fed on each other. Before the rise of radio in the 1920s, newspapers had a virtual monopoly on sports coverage. The *Daily News* published a late-afternoon sports report as its final edition of the day.

BASE BALL

The national pastime was spelled "base ball" early in the century, evolving into the solid word "baseball" between the mid-1920s and the 1940s. The game was defined by intimidating players such as the Detroit Tigers'

Ty Cobb, shown here taking off for first base at the Chicago Cubs' home park, the West Side Grounds, during the 1908 World Series. It was the last World Series won by the Cubs. Cobb, whose mother killed his father in a

suspicious shooting that was later labeled an accident, lived a bitter life. "I had to fight all my life to survive," he said. "They were all against me . . . but I beat the bastards and left them in the ditch."

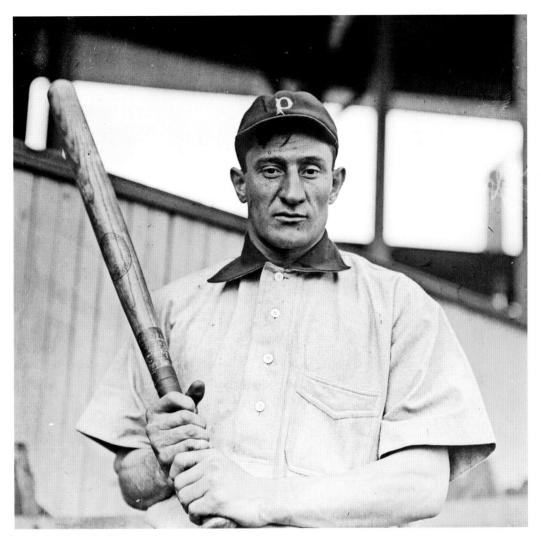

Pittsburgh Pirates star Honus Wagner, shown here in 1903, left a legacy in the field of sports economics. He is generally considered to be the first professional athlete to make a product endorsement, having allowed his name to be imprinted on Louisville Slugger bats in 1905. A 1909 baseball card featuring his picture sold for $2.35 million in February 2007. The card, which advertised tobacco, is rare because Wagner managed to have it pulled from the market. There are conflicting stories about why: some say he did not want kids to buy tobacco, others that the tobacco company hadn't paid him.

The right hand of pitcher Mordecai "Three Finger" Brown was mangled in a farm accident when he was a boy, giving him a memorable nickname and a sneaky sinker ball. Brown played for the Chicago Cubs for ten seasons (1904–1912 and 1916). This photo was taken in 1915, during his one season with the Federal League's Chicago Whales.

Two titans of the age, the New York Yankees' Babe Ruth (wearing cap) and Lou Gehrig (to his left), attracted big crowds during their frequent visits to Chicago. The gentlemanly Gehrig exuded calm and confidence, while Ruth behaved like a mischievous child. "If it wasn't for baseball," Ruth said, "I'd be in either the penitentiary or the cemetery." Here they pose in 1927, their best year together. Ruth hit sixty home runs that year and Gehrig added forty-seven as they led the Yankees to a world championship.

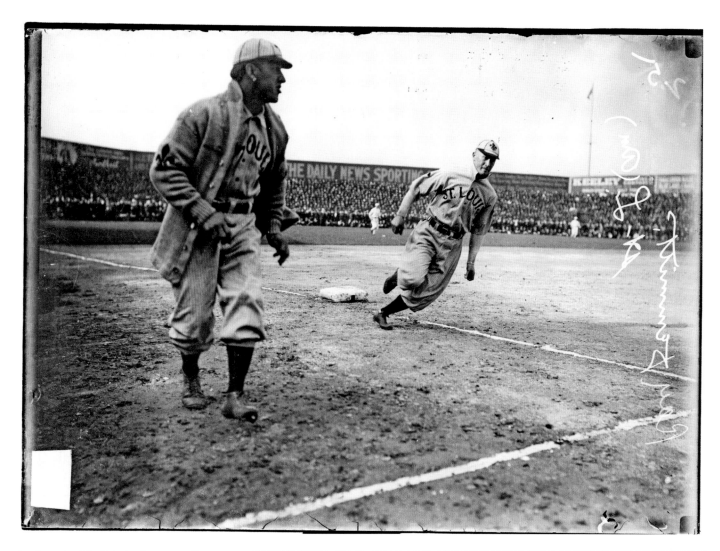

Ray Demmitt of the Saint Louis Browns heads for home at South Side Park, the White Sox ballpark at Thirty-ninth Street and Wentworth Avenue, in 1910. The Sox played there from 1901 to the middle of the 1910 season, when they moved to the newly built Comiskey Park.

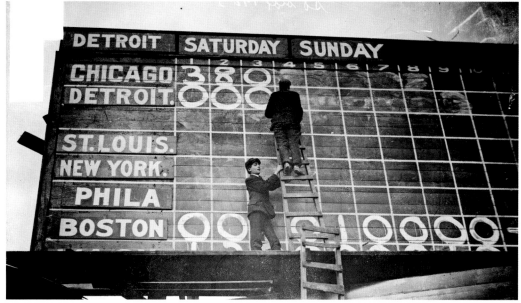

Boys "chalk it up" on the South Side Park scoreboard in 1905.

Kenesaw Mountain Landis, shown throwing out a ceremonial pitch in 1926, never took the field or roamed a dugout, but he was one of baseball's most influential figures. As a federal judge, he helped save the American and National leagues by stalling an antitrust lawsuit by the upstart Federal League in 1915. A few years later, when it was revealed that members of the Chicago White Sox had been bribed by gamblers to lose the 1919 World Series, Landis was appointed as the first baseball commissioner to clean up the scandal. The so-called Black Sox were acquitted by a Cook County jury after their written confessions apparently disappeared from court records. But they got no break from Landis, who banned them from baseball for life.

The West Side Grounds, at Wood and Polk streets, was the home of the Chicago Cubs from 1893 to 1915. Modern-day baseball fans might think the phenomenon of building grandstands on rooftops surrounding the ballpark is unique to Wrigley Field in recent years. But in 1908, the area beyond right field at the West Side Grounds was filled with rooftop seats. The area beyond left field was groundbreaking too: A mental hospital was located there, and some language experts believe that gave birth to the phrase "out of left field."

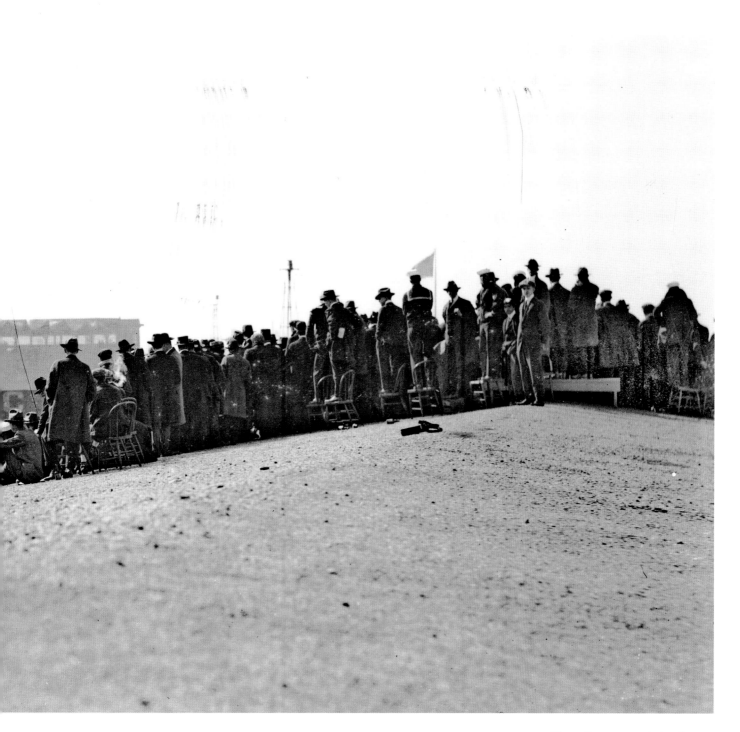

The rooftops were packed on the South Side, too, during the 1917 World Series at Comiskey Park. The White Sox won the world championship that year; it would be nearly nine decades before they repeated the feat.

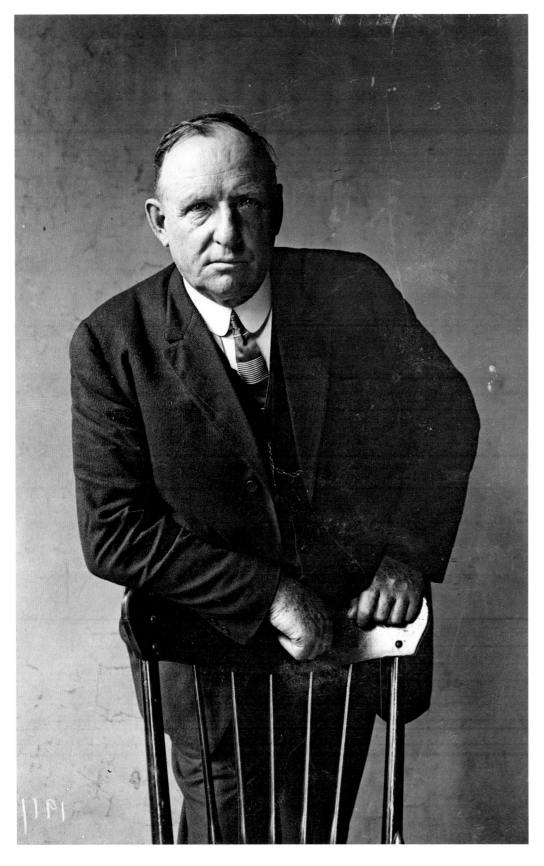

Adrian "Cap" Anson, photographed in 1911, was one of the greatest players of the nineteenth century. He is best known today, however, as the notorious architect of baseball's color line. In 1887 he refused to play a game against a Newark team with an African American pitcher, George Stovey. Other major league players went along, leading to an unwritten but strictly enforced ban against blacks that lasted sixty years.

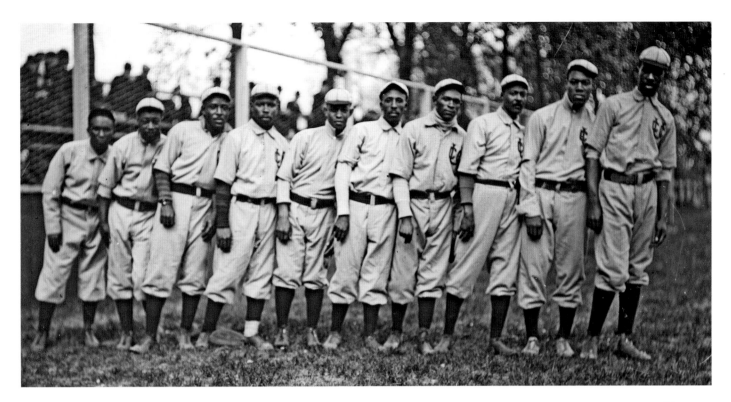

Prejudice didn't keep black people from enjoying baseball. The Chicago American Giants were founded in 1911 by black ballplayer Andrew "Rube" Foster and white tavern owner John Schorling. The team took up residence at South Side Park, recently vacated by the White Sox. In 1920, Foster formed the Negro National League, featuring his Giants and seven other teams. Promoting an aggressive style with plenty of bunts, steals, and hit-and-run plays, Foster's team imposed a five-dollar fine for any player tagged out without sliding.

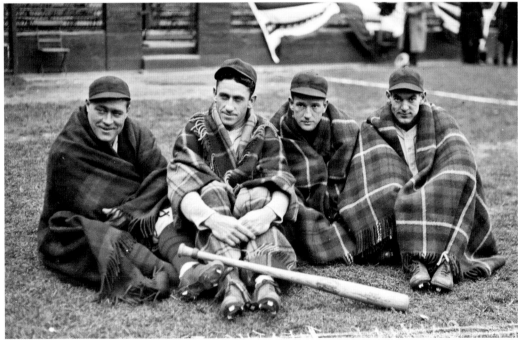

Chicago Cubs players warm up at Wrigley Field in 1929, a year the team reigned as National League champions. Shown are (from left) Hack Wilson, Kiki Cuyler, Cliff Heathcote, and Woody English. Wilson, who still holds the major league season record for runs batted in, was one of the highest paid players of his era. A few years after this photograph was taken, though, his hard drinking knocked him out of baseball, and he died virtually penniless and shunned by his family. The National League paid for his burial in 1948.

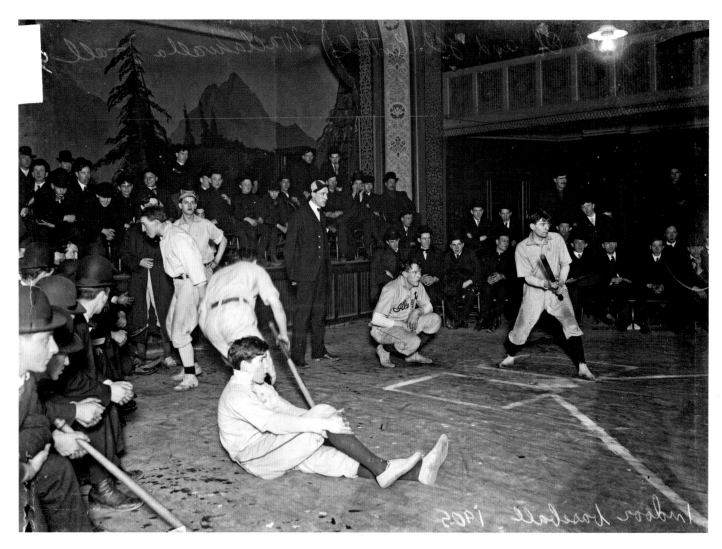

A sport called indoor base ball is played in a Chicago auditorium in 1905. Invented by George Hancock at the Farragut Boat Club on the South Side in 1887, the game was a turn-of-the-century sensation during frigid winters. Players swung a sticklike bat to hit a large, soft ball, and no gloves were required. The diamond was smaller than for the outdoor game, allowing the sport to be played in gyms, armories, and other indoor arenas. Though it was an official interscholastic sport in Chicago for a while, the indoor game made few inroads in other parts of the country. Overtaken by the popularity of basketball, indoor base ball disappeared in the 1920s. But it was forerunner to another Chicago pastime, softball.

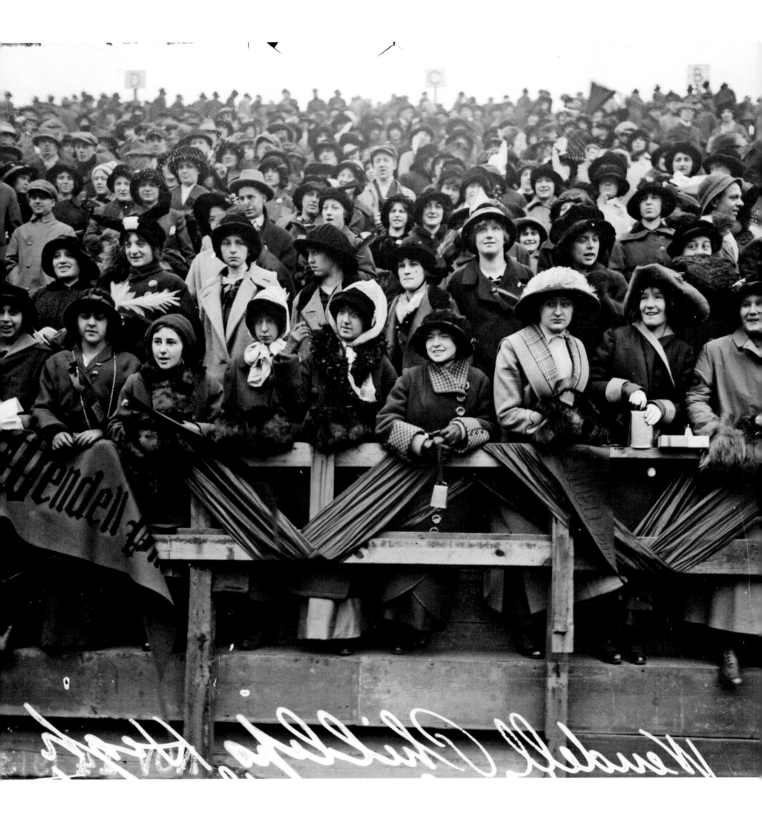

THE GRIDIRON

Wendell Phillips High School boosters root for their football team against South Side rival Hyde Park in 1913.

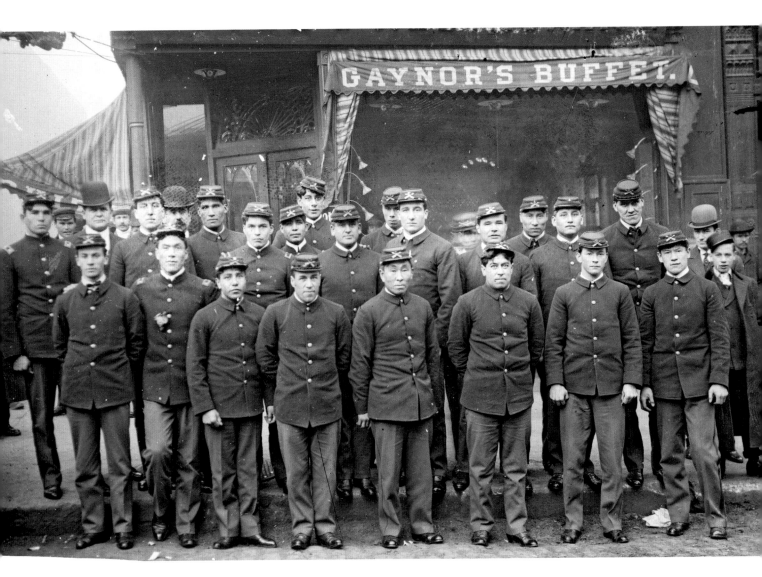

Jim Thorpe, considered by many to be the greatest athlete of the first half of the twentieth century, starred in track and field, baseball, and football. One of his first visits to Chicago was as part of the Carlisle (Pennsylvania) Indian School football team, coached by Glenn "Pop" Warner. Thorpe (front row, far right) stands with the team outside a restaurant during Carlisle's 1907 visit to play the University of Chicago.

Harold Grange, from the western
suburb of Wheaton, was nicknamed
"Red" because of his shock of red hair.
But as he piled up yardage as a star
running back for the University of Il-
linois, he earned other nicknames:
"the Galloping Ghost," "the Wheaton
Iceman," "the Flying Terror." Grange
also starred in the silent-film sensa-
tion *One Minute to Play* in 1926 and
put his name on teddy bears, candy
bars, and even meat loaf. After col-
lege, Grange lent legitimacy to the
new National Football League when
he signed a hundred-thousand-dol-
lar contract to play for the Chicago
Bears. Barnstorming around the
nation, Grange and the Bears helped
establish the professional sport,
which was then overshadowed by
college football.

After immigrating with his family from Norway to Chicago, Knute Rockne learned the game of football on the sandlots of Logan Square. He worked in the Chicago post office for three years while saving money for college. He attended Notre Dame, where he eventually became coach of the football team. The legendary leader of the Fighting Irish was a motivator and an innovator, persuading his players to "win one for the Gipper" and refining the use of the forward pass. Rockne, shown here posing in an airplane hangar in Chicago in the 1920s, died when the small plane in which he was a passenger crashed into a Kansas pasture in 1931.

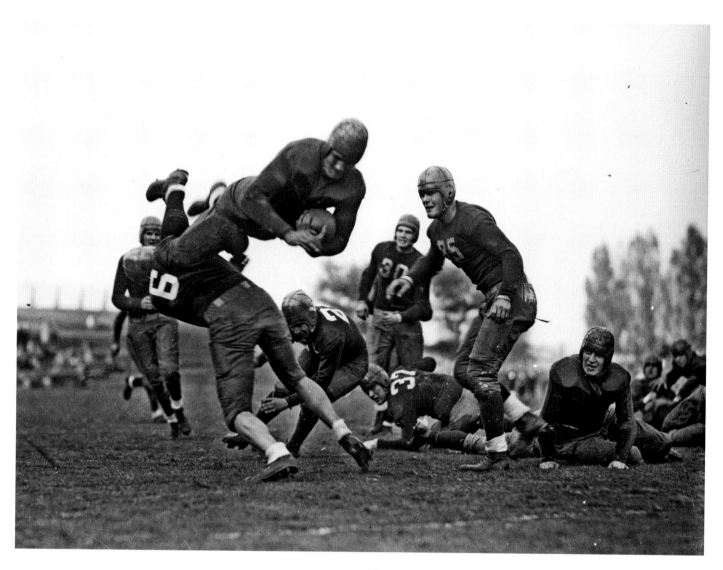

Without face masks or heavy padding, football of the era was a bruising, grind-'em-out affair in which athletes played both offense and defense. Here the powerful Bronko Nagurski, fullback and defensive lineman for the University of Minnesota, dives for extra yardage against Northwestern University in Evanston in 1930. Minnesota coach Doc Spears supposedly discovered Nagurski when, on a recruiting trip, he stopped his car to ask directions from a young man plowing a field. To show the way, Nagurski lifted the heavy plow and pointed it in the proper direction. Coach Spears arranged a scholarship. Nagurski went on to play professionally for the Chicago Bears and also worked as a professional wrestler.

PUGILISTS

Six-foot-six, 260-pound Primo Carnera gives fans a lift during a 1930 visit to Chicago, where he made short work of his opponent, Elzear Rioux, knocking him out in the first round. Three years later, the "Ambling Alp" became the only Italian to win the world heavyweight boxing title.

Jack Johnson, measuring up to fellow boxer Joe Choynski in 1909, was the country's first African American heavyweight champion—a hard puncher in the ring and a reckless swinger out of it. The son of a slave, he was refused a match with white champion Jim Jeffries, only to win the title in 1908 after Jeffries's retirement. The thought of a black champion so offended Jeffries that he came out of retirement as the "great white hope," but he was beaten by Johnson in 1910 in Reno, Nevada. Johnson often dated white women, which incensed authorities and may have led to his legal troubles. After he opened a Chicago nightclub called Cafe de Champion in 1912 and began spending time with a white secretary named Lucille Cameron, authorities charged him with transporting the woman across state lines for illicit sexual purposes, a violation of the "White Slave Traffic Act." He married Cameron but was convicted anyway. Johnson fled the country, returning seven years later to serve a prison term.

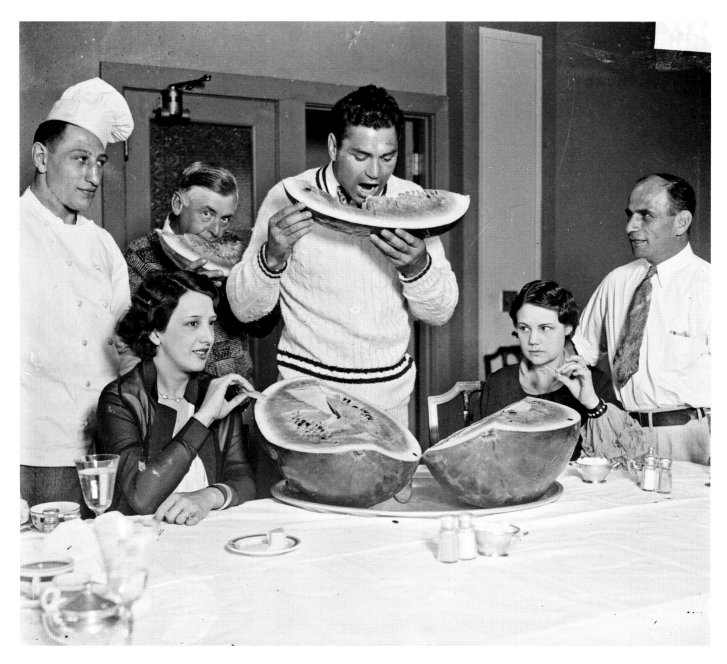

Jack Dempsey (above) lived the high life and ate up publicity, while Gene Tunney (right) was an unassuming, disciplined teetotaler. Tunney won twice against Dempsey, including their famous 1927 rematch at Soldier Field. The event drew about 105,000 fans who paid a combined $2.65 million—a record that stood for fifty years.

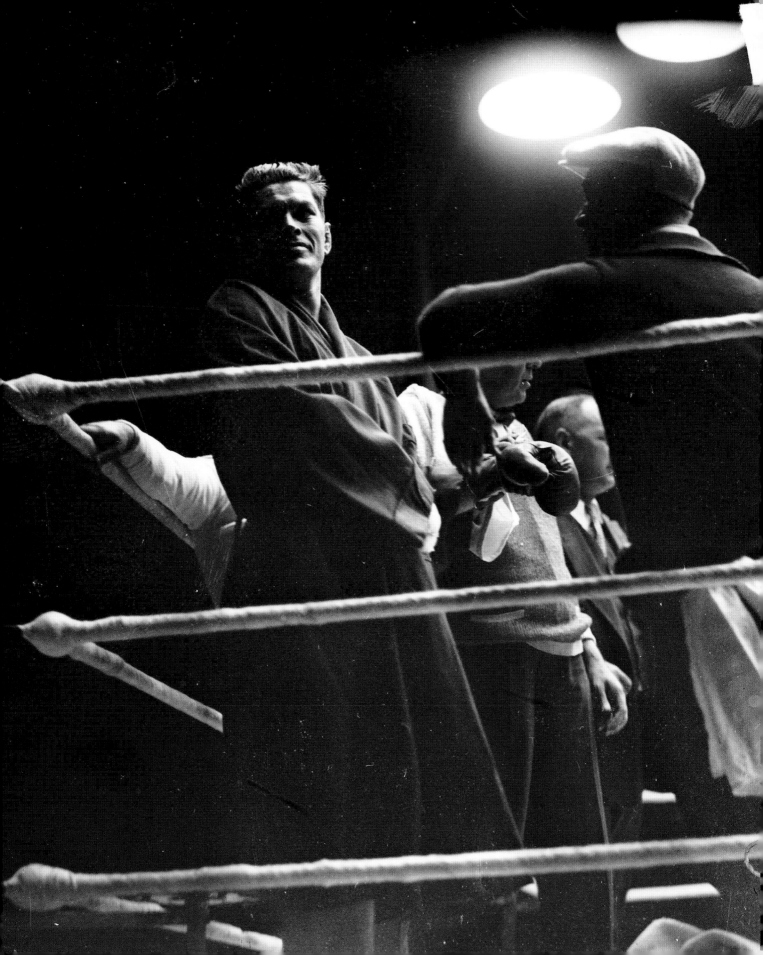

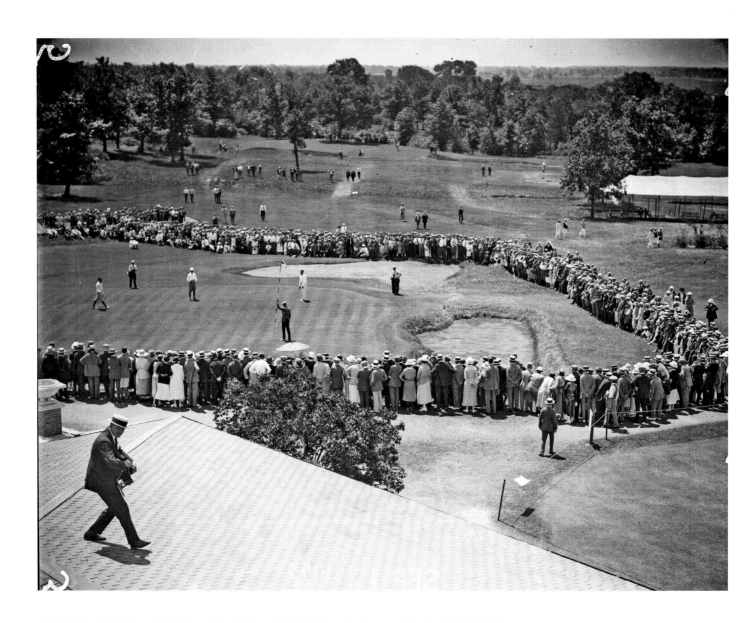

THE SPORTING LIFE

The Skokie Country Club in north suburban Glencoe hosted the 1922 U.S. Open,
won by Gene Sarazen.

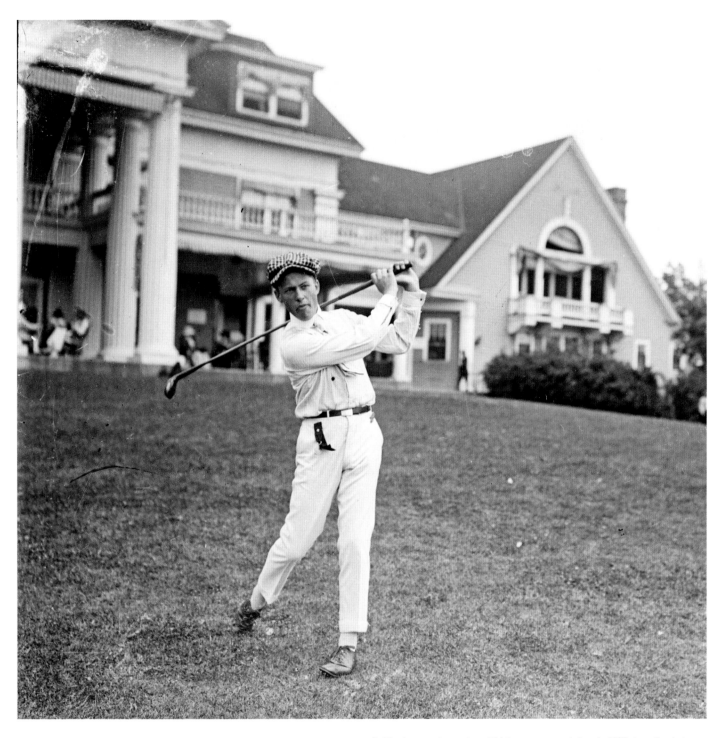

Bobby Jones, who captured thirteen major championships between 1923 and 1930, was just a teenager when he teed off here in 1917 at the Midlothian Country Club in Chicago's south suburbs. After winning golf's grand slam in 1930, he retired at age twenty-eight. Jones's philosophy: "Competitive golf is played mainly on a five-and-a-half-inch course . . . the space between your ears."

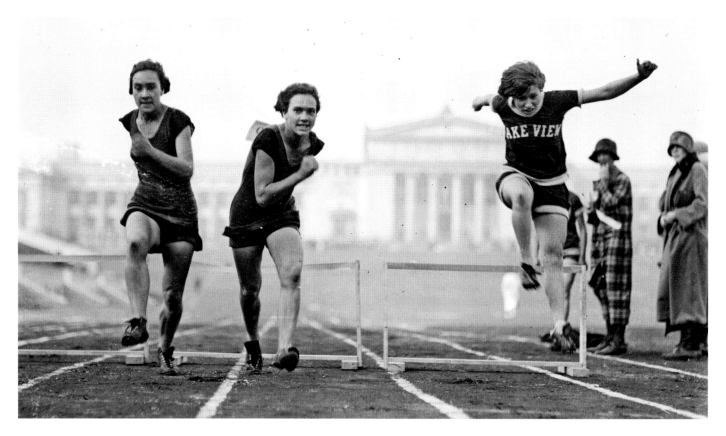

These hurdlers—from left, Margaret Sheffield, Elizabeth Sheffield, and Norma Zilk—performed on a big stage in 1924: the new Municipal Grant Park Stadium, soon to be renamed Soldier Field. Zilk, of Lake View High School, at one time held the women's world records in the 80-yard indoor dash and the 220-yard outdoor dash.

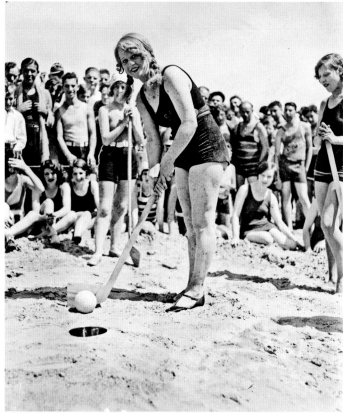

The entire golf course was a sand trap when people played "beach golf," a gimmick sport of 1929.

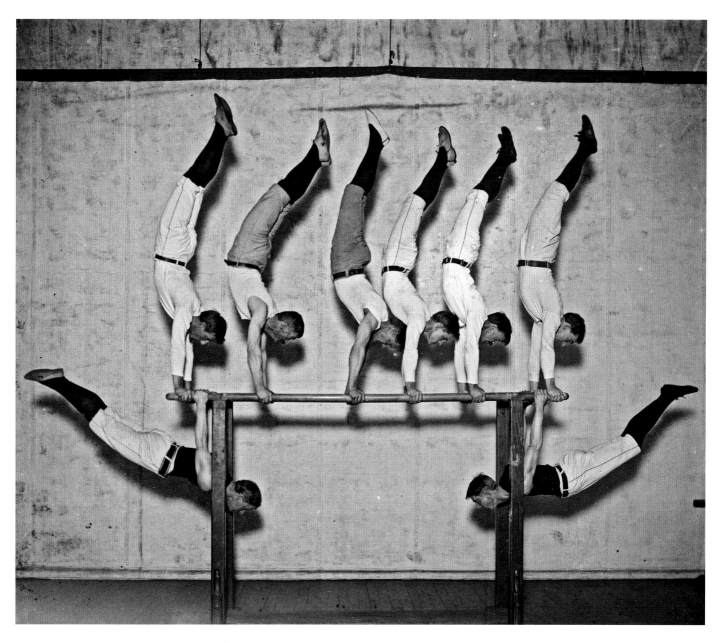

Founded in nineteenth-century Germany, the *Turngemeinde*, or "gymnastics organization," was brought to this country by immigrants. In Chicago and other cities where the group flourished, its members (such as these, photographed in 1905) were known simply as Turners. Today, children still learn gymnastics at Turners centers.

Because it was difficult to photograph swimmers in the pool, *Daily News* photographers captured them in "action" perched on a table. For publication, the newspaper would remove the background. Shown here is W. J. Rayburn, a Central YMCA swimmer, in 1909.

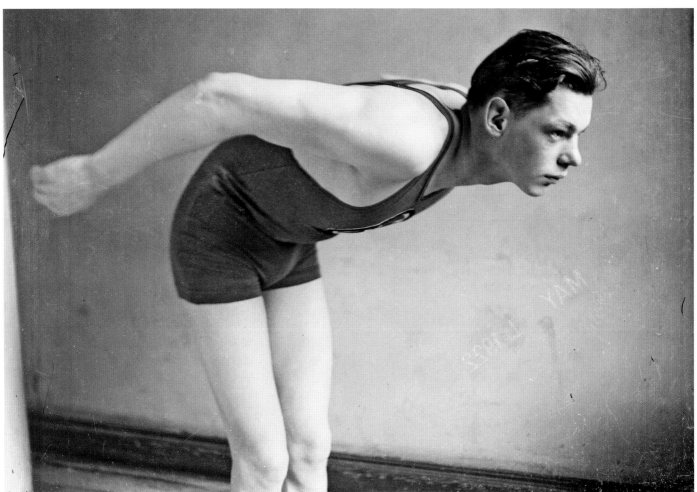

Janos Weissmuller, born in 1904 in Freidorf, Hungary (now a part of Romania), moved with his family to Chicago, became known as Johnny, learned to swim at Fullerton Beach, and lied about his age in order to make the YMCA swim team. In 1924, two years after this photograph was taken, he won the first of his five Olympic gold medals. Weissmuller's skills helped save lives when an excursion boat, the *Favorite*, capsized in Lake Michigan in 1927 with seventy-one passengers aboard. Twenty-seven people drowned, including sixteen children, but many were saved by Weissmuller and other rescuers who rowed boats to the site. In the 1930s, Weissmuller achieved his greatest fame as the Hollywood actor who uttered the words "Me Tarzan, you Jane."

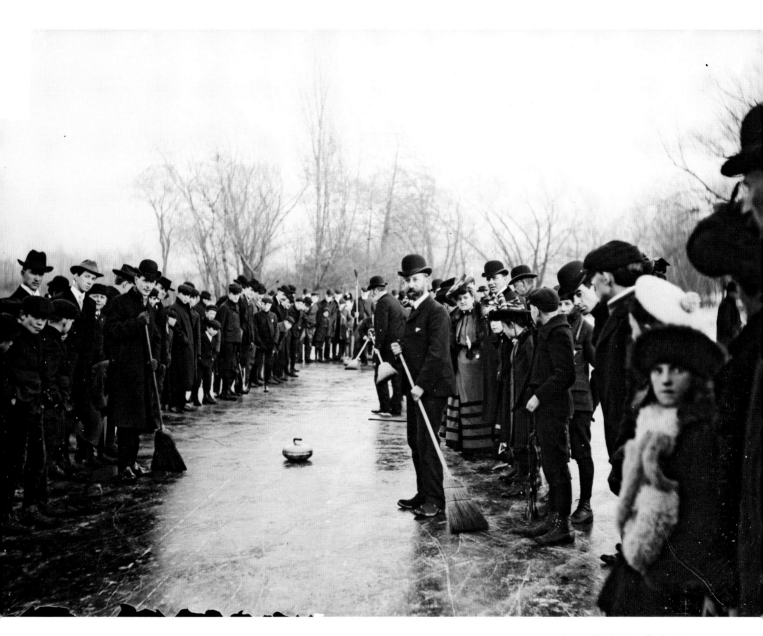

A crowd in Jackson Park gets swept up in the sport of curling in 1903. In the game, which dates back to sixteenth-century Scotland, one player slides a "rock" of polished granite across a sheet of ice toward a target as his teammates sweep the ice ahead to influence the rock's movement. The sport's popularity has extended farther south in recent years as it has become easier to produce ice artificially. Curling became an official Olympic sport in 1998.

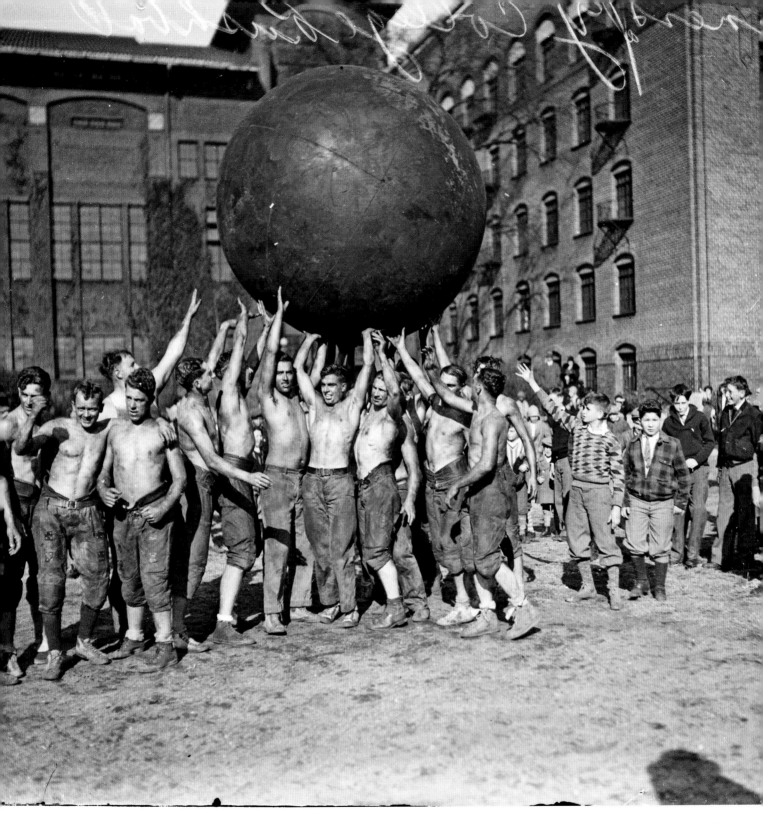

Players hoist a huge leather ball in the sport of pushball, invented by M. G. Crane of Newton, Massachusetts, in 1894. The game bore a few similarities to football: It was played by two teams on a field with goalposts at either end, and it had a high potential for injury. Players attempted to push the giant ball under the goalpost's crossbar (for five points) or to toss it over the bar (for eight points). The game was sometimes played on horseback. The event shown here took place in 1928 at Central YMCA College.

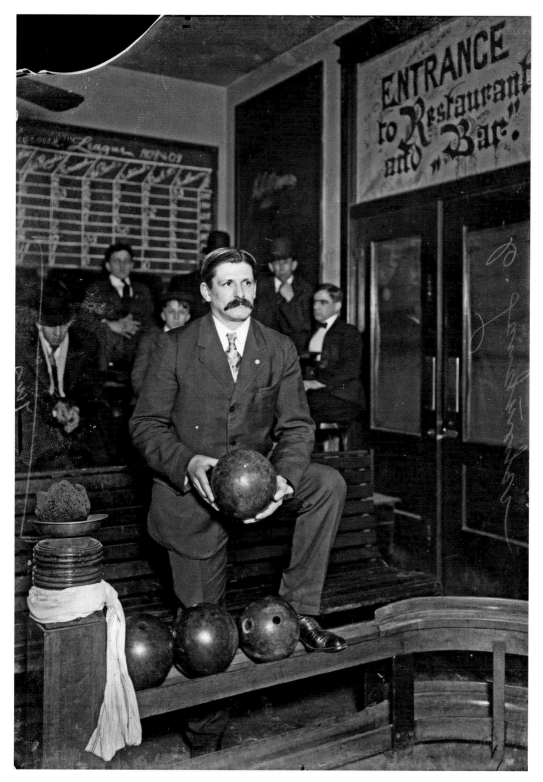

Bowler C. Langmeyer concentrates on the game in 1908. Bowling balls were once made of a hard wood called lignum vitae, but the Chicago-based Brunswick-Balke-Collender company revolutionized the industry in 1914 with its "Mineralite" ball, featuring a "mysterious rubber compound." It would be another four decades before technology replaced pin boys with automatic pinsetters.

WATCHING THE KIDS

Any athlete who had a baby face risked having the word "Kid" attached to his name. Even Jack Dempsey was once known as Kid Blackie. Kid Mitchell, the boxer shown here in 1908, was no Dempsey.

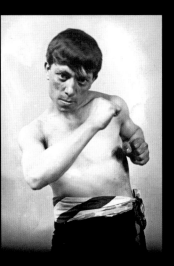

Kid Trimbles, boxer, 1907.

Kid Herman, boxer, 1906.

Paul Cantway, "the Bitter Root Kid," boxer, 1916.

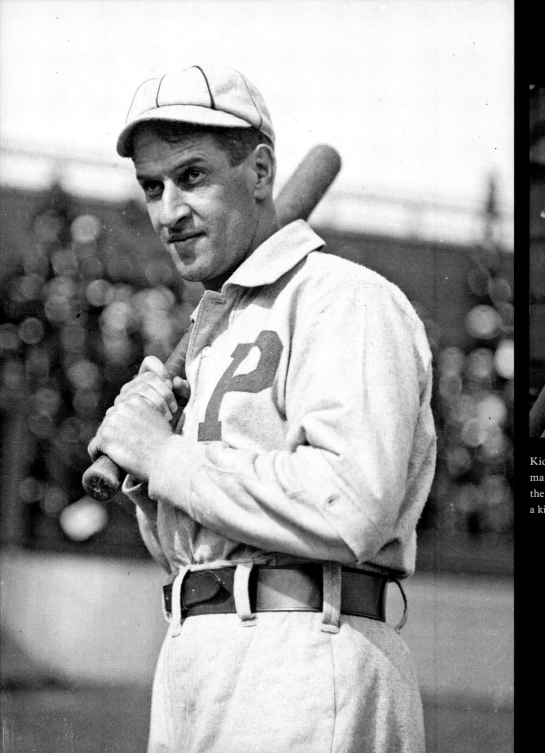

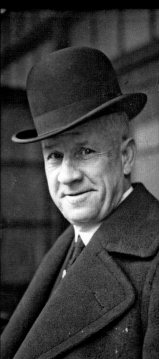

Kid Gleason, shown in 1921, was manager of the White Sox during the Black Sox scandal and remained a kid for life.

CHAPTER SEVEN

POLITICOS AND PREACHERS

A city and a nation, wrenched by war, disease, and riots, was hungry for visionaries, and found itself led—or misled—by mayors, aldermen, presidents, religious figures, and earnest advocates of clean living.

Chicago has long been the nexus of American politics, playing host to twenty-five national political conventions, including the 1920 Republican "smoke-filled room" that propelled Warren G. Harding to the presidency.

In Chicago's early years, mayors came and went. Twenty-three men served in the top political spot during the city's first forty years. By the turn of the century, however, fledgling political machines were in place. Two men—Carter Harrison Jr. and William Hale Thompson—reigned over Chicago for twenty of the century's first thirty years.

The city's political royalty included the Lords of the Levee, Michael "Hinky Dink" Kenna and "Bathhouse" John Coughlin, the First Ward aldermen who ruled over a kingdom of vice in the Levee district on the Near South Side. Hinky Dink famously declared, "Chicago ain't no sissy town." But the town has always had its share of do-gooders, ready to battle City Hall corruption or lead their followers toward salvation. One of the most prominent was Billy Sunday, professional baseball player turned evangelist, who traveled the nation spreading the gospel and battling booze. Sunday became a national figure, but poor Billy will likely be most remembered for the song "Chicago (That Toddlin' Town)," made famous by Frank Sinatra, which calls Chicago "the town that Billy Sunday could not shut down."

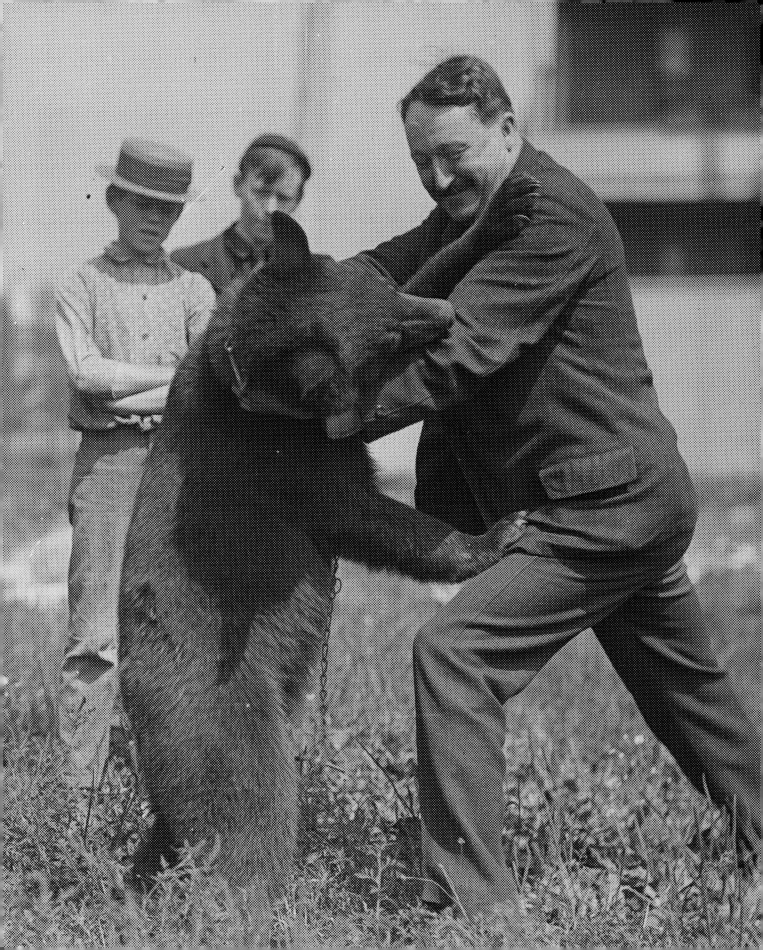

LOCAL LEGENDS

Chicago's grafters were known as "boodlers" and the good-government types were called "goo-goos." There were always more of the former than the latter. Two of the most unrepentant boodlers were First Ward bosses "Bathhouse" John Coughlin (left, pictured in 1928) and Michael "Hinky Dink" Kenna (shown in 1924). Coughlin, so nicknamed because he'd worked in a Turkish bath as a young man, designed his own emerald-green suits and wrote ballads with titles such as "Dear Midnight of Love." The press depicted him as a buffoon, but he collected hundreds of thousands of dollars to protect gambling and prostitution. More serious-minded was his partner, Hinky Dink, whose nickname was slang for a short fellow. Kenna, a teetotaler who owned a tavern, amassed a fortune from shady transactions. When he died, he left more than one million dollars to his family and set aside thirty-three thousand dollars for a mausoleum. His family chose an eighty-five-dollar tombstone instead.

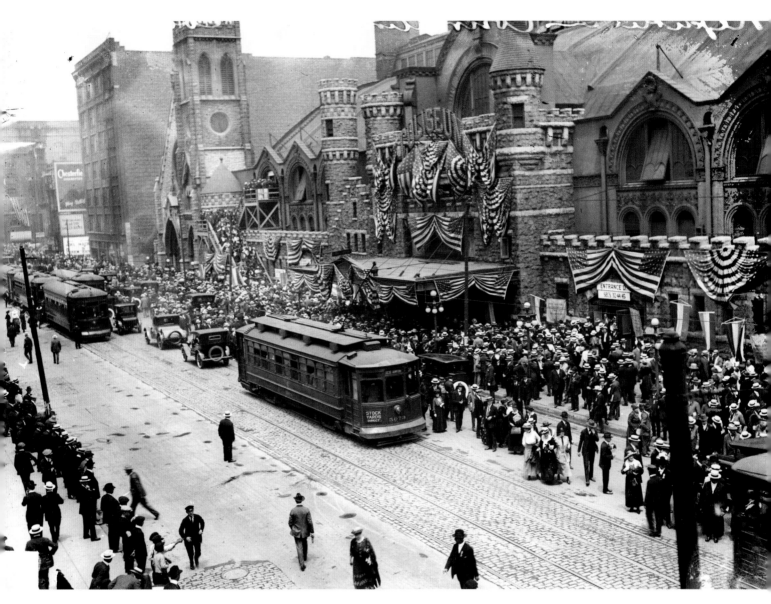

The Coliseum, at 1513 South Wabash Avenue, was the scene of major political meetings such as the 1920 Republican National Convention, shown here. It also hosted boxing matches, auto shows, and notorious parties known as the First Ward balls. Aldermen Coughlin and Kenna sponsored the balls, which were legendary for their debauchery. One year, a reporter counted twenty thousand guests, who were said to have consumed ten thousand quarts of champagne and thirty-five thousand quarts of beer "before they sent for reinforcements." Reformers denounced the "carnival of evil," demanding that it be shut down. "All right, we'll compromise," Coughlin responded. "We won't let parents bring their children. There!" That didn't satisfy the reformers. Under pressure, Mayor Fred A. Busse banned the bacchanalia in 1909. The *Daily News* collection has no pictures of any of the balls, which is understandable: One year, a photographer from another newspaper was beaten outside the event.

Aldermen were as much a part of the city's entertainment as the vaudeville shows downtown. Here Alderman John E. Scully wrestles a bear in 1904 at the Madison Street Carnival, which he managed, in East Garfield Park. The previous year, Scully tried to persuade the Lincoln Park Zoo to parade an elephant down Madison Street, but zookeepers thought it was beneath the elephant's dignity.

William Hale "Big Bill" Thompson, shown fishing on the Illinois River in 1915, was the quintessential Chicago politician of his time: crooked, loved, hated, and reelected. He won the first of his three terms as mayor in 1915 by taking a stand on an issue he had no control over: World War I. It played well with German and Irish voters when he blamed the British for the war. (In later years, he declared that if King George V came to Chicago, he would "crack him in the snoot.") Before Prohibition, Thompson declared that he was "dry," but when the country banned booze, the mayor gave beer-running gangsters free rein. When sentiment grew to end Prohibition, Thompson declared that he was "wetter than the Atlantic Ocean." The mayor was wet all right. He owned a speakeasy on a schooner in Belmont Harbor called the Fish Fans Club. Described as an organization promoting the fish population in American waters, it was just a watering hole for politicians. When Thompson won his third term, so many celebrants climbed aboard that the schooner sank.

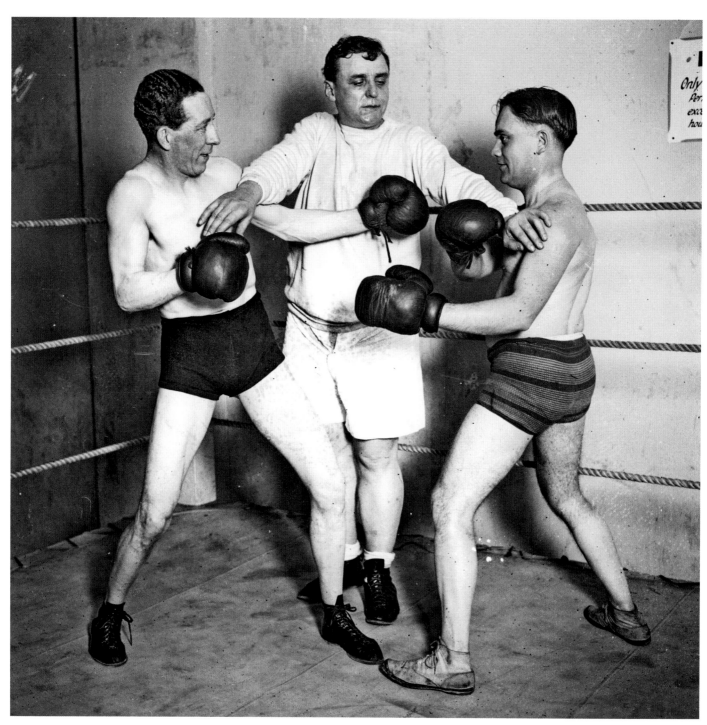

Alderman John H. Lyle (left) battles Alderman John J. Touhy as then-alderman and future mayor Anton Cermak referees in 1921. Cermak, a Bohemian immigrant called "Tough Tony" by many and labeled a "bohunk" by Big Bill Thompson, became mayor in 1931 after Thompson's graft-ridden reign. Cermak, however, wasn't a full-fledged reformer; as an alderman, he had used his inside information on government land use to become rich. Cermak's tenure as mayor was cut short when he went to Miami in 1933 to make amends with President-elect Franklin D. Roosevelt, whom he had opposed for the Democratic nomination. Giuseppe Zangara fired five shots at FDR in a Miami park but missed, hitting Cermak instead. Chicago's mayor died three weeks later. In the kind of swift justice unthinkable today, Zangara was executed in the electric chair fourteen days later. Today, Chicago has major roads honoring both Roosevelt and Cermak. They run parallel, ten blocks apart, and never meet.

THE NATION AND THE WORLD

A campaigner holds his candidate in high regard at the 1908 Democratic
Convention in Denver, which nominated William Jennings Bryan.

The 1912 Republican Convention, held at the Coliseum **(left)**, pitted former president Theodore Roosevelt against incumbent William Howard Taft. Feeling that the deck was stacked against them, Roosevelt supporters in the gallery tooted horns and rubbed sandpaper together to imitate the sounds of the Taft "steamroller." When Taft was nominated on the first ballot, Roosevelt's backers broke away to form the Progressive Party, which held its own convention two months later in Chicago. When Roosevelt declared, "I am as strong as a bull moose and you can use me up to the limit," the progressives became known as the Bull Moose Party. The Roosevelt-Taft split led to the election of the Democrat, Woodrow Wilson. Roosevelt is shown **(above)** during a visit to Chicago the next year.

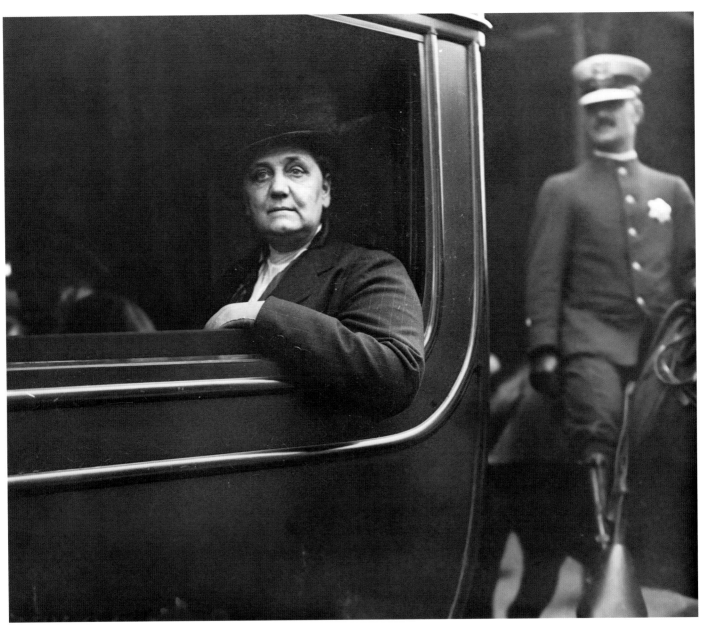

The Daughters of the American Revolution called Jane Addams "the most dangerous woman in America." A freethinker with practical talents, she presided over the moral center of Chicago: Hull-House, a "settlement house" for new immigrants at 800 South Halsted Street. At first, Addams and cofounder Ellen Gates Starr intended to provide only a kindergarten and cultural lectures, but they eventually offered public baths, citizenship classes, an employment bureau, theater performances, art exhibitions, Chicago's first public swimming pool, and a base of operations for labor organizers and social activists. Addams, shown in 1915, was her ward's garbage inspector. She also mediated strikes, pushed for child labor laws, marched for women's suffrage, and helped found both the National Association for the Advancement of Colored People and the American Civil Liberties Union. She aroused the greatest animosity with her pacifist stand during World War I. In 1931 she became the first American woman to win the Nobel Peace Prize.

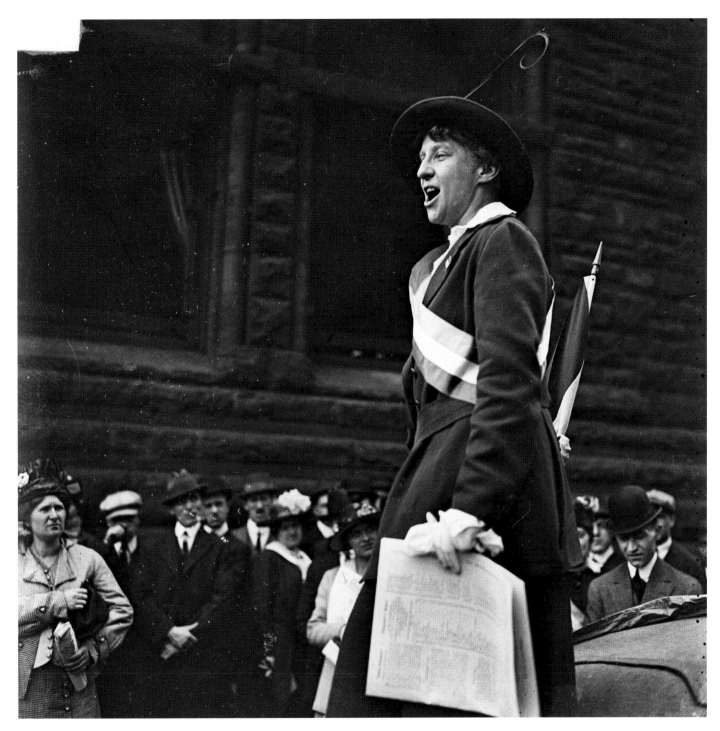

Mabel Vernon, shown in Chicago in 1916, was a tireless campaigner for women's voting rights and like other suffragettes often faced public ridicule. In a song of the era, "Since My Margaret Became a Suffragette," a man complained that his sweetheart "wears the pants that kill romance." But the suffragettes soldiered on. While some favored a nonconfrontational approach, Vernon was a radical. She once heckled President Woodrow Wilson as he attempted to give a speech. She also picketed the White House and chained herself to the gates, earning three days in jail. By 1919 women had full voting rights in fifteen states, but in twelve states they were shut out entirely. In the rest of the states, they might be able to vote only in primaries or on bond issues or for the school board. Full rights came the next year, with ratification of the Nineteenth Amendment.

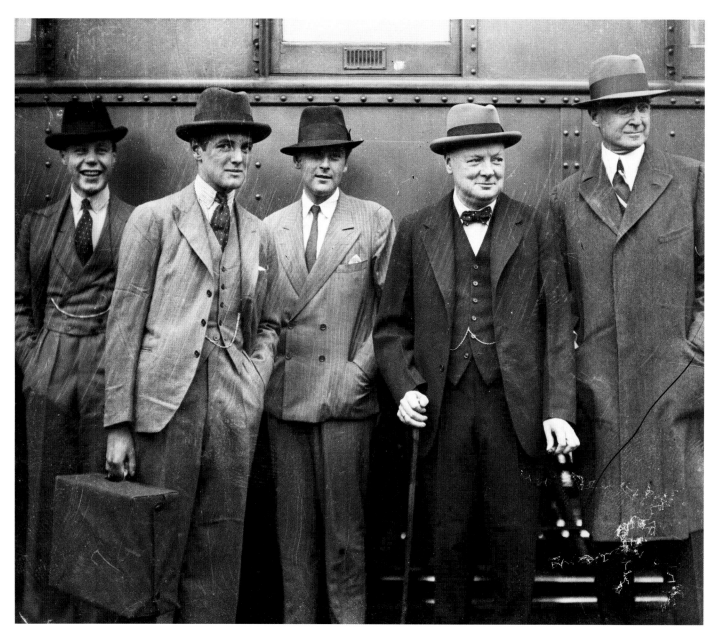

For British politician Winston Churchill (second from right), 1929 was the beginning of the "wilderness years," a decade in which he was out of power and almost out of money. Dumped as chancellor of the exchequer, Churchill toured North America. In Chicago, he told the Commercial Club that he wanted the British and U.S. navies to be "equal on the seas." After that, it was on to New York City, where his visit coincided with a capitalist catastrophe, the stock market crash. "Under my window, a gentleman cast himself down fifteen storeys and was dashed to pieces," he wrote. The aristocratic Churchill survived the Great Depression and was vindicated in 1939 when his warnings about the Nazis proved true. As prime minister, he led Britain to victory in World War II.

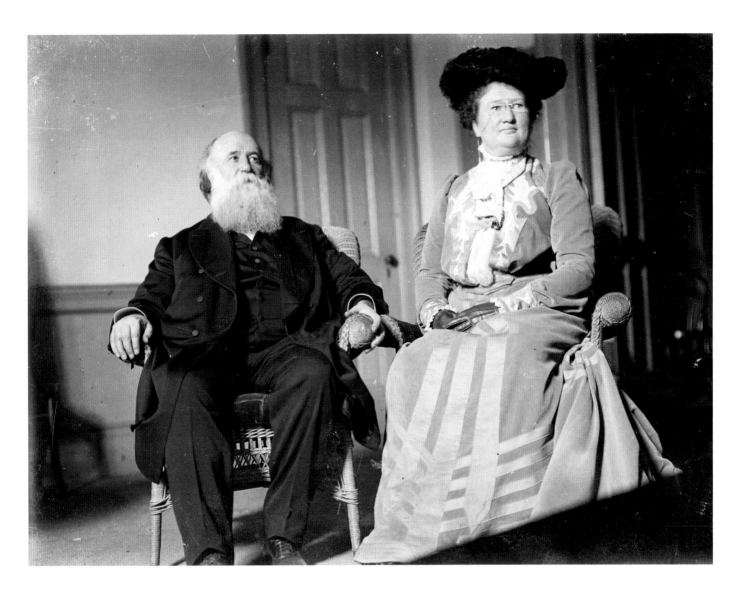

MORAL AUTHORITIES

John Alexander Dowie, shown in 1903 with his wife, Jeanne, was born in Scotland, moved to Australia, and came to Chicago to evangelize the needy and heal the sick. He first set up shop outside the World's Columbian Exposition in 1893, across the street from Buffalo Bill's Wild West Show. Three years later, Dowie founded the Christian Catholic Church—separate from the Roman Catholics—to attack the many sources of sin, including liquor, tobacco, pork, theaters, doctors, and newspapers. Newspapers and doctors fought back: The *Daily News* interviewed psychiatrists (then known as "alienists") for an article headlined "Call Dowie a Maniac: Chicago Alienists Say the Healer Is Degenerate of Dangerous Type." The police were after Dowie too, arresting him many times for practicing medicine without a license. In 1900, the minister established the city of Zion, north of Chicago, and made his own laws. But Dowie upset his followers by declaring himself to be the prophesied Elijah the Restorer, and his building boom soon pushed the town into bankruptcy. He was deposed as church leader in 1905 and died two years later.

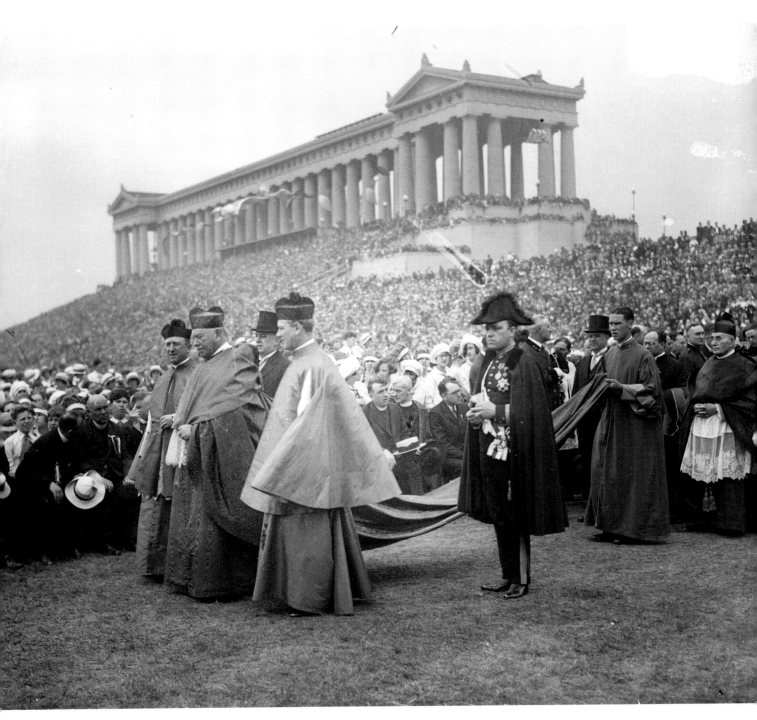

Roman Catholicism flourished in
Chicago, home to many thousands of
immigrants from Ireland, Italy, and
Poland. In 1926, Catholics filled Sol-
dier Field as Cardinal George Mun-
delein led a clerical procession at the
International Eucharistic Congress,
featuring a children's chorus of sixty-
two thousand. Mundelein became
the youngest American Catholic
archbishop when he was appointed at
age forty-three in 1915. The Vatican
had openings for bishops in Chicago
and Buffalo, and planned to send
Mundelein to upstate New York. But
Canadians complained about the ap-
pointment of a German American in
the border city while their nation was
at war with Germany. So the Vatican
swapped bishops, and Mundelein
went to Chicago. In 1924 he became
the first cardinal west of the Allegh-
eny Mountains.

Cardinal Mundelein was so well regarded that one of Chicago's northern suburbs is named after him, but he wasn't welcomed by everyone. At a banquet in his honor at Chicago's University Club in February 1916, the chicken soup was spiked with arsenic by an anarchist chef named Jean Crones. More than a hundred guests became ill, but the cardinal and the rest of those at the head table were spared. Still, Illinois governor Edward Dunne was described as "pale as a ghost" at the sight of the city's most prominent citizens vomiting en masse. The cook fled the banquet. When police went to his room in a Near South Side rooming house (pictured), they found anarchist literature and chemistry equipment. The *Tribune* called it a "laboratory of death," though no one had died. Various reports placed Crones on a train to Saint Louis, in New York City, in Boston, in Minneapolis, and even in Pittsburgh disguised as a nun. He was never captured.

Lucy Page Gaston, shown with a young man described as "boy detective Perry Rathbun," launched a religious crusade against tobacco when she founded the Anti-Cigarette League in Chicago in 1899. Gaston viewed cigarettes as "coffin nails" that not only damaged smokers' health but led them to wife-beating and other crimes. She even suspected a Bolshevik plot because some cigarette brands were imported from Russia. Gaston was particularly incensed when Warren Harding, a smoker who she thought had a "cigarette face," was elected president. Seventeen-year-old Rathbun worked undercover, checking whether stores would sell cigarettes to minors.

Rodney "Gypsy" Smith, posing in Chicago in 1909, was born in a tent outside London, raised in a gypsy camp, and never attended a day of school. Smith joined the Salvation Army in 1877 but was kicked out for accepting a gold watch and money from friends—a violation of the group's strict rules. The dismissal did not stop him: He became a world-class traveling preacher, making more than thirty trips to America. During one visit to Chicago, Smith marched on the Levee district in a frontal assault against iniquity. Several thousand people joined him in praying and singing "Nearer, My God, to Thee" in front of the taverns and houses of ill repute. Then Smith left. The crowd of sightseers that had followed Smith stayed around, making for a busy night of commerce in the Levee.

BILLY SUNDAY

William Ashley Sunday was born in Iowa, raised in an orphanage, and became a professional baseball player, excelling as a base stealer but batting a mediocre .248. He made better contact as a Presbyterian preacher, a role he embraced after being "saved" at the Pacific Garden Mission in Chicago. Sunday's most famous sermon was entitled "Get on the Water Wagon." At the time, horse-drawn water wagons sprayed dirt roads to keep down the dust, and a person who swore off liquor was said to have "climbed aboard the water wagon." That phrase has evolved into the modern expression "on the wagon." Sunday helped push the nation into Prohibition—a development that filled him with irrational optimism. "The rain of tears is over," he said. "The slums will soon be a memory." Sunday's speaking style was athletic and flashy, and he demonstrated it in the basement of his home for a *Daily News* photographer.

CHAPTER EIGHT

FLIVVERS AND FLYING MACHINES

It was an era of dizzying technological advances.

Three giant steps made the world smaller: the rise of automotive travel, the invention of the airplane, and the emergence of radio as a mass medium. Albert Einstein published his theory of relativity, and there were many more mundane developments, including the pop-up toaster, frozen food, and cellophane.

Nothing changed the landscape of Chicago or America during the early twentieth century as much as the automobile. The first "horseless carriages" took to the open road in the 1890s. At the turn of the century only 150 miles of U.S. road were paved. Just fifteen years later, though, Chicago had eighteen hundred miles of paved streets.

Henry Ford's Model T, first produced in 1908, made the automobile accessible to the masses. By the 1910s Chicago had its first traffic jams, by the 1920s, its first traffic lights.

The marvel of the age was the airplane. In 1903, Orville and Wilbur Wright took their "whopper flying machine" airborne. Chicago's International Aviation Meet in 1911 convinced many that flight was more than a fad. Sixteen years later, Charles Lindbergh's transatlantic flight proved once and for all that airplanes would change the way we lived.

Mass communication was revolutionized by the radio. In a two-year period in the early 1920s, America went from having no commercial radio stations to having five hundred. Chicago became a broadcasting powerhouse. *Daily News* photographers took hundreds of pictures of early radio—including more than one hundred photographs of the newspaper's own station, WMAQ.

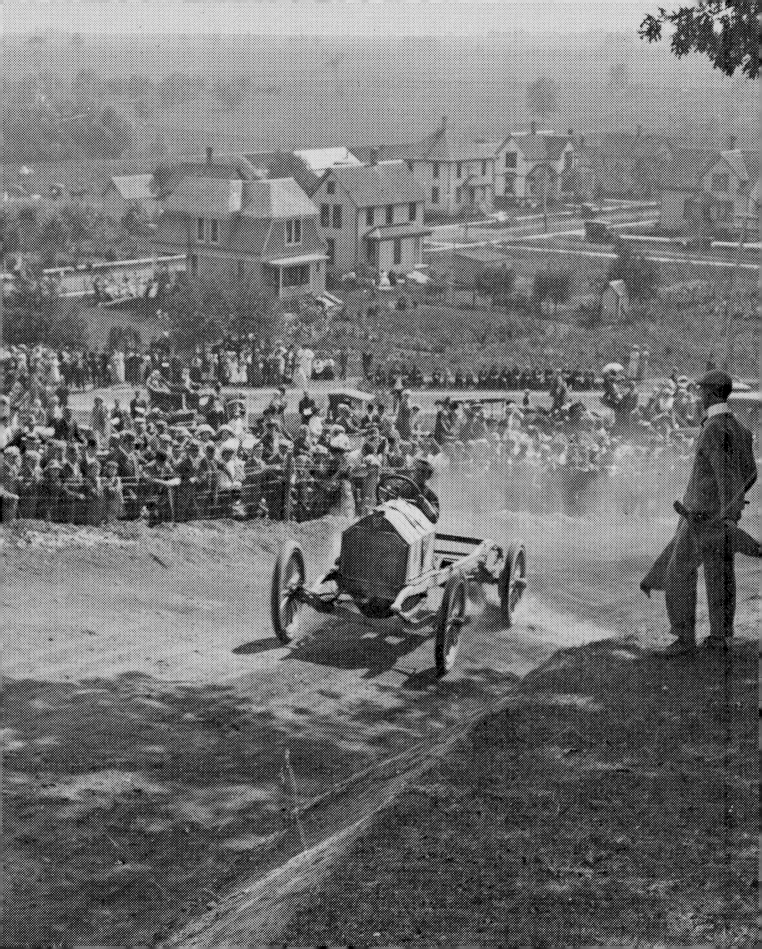

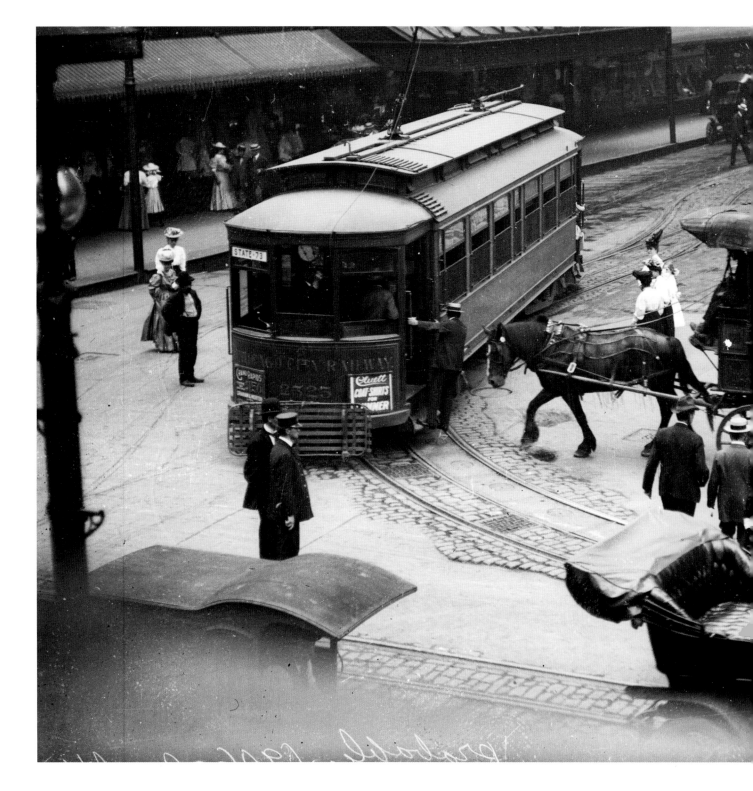

ARRIVAL OF THE AUTOISTS

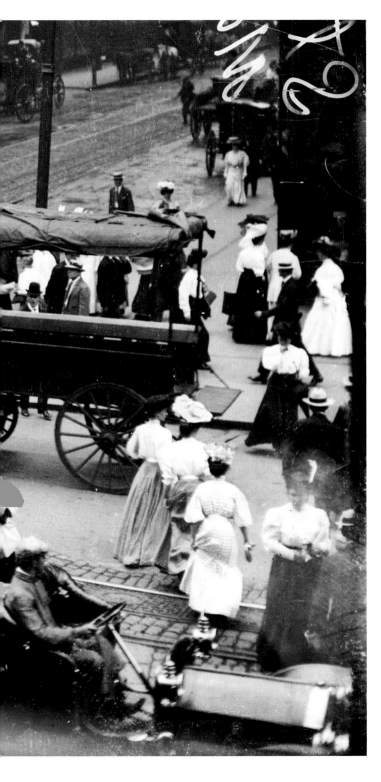

At the corner of State and Madison streets in 1906, it's pedestrian versus horse cart versus streetcar versus automobile.

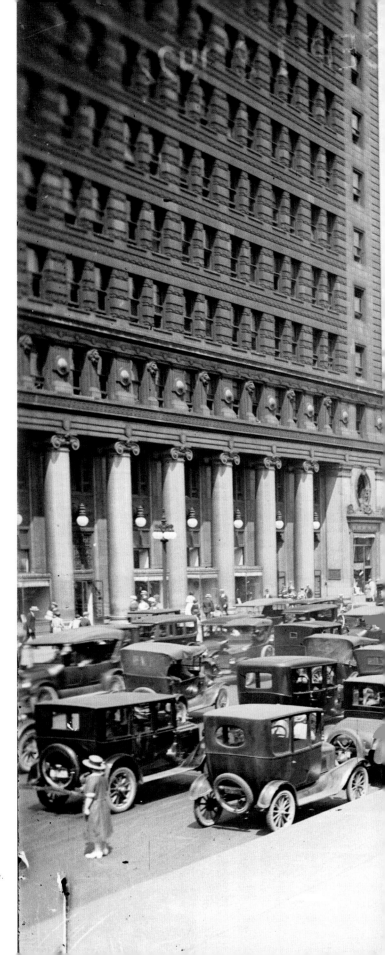

Motor-driven vehicles overwhelmed Chicago during the first three decades of the twentieth century. In 1900 there were 377 registered autos; by 1930, 478,204 cars competed for space on the crowded streets. Chicago's speed limit was raised from eight to ten miles per hour in 1904. Politicians struggled to handle the growing problem of "autoists" intent on "scorching," nowadays known as speeding. There was no opportunity to scorch during the Michigan Avenue traffic jam shown here, which occurred during the 1922 streetcar strike.

194

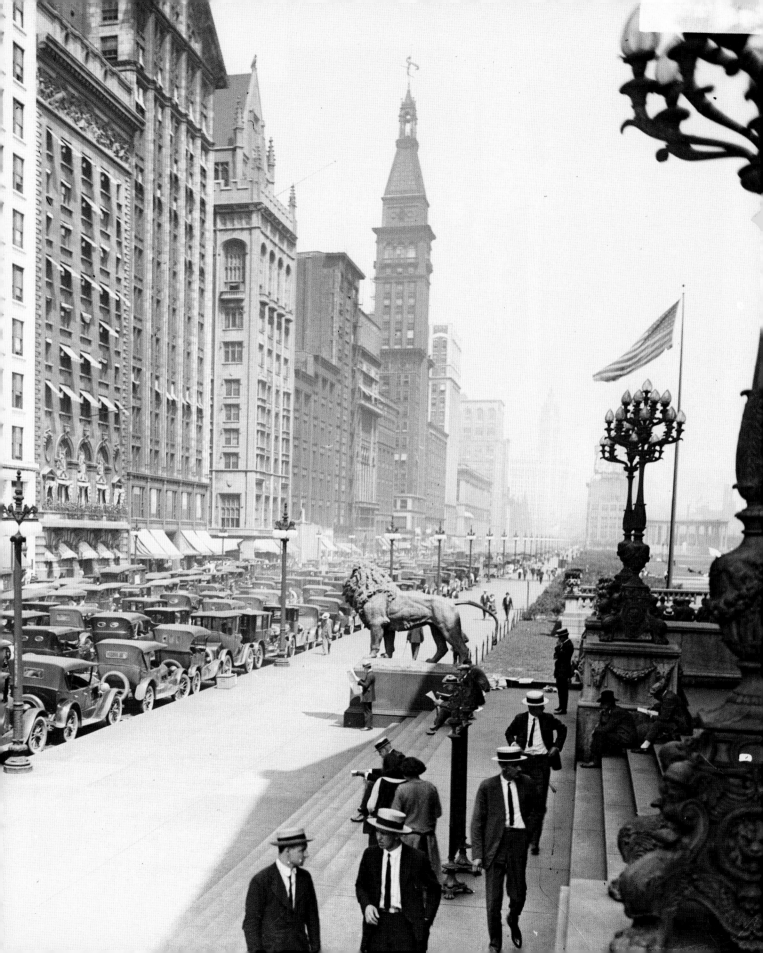

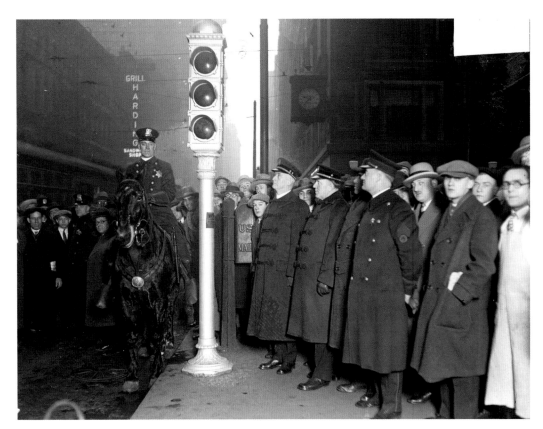

A crowd gathers in 1926 at the corner of Clark and Randolph streets to admire a newfangled device: the traffic light.

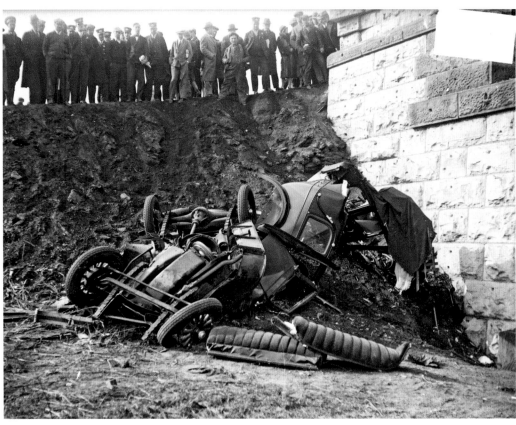

Wreckage at Thirty-first Street and Western Avenue after an auto accident in 1928.

Automobiles—"flivvers," "jalopies," "breezers"—were among the accesso- ries of the flapper, a liberated young woman who bobbed her hair, wore makeup, and danced in public, often to jazz bands or records. Shown here are two young women outside the Belmont Theater in 1927.

The Algonquin Hill Climb was held
once a year from 1906 to 1912, draw-
ing up to twenty-five thousand spec-
tators to the northwest suburban
village of Algonquin, population 550.
The idea was to demonstrate the
climbing power of autos, challeng-
ing one of the main knocks against
car travel.

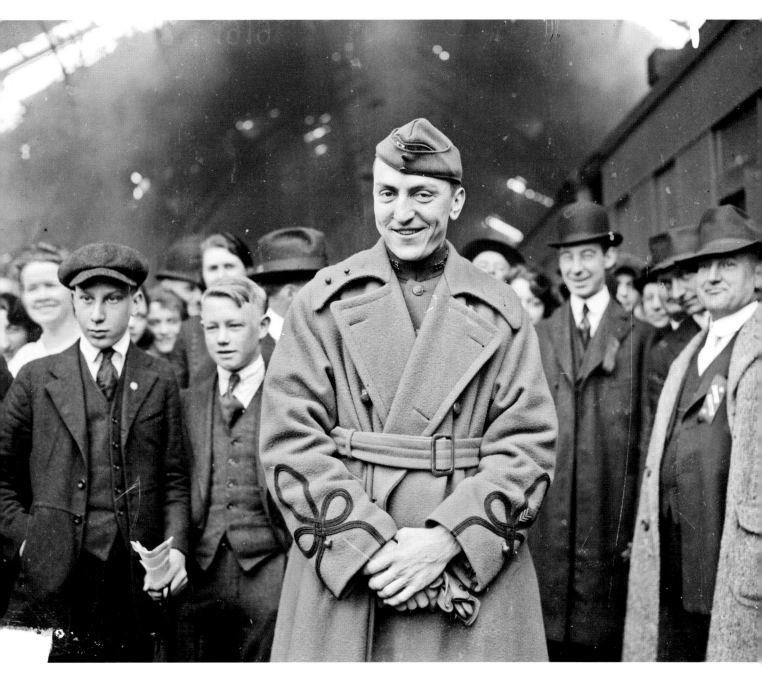

Eddie Rickenbacker was a bridge between the new form of transportation, autos, and the even newer: airplanes. A native of Columbus, Ohio, Rickenbacker represented Firestone-Columbus at the Chicago Auto Show in 1909 and was a daredevil driver on the auto-racing circuit.

He entered World War I as a chauffeur and steered his way into the air corps after repairing the stalled car of aviation chief Billy Mitchell along a road in France. While other soldiers were hunkered down in the trenches, Rickenbacker became a high-flying celebrity, risking death daily, lunch-

ing with newspaper reporters if the weather was bad, and throwing parties when circumstances allowed. When the war was over, Rickenbacker, shown here in 1919, found himself America's top ace, with twenty-six confirmed kills.

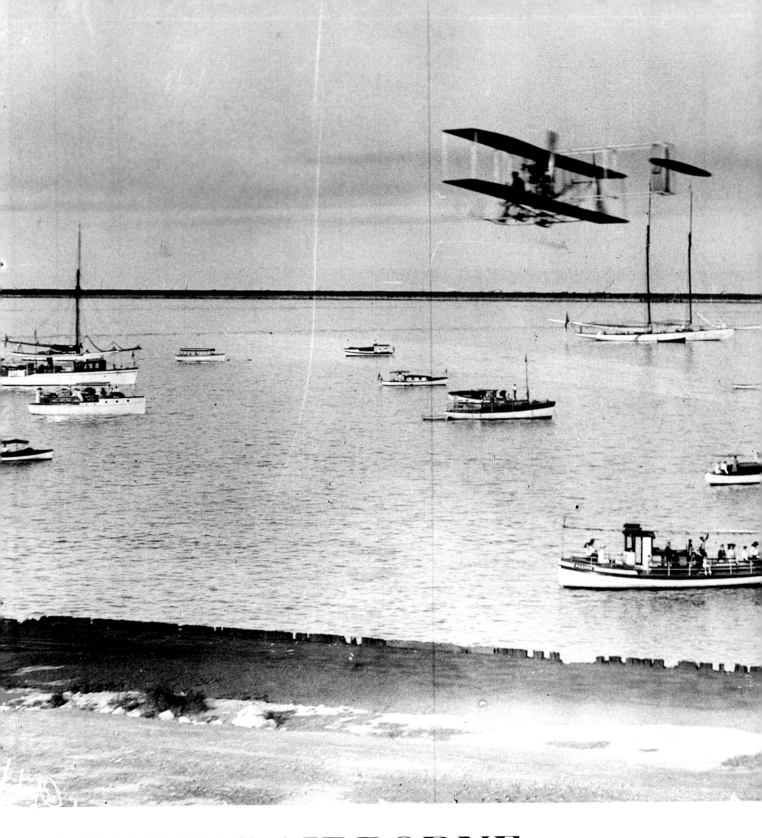

GETTING AIRBORNE

The nine-day International Aviation Meet drew three million spectators in Chicago in 1911, despite a lawsuit by the inventors who created the craze, Orville and Wilbur Wright. In their zeal to enforce their patents, the Wrights served as an impediment to aircraft innovation in the years after their first powered flight in 1903. Chicago's meet organizers fought off the lawsuit. C. P. Rodgers, shown here in a grand flight over the lakefront, won the duration contest by staying airborne for nearly three hours.

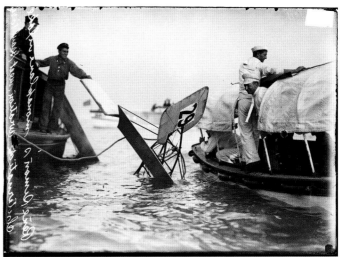

But all was not glory. Two fliers died, and others suffered ignominious crashes. Rene Simon wrecked his Moisant twice, smashing into a tree on the first day, and then days later skidding into Lake Michigan after his engine stalled. Simon survived the plunge, and an excursion boat picked him up before he got wet.

When early aviators executed a wild maneuver, it was called "pulling a Beachey"—a reference to America's first great stunt pilot, Lincoln Beachey. He flew under bridges, buzzed buildings in Chicago's Loop, and even flew inside a building—Machinery Hall in San Francisco. His spirals, loops, rolls, and "Dive of Death" were performed in a lightweight plane that was easily dismantled so that it could be shipped from town to town in packing crates. Beachey, shown here in Chicago in 1914, was a morose iconoclast who kept newspaper clippings about the fliers who died trying to imitate his feats. He walked with a limp and eschewed the leather caps, jackets, cavalry pants, and boots of other aviators, preferring a pinstriped suit and a golfing cap that he turned around with a flourish just before takeoff. Once aloft, he would fly low over the bleachers, forcing fans to "hit the planks." At an air show in 1915, his plane lost its wings in a dive and plunged into San Francisco Bay. Beachey survived the impact but drowned.

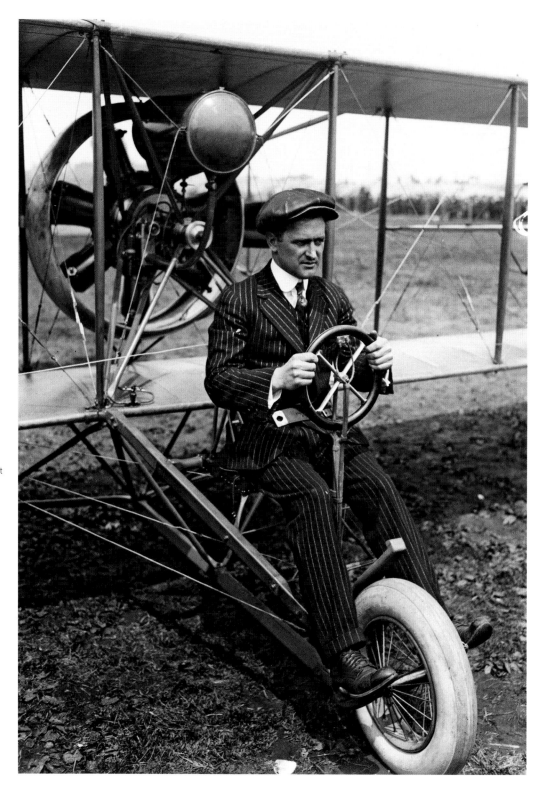

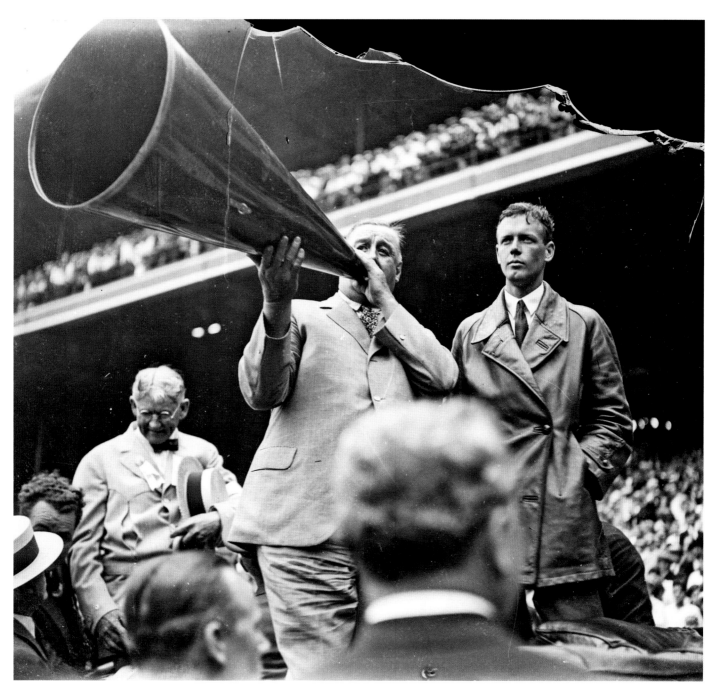

Before he became a national hero, Charles Lindbergh earned his wings through years of dangerous, daring flights that drew little attention. He was a barnstormer in Colorado who performed "deaf flights"—promoting the dubious idea that taking deaf people into the stratosphere would improve their hearing. He carried photos and news copy for Chicago papers. As an air-mail pilot on the Chicago–Saint Louis route, he had to bail out in a parachute twice in six weeks. For his greatest exploit, a flight across the Atlantic Ocean, he did not pack a parachute because it weighed too much. Today, it may be difficult to grasp the impact of Lindbergh's crossing of the Atlantic. A twenty-five-thousand-dollar prize for a New York–Paris flight had gone unclaimed for eight years. Just twelve days before Lindbergh took off, a plane with two pilots left France headed west, never to be heard from again. But Lindbergh made it across the ocean in thirty-three hours, landing his *Spirit of St. Louis* on May 21, 1927, at Le Bourget amid a frenzied crowd of 150,000. In typical businesslike manner, his first words were, "Are there any mechanics here?" Lucky Lindy landed in Chicago later that year during a nationwide tour, and when he visited Comiskey Park, he let a megaphone-wielding Mayor William Hale Thompson do much of the talking.

After Lindbergh's exploits, the race was on to become the "Lady Lindy"—the first woman to cross the Atlantic by nonstop airplane. Actress Ruth Elder **(left)** teamed up with pilot George Haldeman for an attempt in October 1927. Though some people dismissed it as a publicity stunt to help her Hollywood career, Elder reportedly flew nine of the twenty-eight hours they were in the air. Bad weather and a leaky oil line forced them down about three hundred miles short of their goal, but a Dutch oil tanker picked them up unharmed. Amelia Earhart **(above)**, who was less interested in show business but no less interested in fame, waited for better weather. In June 1928, she made it across the Atlantic on a plane piloted by two men. Earhart admitted that she had been mere "baggage," but she became a media star. Earhart spent most of her youth in Kansas but moved to Chicago as a teenager and graduated from Hyde Park High School in 1916. She is shown here during a homecoming parade in Chicago in 1928. Earhart flew across the Atlantic by herself in 1932, and three years later she became the first pilot of either sex to fly from Hawaii to California. In June 1937, she and navigator Fred Noonan set out to circle the globe by plane. The pair disappeared July 2 in the South Pacific, leaving a mystery that endures to this day.

GAINING TRACTION

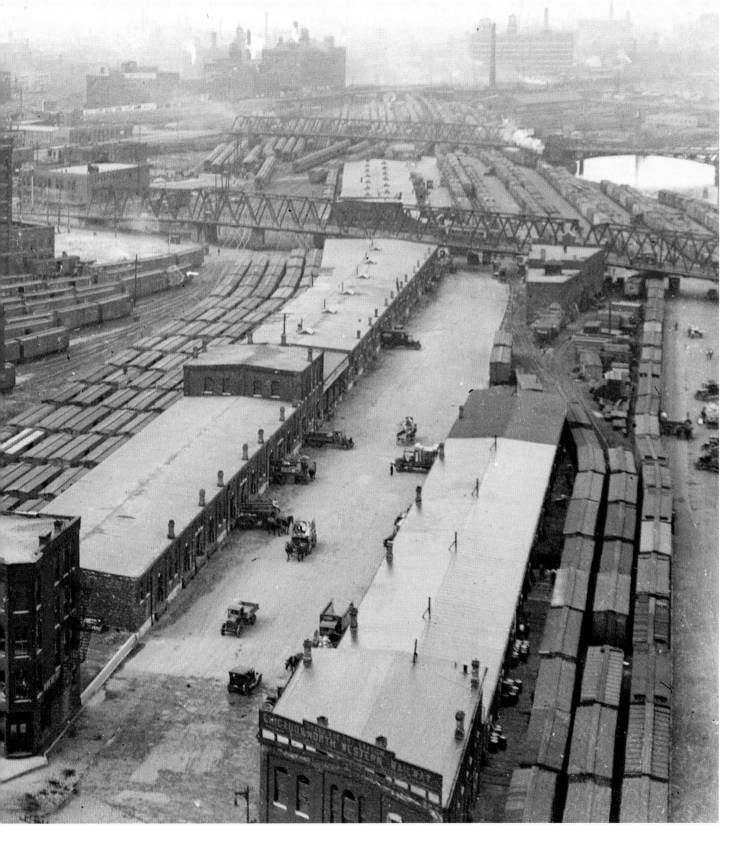

Chicago's landscape was dominated by the rails, as shown by this bird's-eye view looking northwest from the edge of the Loop in 1925.

These children leaving for summer
camp in 1905 were among the mil-
lions riding the trains in Chicago.

What we today call public transit was, in the early twentieth century, called "traction." At one time, Chicago had the most extensive system of cable cars in the world, but it converted to electric streetcars in 1906, the year this photograph of men stepping off of a Chicago Union Traction Railway streetcar was taken. About 380 million transit trips were taken in the city that year—a figure that soared to nearly 900 million by 1930. These figures might suggest financial success for the private transit companies, but many operations went bust, burdened by city regulations, including a five-cent cap on fares in the first two decades of the century. Chicago's mass transit didn't go public until the 1940s.

Freight tunnels were built forty feet below street level downtown to deliver coal and other goods to office buildings. The tunnels also served as a conduit for telephone and telegraph wires. About sixty-two miles of tunnels were constructed between 1899 and 1909. Eight decades later, the tunnels had been all but forgotten until a piling driven into the Chicago River bottom in 1992 punctured the ceiling of one tunnel, unleashing an underground flood that dumped 250 million gallons of river water into Loop basements and caused an estimated billion dollars in damage.

Facing page: A pedestrian walkway leads from the new *Daily News* building, 400 West Madison Street, to the commuter trains heading to Chicago's suburbs in 1929.

TO C. & N.W. RY. TRAINS

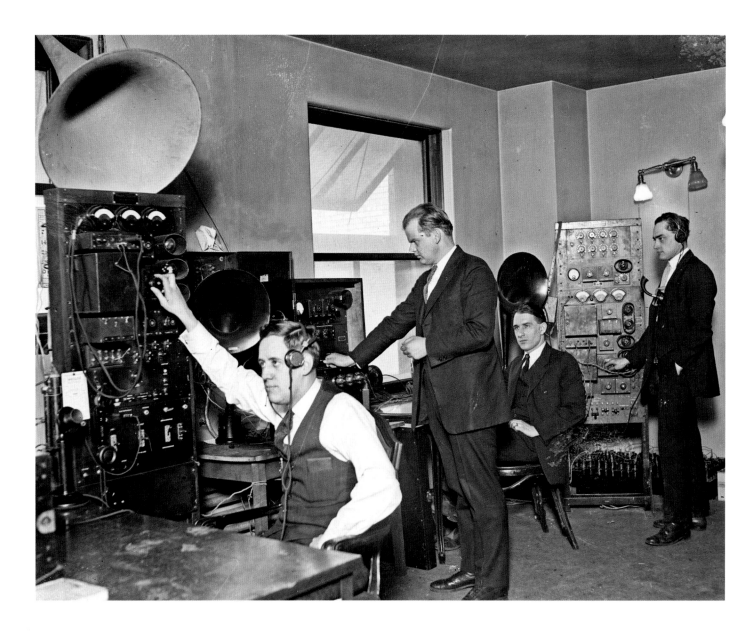

INTO THE ETHER

The word *radio* came from *radiation*, based on the way the signals spread. But an old-fashioned theory held that such signals moved through an invisible ether, and the terms *ether* and *radio* were synonymous in headlines of the time. By any name, revolution was in the air in the 1920s. Suddenly, millions of people shared the same news, music, and entertainment. The *Daily News* joined forces with the Fair Store in 1922 to form WMAQ. The let-

ters did not stand for any particular slogan, although in latter years people would say it meant "We Must Ask Questions." Until 1927, the *Daily News* would not let WMAQ operate on Sunday. (It didn't publish a paper that day.) The National Broadcasting Company bought WMAQ in 1931.

Facing page: Russell Pratt, a WMAQ announcer who was part of a comedy team known as "the Three Doctors," works in 1926 in the station's studio, which was surrounded by drapes to cut down on the echo. The station and its program director, Judith Waller, helped define radio, introducing the nation's listeners to *Fibber McGee and Molly*, *Amos 'n' Andy*, *The Great Gildersleeve*, and other popular shows. WMAQ set up remote broad-

casts from University of Chicago classrooms and pioneered children's programming, hiring Georgene Faulkner as the "Story Lady." It also put the Cubs, White Sox, and college football on the radio. The curtain finally fell on WMAQ in the year 2000, when its owner decided to use the 670 AM frequency for a sports talk station.

MODERN MARVELS

Chicago embraced new uses for electricity, and the Electric Show at the Coliseum in 1911 was but one highlight. Many people considered the 1893 World's Columbian Exposition to have been electricity's coming-out party for all of America. The city also was home of the world's first all-steam turbine generating station, the Fisk Station, built in 1903. The Chicago Edison Company had a monopoly from 1887 to 1897, when the Commonwealth Electric Company obtained a city franchise as well. Ten years later, the companies merged into a monopoly that serves the city to this day: Commonwealth Edison.

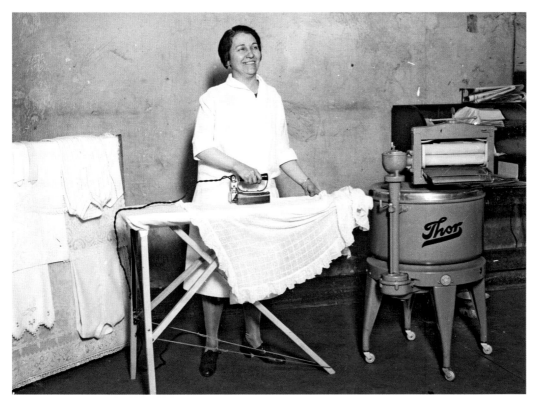

Technology made life easier in large and small ways. Here Myrtle T. Blackridge displays her electric iron and modern clothes washer in 1928. Many home conveniences were invented in the 1800s but became practical only with the coming of domestic electric power in the early 1900s. Chicago's Hurley Machine Company marketed the first electric washer—known as the Thor—in 1908.

Cook County officials examine their electric chair in 1927. As electrical devices gained favor, inventor Thomas Edison defended the value of his DC (direct current) system versus the more efficient AC (alternating current) used by his competitors, such as the Westinghouse Company. When the state of New York decided to build an electric chair, Edison urged that rival AC be used, to encourage the idea that it could be lethal. Instead of announcing that inmates had been electrocuted, Edison suggested, officials should say they had been "Westinghoused."

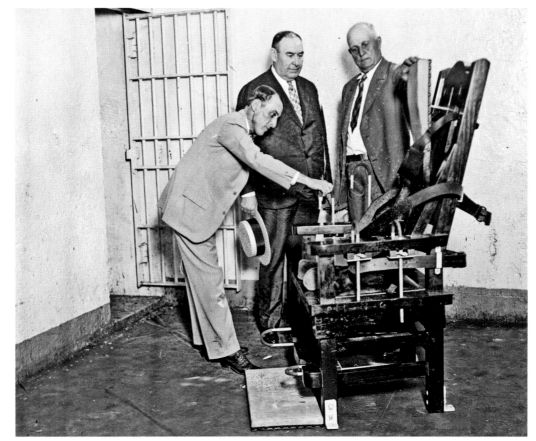

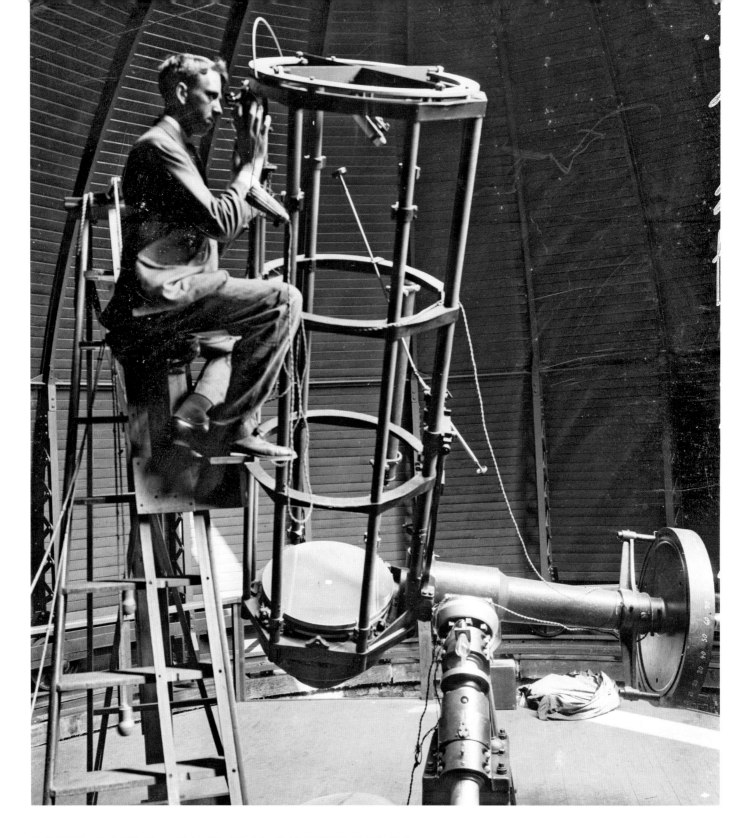

HIGH CONCEPTS

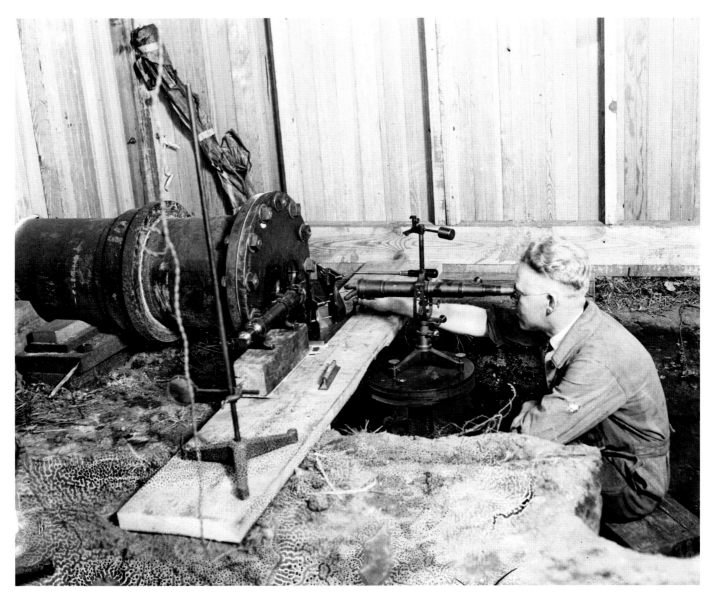

Facing page: A worker assembles a telescope at Yerkes Observatory, a University of Chicago research facility in Williams Bay, Wisconsin. The observatory was founded in 1897 by astronomer George Ellery Hale and financed by tycoon Charles Tyson Yerkes. Unlike other telescope stations that were mere observation points, Yerkes included a research lab. It boasted a forty-inch refracting telescope, which remains the world's largest (more efficient reflector designs have since taken over). When the two forty-inch lenses were shipped from Massachusetts to Yerkes in the 1890s, they were sewn into soft cloths and packed in separate boxes filled with "curled hair."

Physicist Albert A. Michelson, shown here in 1923, joined the new University of Chicago in 1892. Specializing in optics, his greatest achievement was to prove that the speed of light was a constant, a feat that earned him a Nobel Prize in 1907. Michelson also used light waves as a standard to make precise measurements at great distances. He determined the diameter of the star Betelgeuse, providing, according to the Nobel organization, "the first determination of the size of a star that could be regarded as accurate."

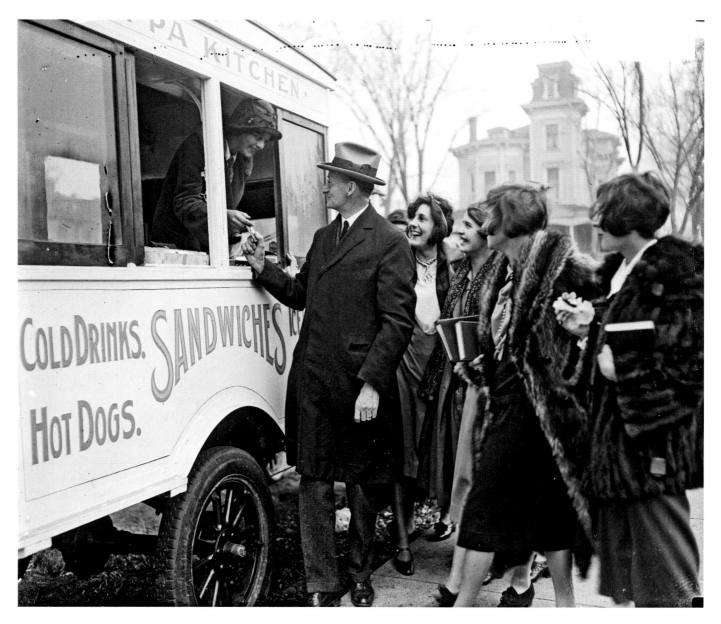

"The human race is carnivorous, but does not like to be reminded of the fact." So said Walter Dill Scott, shown here ordering fast food on the Northwestern University campus in 1926. Scott's 1903 book *The Theory of Advertising*, a seminal book in its field, took marketing out of the carny tent and into the psychology department. After revolutionizing the advertising industry, Scott took a scientific approach to personnel assessment, devising the U.S. Army's system of aptitude testing during World War I. From 1920 to 1939, he was president of Northwestern University, where he quadrupled the endowment, founded the schools of journalism and education, and created the downtown Chicago campus for medicine and law.

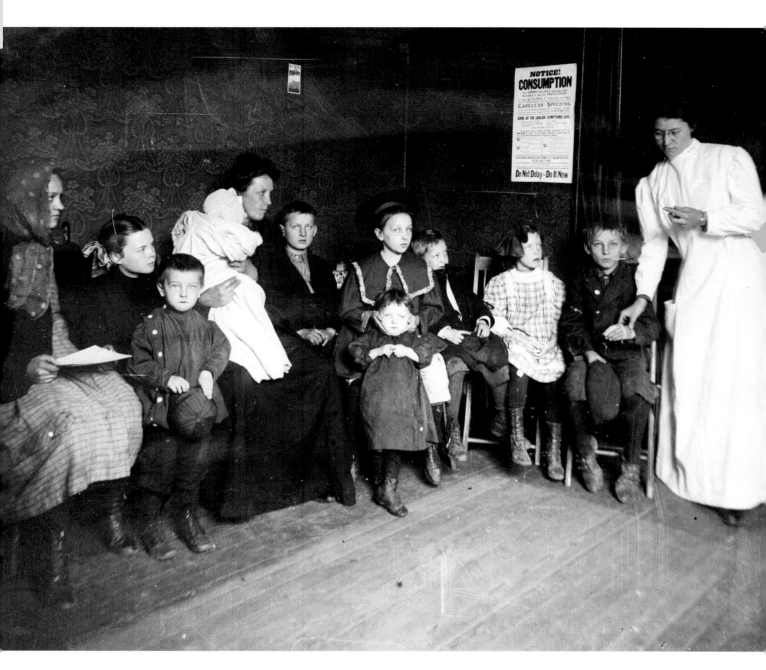

The era saw dramatic technical innovations in medicine, including the artificial kidney (1913) and the medical use of insulin (1922), but one disease that resisted a cure was tuberculosis, then also known as "consumption." The Chicago Tuberculosis Institute, shown in 1910, was a place where patients could rest and eat a healthy diet while being isolated from the general population. The institute issued a series of postcards urging clean lifestyles, such as daily bathing and no spitting in public. Not until the mid-1940s did researchers find drugs that could kill tuberculosis.

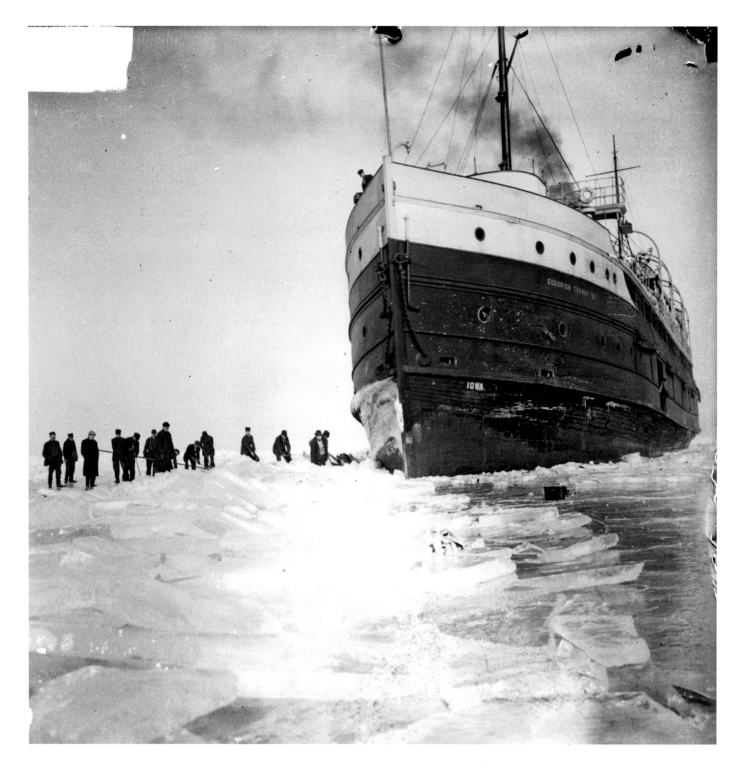

SAILING INTO THE SUNSET

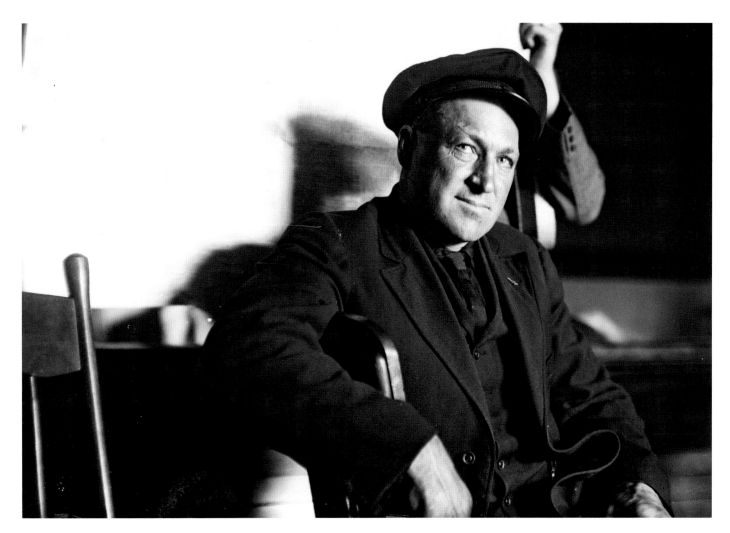

Facing page: At the turn of the century, Chicago was the nation's busiest port in terms of the number of ships and boats arriving and departing. But in the first few decades of the new century, railroads hauled the bulk of the freight business away from the maritime industry. The steamer *Iowa*, shown in 1912, demonstrated a distinct disadvantage of ship travel—vulnerability to the weather. It was trapped in Lake Michigan's ice twice that winter but broke free both times. A year later, the *Iowa* was badly damaged in a collision with another ship. After being rebuilt, it went back out, only to get stuck in ice in 1915. This time, there was no escape. The ship, broken to bits, sank to the bottom.

Ice wasn't the only hazard on Lake Michigan. There was also a pirate named "Roaring Dan" Seavey, shown in 1908. Based in Michigan's upper-peninsula port of Escanaba, Seavey would sneak his schooner into ports before dawn and grab goods off docks. He was also known to set up false buoys in shallow waters, tricking ship pilots into running aground. When the crews abandoned ship, Seavey's schooner would slip in and collect the cargo. He sold most of his booty to Chicago wholesalers.

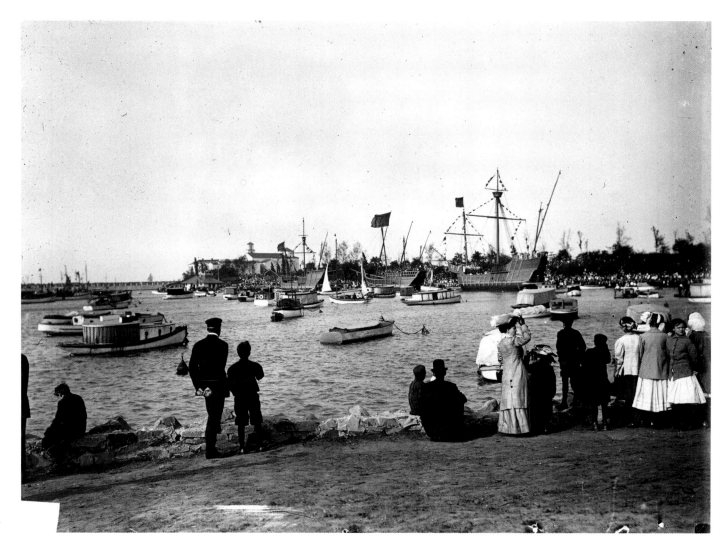

Replicas of Christopher Columbus's vessels—the *Niña*, the *Pinta*, and the *Santa María*—sit in Jackson Park harbor on the South Side during a Columbus Day celebration in 1910. The ships were built in Spain in 1892 and sailed across the Atlantic Ocean to celebrate the 1893 World's Columbian Exposition. They were then moored in Jackson Park. The *Pinta* sank in 1918, the *Niña* was destroyed by fire in 1919, and the *Santa Maria* was lost to fire in 1952.

Facing page: In November 1912, the three-masted schooner *Rouse Simmons* went down in a fierce Lake Michigan storm while hauling a load of Christmas trees to Chicago from upper Michigan. Captain Herman Schuenemann and as many as seventeen other crew members were lost. In 1915, the *Daily News* photographed Schuenemann's daughter Elsie at the wheel of a new "Christmas tree ship."

But it appears unlikely that Elsie actually plied the lake—if she had been piloting this ship, she would have been facing the other way and standing beside the wheel, not behind it. According to reports, the trees were in fact shipped by rail and then loaded onto a boat docked on the Chicago River to preserve the charming tradition that Captain Schuenemann had established.

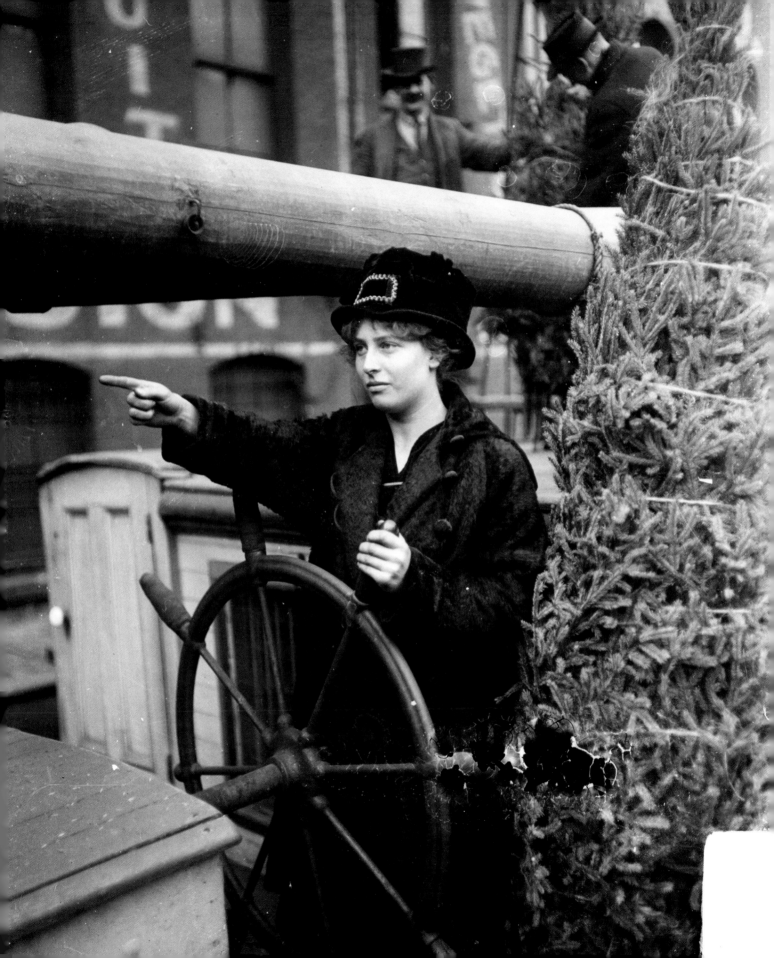

Facing page: Chicago in the era of the horse was a very different place. There were water troughs along the streets, "road apples" (horse dung) beside the curbs, and blacksmith shops all around the city. Chicago was a center for the production of saddles because the stockyards provided a ready supply of leather. The horse and wagon shown here are in front of the Belden Avenue Baptist Church in Lincoln Park in 1916.

This blacksmith is pictured in 1906, a time when automotive horsepower was replacing horseflesh throughout the city: The number of horse-drawn vehicles fell from more than fifty-three thousand in 1908 to fewer than ninety-six hundred in 1930.

WEIRD SCIENCE

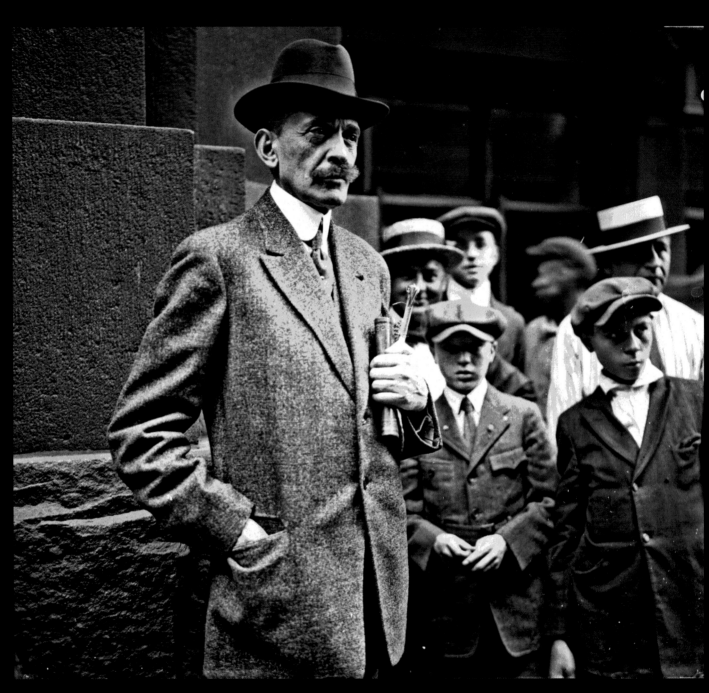

Serge Voronoff, a Russian-born physician based in Paris, performed xenotransplants—transfers of organs from one species to another. To be more specific, he grafted tissue from monkey testicles onto human beings. At least five hundred men received the operation in the 1920s and 1930s, many of them millionaires who paid thousands of dollars for the "rejuvenating" surgery. Chicago magnate Harold McCormick received a version of the operation from Dr. Victor Lespinasse. Despite Voronoff's worldwide travels to promote the treatment, mounting medical evidence proved it was worthless.

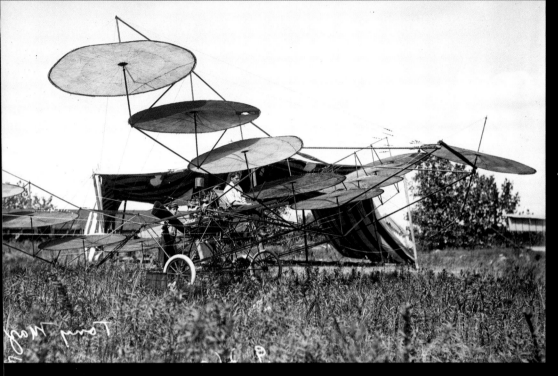

Chicagoan James F. Scott's 1910 flying machine was supposed to work somewhat like a helicopter, gaining lift as its disks rose and fell under the power of a lightweight engine. A model of the aircraft performed "all sorts of stunts," according to reports. But the full-size version failed to fly.

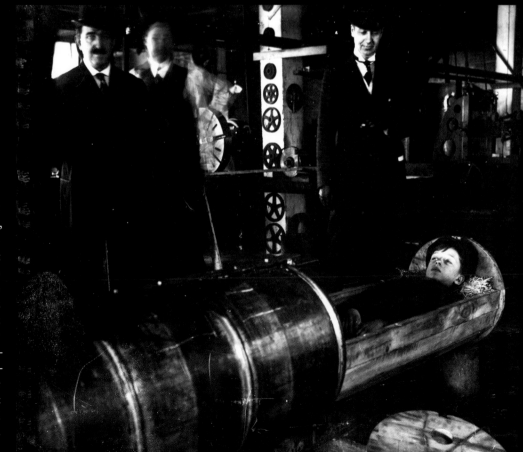

Robert Stoetzel, thirteen, was a guinea pig for his inventor father, Joseph, who devised a pneumatic tube system to send packages long distances; small freight could have been transported from Chicago to New York, for instance, in seven hours. To show his confidence in the tube's safety, Joseph used his son as cargo in a 1908 demonstration for postal officials. Young Robert had one word for the *Daily News* after the test: "Whew!" The concept was never embraced, and air mail became practical without the need for transcontinental tubes

CHAPTER NINE

SIDEWALKS AND SKYLINES

The Chicago that we know today, that exuberant city by the lake, was substantially defined during the first three decades of the twentieth century. Many of its landmarks—Buckingham Fountain, Soldier Field, Navy Pier, the Field Museum— were planned and built then. Signature areas of the city—including Lake Shore Drive, the Michigan Avenue shopping district, and the LaSalle Street financial district—also came of age during those years.

Much has changed on the street since the horse-and-buggy days. Cobblestones have been paved over, awnings removed from storefronts, and cornices taken down from skyscrapers. Street life, however, remains remarkably similar. Mail carriers still make their rounds, shoppers crowd into the Loop to buy Christmas gifts, and cops patrol their beats—though they may ride Segway scooters instead of wearing out their shoe leather these days.

These early years, when the city was captured under glass, were alive with new ideas. Architect Daniel H. Burnham proposed a grandiose plan for a Chicago of wide boulevards and elegant public buildings, à la Paris. The Plan of Chicago never officially came to fruition, but many of those who love and care about Chicago embrace its ideas, and Chicago is slowly but steadily evolving toward Burnham's vision.

The *Daily News* photographers found it impossible to take pictures of futuristic visions, of course. But in photographing the here and now, they produced a vivid record of much that is now done and gone—as well as the quintessential Chicago that is here to stay.

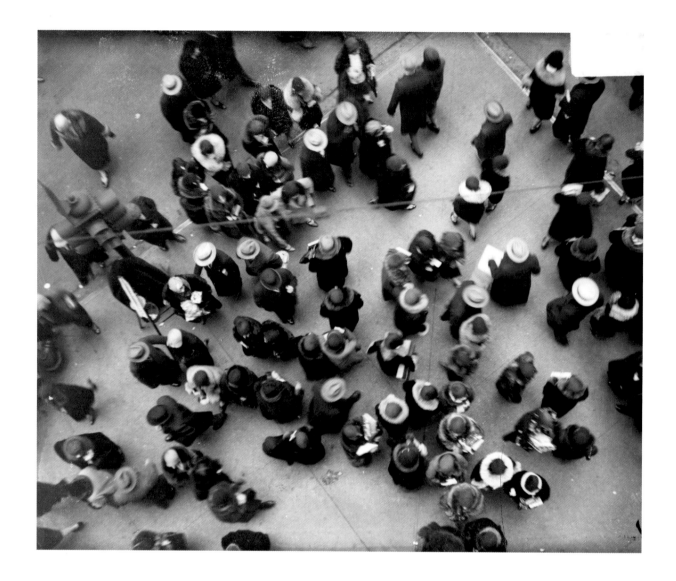

STREET SCENES

Chicago's epicenter, the corner of State and Madison streets, was brimming with pedestrians in 1929.
Some called it the world's busiest corner.

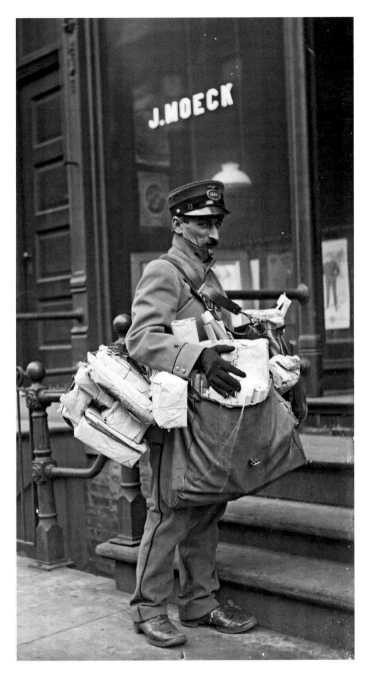

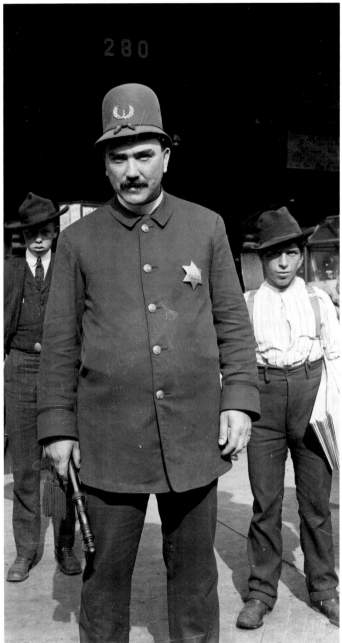

Among the men on the beat are a mailman delivering holiday packages in 1904 and police officer Richard Mackay, who rescued a young girl trapped under a car in 1903. Their jobs got a bit easier in the next few years when Chicago standardized its street numbering system, with eight blocks to the mile, extending in all four directions from the corner of State and Madison streets.

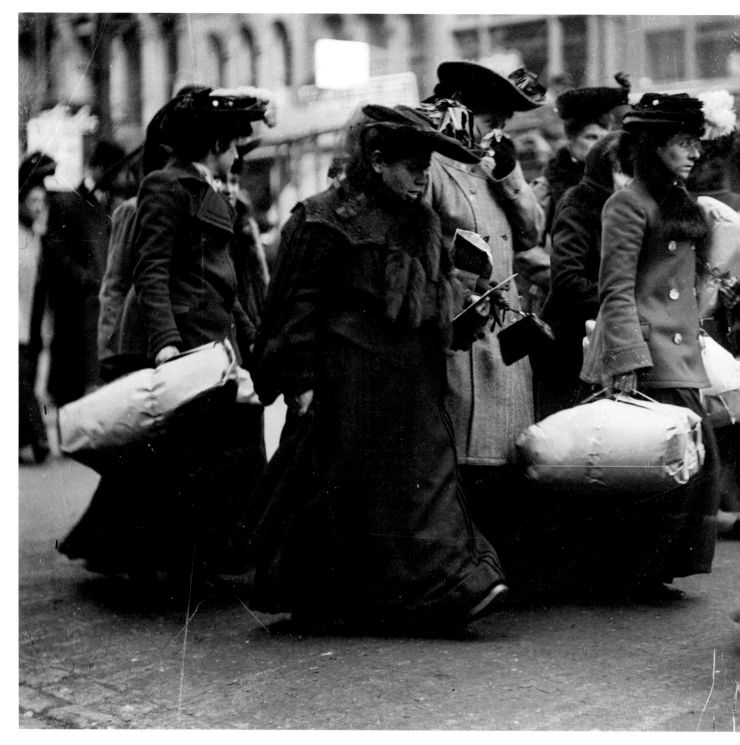

Christmas shopping, 1903.

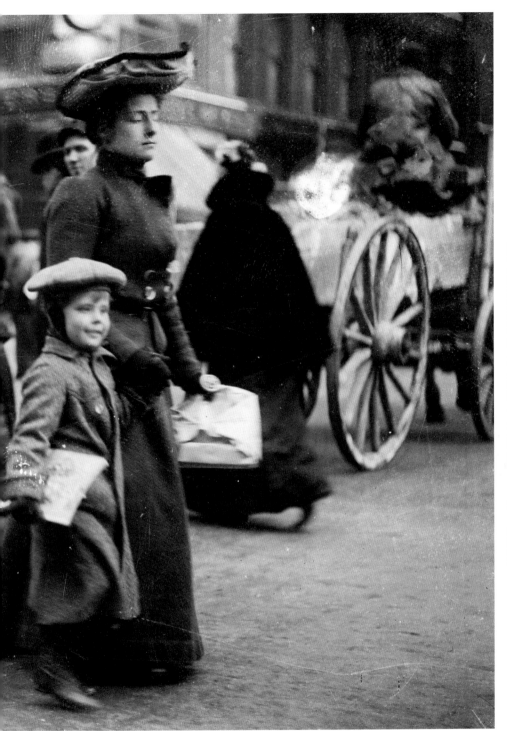

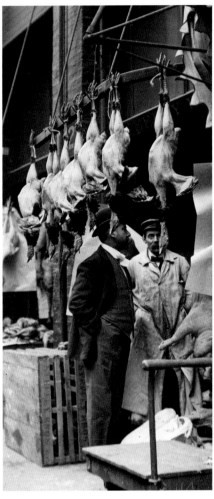

Freshly plucked chickens hang over
a doorway at the South Water Street
market downtown in 1910.

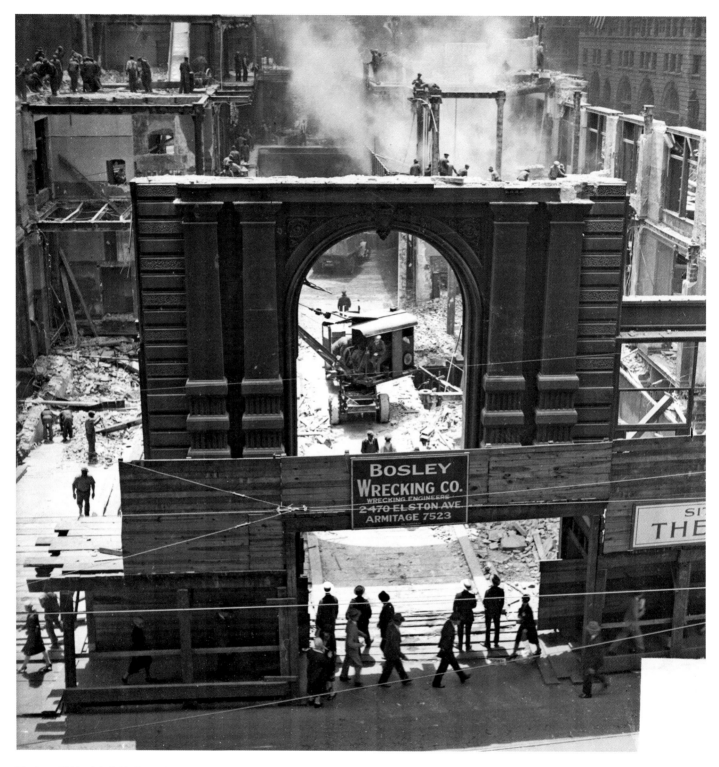

The lot at 33 North LaSalle Street is cleared in 1928 after the demolition of a much-admired early skyscraper, the Chamber of Commerce Building. Built in its place was the Foreman National Bank building, now known as the American National Bank Building.

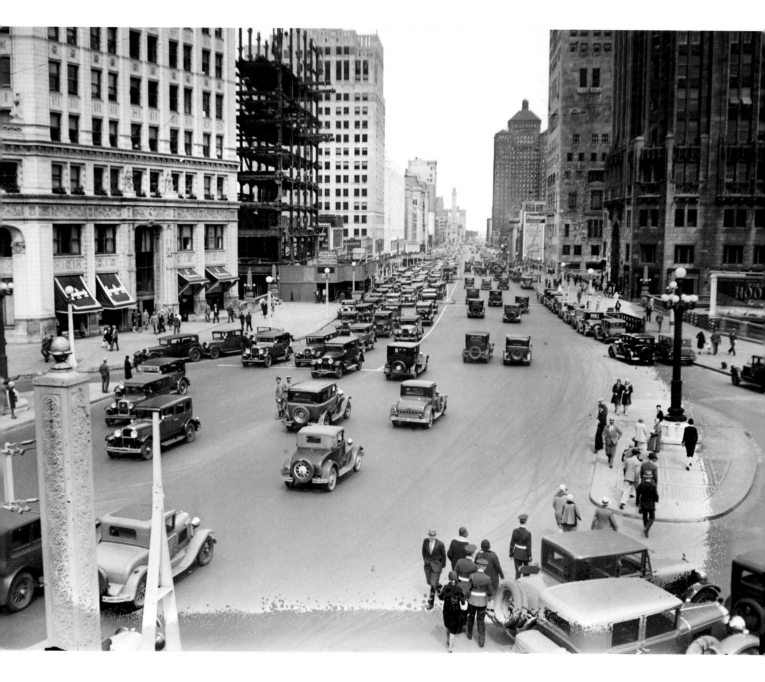

ESSENTIAL CHICAGO

One particular mile became magnificent in the 1920s when the Michigan Avenue Bridge was built, along with two buildings that formed a gateway welcoming shoppers and tourists to the north end of the bridge. At left is the Wrigley Building, built 1920–1924, with a cornerstone that contains samples of Wrigley chewing gum. At right is the Tribune Tower, built 1922–1925 after an international architectural competition.

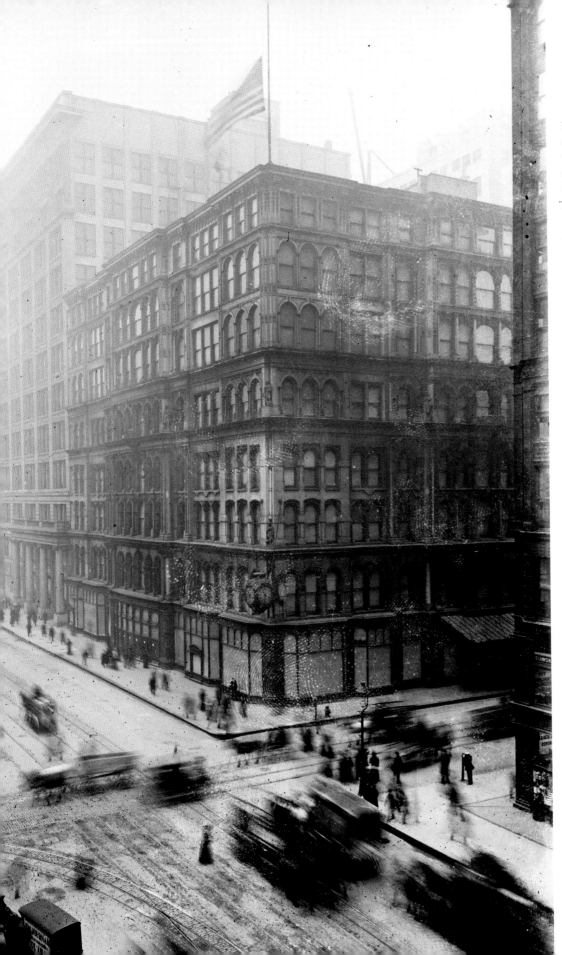

The Marshall Field's department store at the corner of State and Washington streets made itself into a landmark, featuring its signature clock and Tiffany dome. The phrase "Give the lady what she wants" was born there, as was the idea of a bridal registry. The business operated under the Field's name for more than 150 years, until the stores were absorbed into the Macy's chain in 2006.

Facing page: LaSalle Street, north of the old Board of Trade Building on Jackson Boulevard, has retained the same feel that it had in 1927.

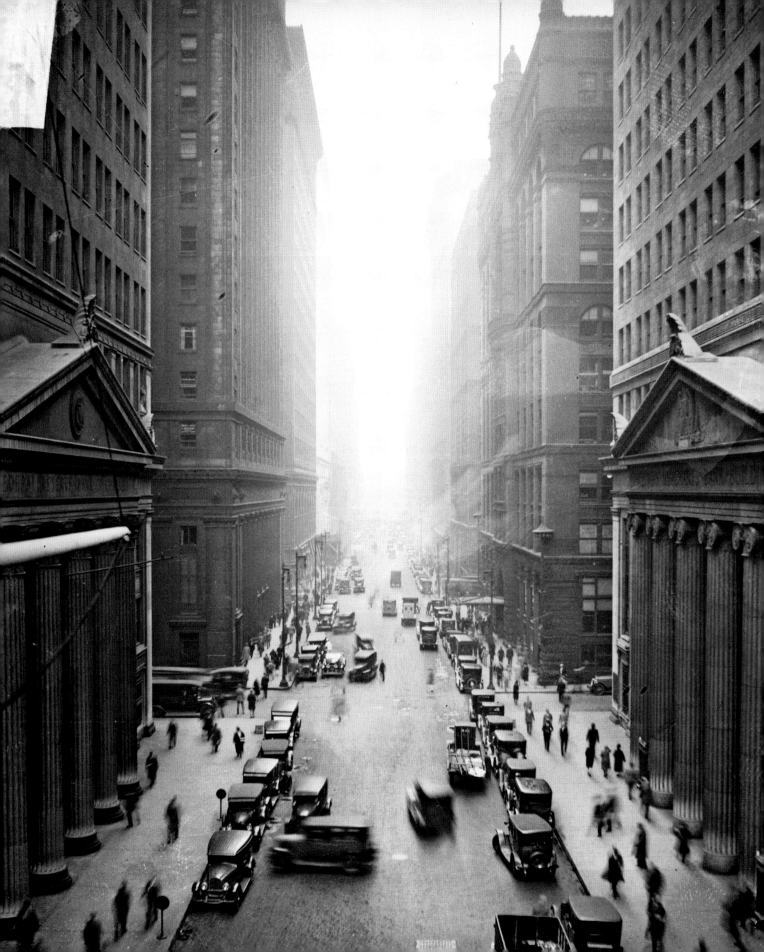

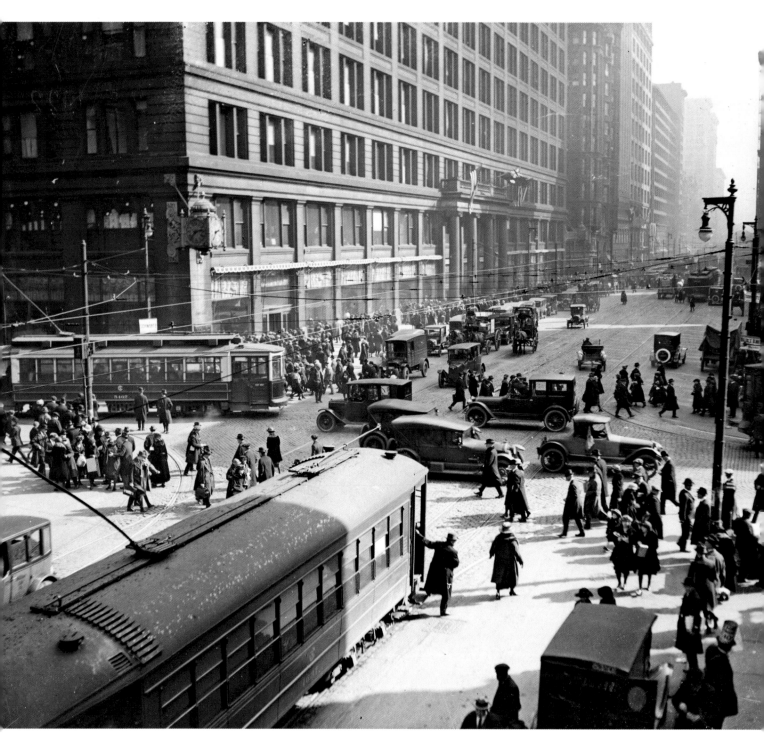

State Street was the city's premier shopping area when this photograph was taken in 1922. It also was prime people-watching territory. One *Tribune* writer strolled up State Street from Congress Parkway to this corner, State and Randolph, in 1921 and arrived with the following fashion fact: Girls who bobbed their hair did not wear rolled stockings, and vice versa.

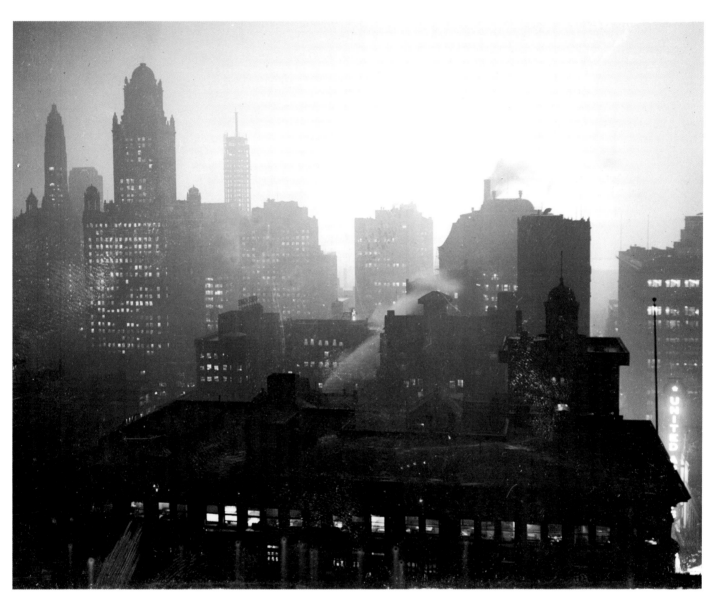

The city at night, as viewed from the Sherman Hotel at Clark and Randolph streets in 1929.

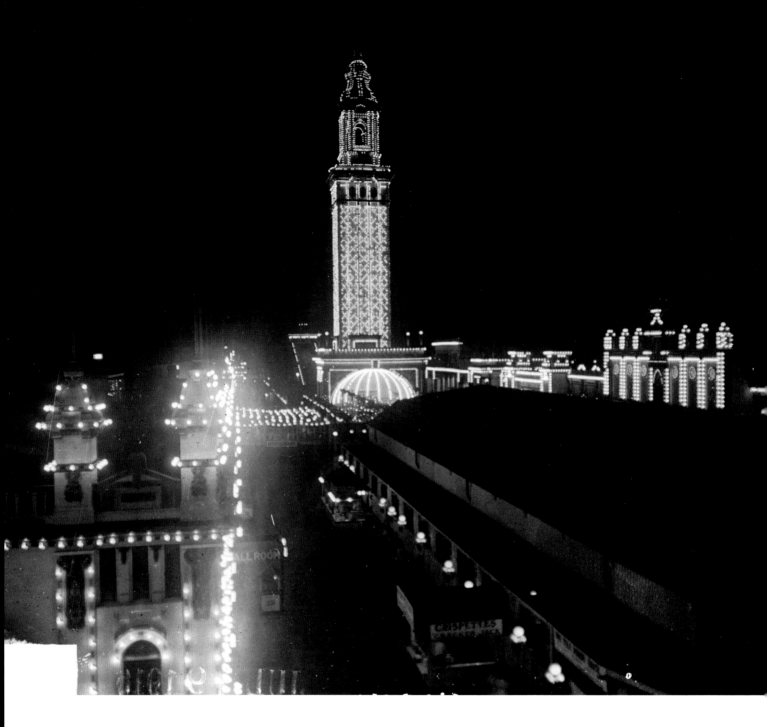

LOST IN TIME

The White City amusement park, illuminated by 250,000 incandescent lights, recalled the grand Beaux Arts architecture of the 1893 Columbian Exposition. White City was billed as the largest amusement park in the country when it opened in 1905 at Sixty-third Street and Park Avenue (now called Martin Luther King Jr. Drive). The bulk of the park shut down in the mid-1930s, though vestiges survived into the 1950s.

Spectators stand outside the monkey show at Riverview Park in 1916. The seventy-four-acre amusement park opened in 1904 along the North Branch of the Chicago River at Belmont Avenue, and for decades was a popular North Side attraction, mixing Chicagoans of all kinds. Up to two hundred million people passed through the turnstiles before an investment firm bought and abruptly demolished the park in 1967.

Facing page: The Bridewell, at Twenty-sixth Street and California Avenue, was where Upton Sinclair's fictional character, Jurgis Rudkus, was jailed in the novel *The Jungle*. The city prison, officially known as the House of Correction, was built in 1871. Here men push wheelbarrows in the prison stone quarries in 1907. Construction began on a new county jail and courthouse at the site in 1928.

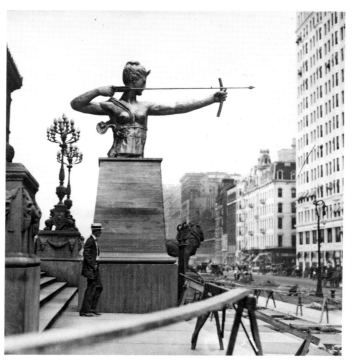

Diana competes for attention with Edward Kemeys's famous lions in front of the Art Institute in 1909. The statue of Diana was shown as part of a memorial exhibition of the work of Augustus Saint-Gaudens. Members of the nearby Cliff Dwellers club complained that *Diana* didn't harmonize with its Michigan Avenue surroundings, and they joked about shooting the "contraption" from their vantage point in the upper reaches of Orchestra Hall, just across the street. The statue was removed when the exhibition closed.

High Bridge, which spanned the lagoon at Lincoln Park, was built in 1894. It offered a view of the North Side from seventy-five feet up, but distraught Chicagoans found another use for it. In 1919, a policeman told the *Tribune* there were sometimes two suicides there in the same week. Authorities posted a guard and studied the possibility of hanging nets to catch jumpers, but they couldn't shake the structure's popular name of "Suicide Bridge," which was even featured on postcards for tourists. The bridge was torn down in 1919.

CITY ON THE MAKE

Many Chicago monuments, such as Buckingham Fountain, were created during a heady period of economic prosperity and civic ambition in the early twentieth century. The fountain, at Columbus Drive and Congress Parkway, was touted as the largest in the world when it began operation in 1927. Designed by Edward H. Bennett and built by Marcel Loyau, it was conceived as a memorial to Clarence Buckingham by his wealthy sister, Kate Buckingham. Her gift included a three-hundred-thousand-dollar trust fund for maintenance, which financed a two-million-dollar-plus renovation in 1994.

Wrigley Field began in 1914 as a single-decked ballpark called Weeghman Park, home field for Chicago's entry in the upstart Federal League. The ballpark at Clark and Addison streets was built in less than seven weeks, despite a two-day labor strike. For the first two seasons, the home team was variously called the Chicago Federals, the Chi Feds, and the Chicago Whales. When the Federal League folded, the National League's Chicago Cubs moved in. In 1920, the stadium was renamed Cubs Park, and in 1926 it became Wrigley Field. An upper deck was built in 1927, and a major renovation began in 1937 adding the ivy and scoreboard that are so familiar today. Lights weren't installed until 1988.

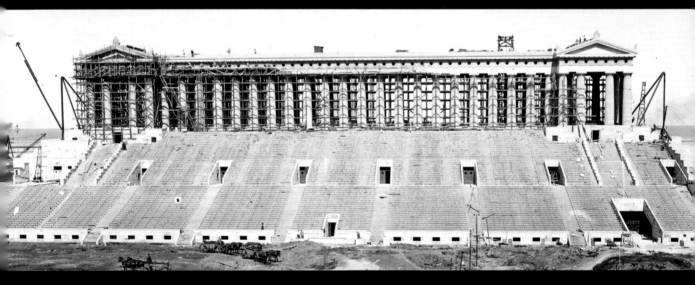

Soldier Field, originally called Municipal Grant Park Stadium, was dedicated in 1925 to honor deceased soldiers from World War I. It has hosted religious events, concerts, stock-car races, fireworks shows, tractor pulls, rodeos, ski-jumping contests, and both professional and amateur football. In 1937 a high school football game drew more than a hundred thousand fans. A major renovation in 2003 retained the stadium's famous colonnades but otherwise transformed the structure into a modern arena. Architecture critics howled, and the federal government revoked Soldier Field's status as a national historic landmark.

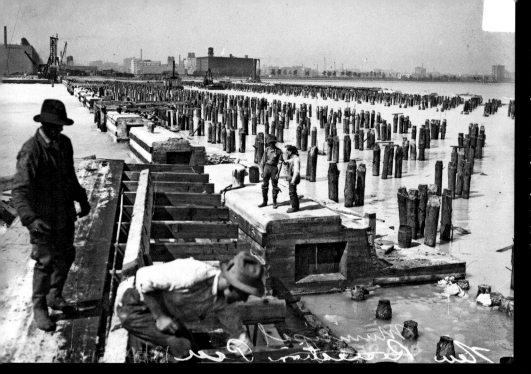

If Daniel Burnham's Chicago Pla[n] had been fully realized, there woul[d] be two piers as grand as Navy Pie[r.] The three-thousand-foot extensio[n] into Lake Michigan started out a[s] Municipal Pier, as seen in this 191[?] photo. Used for naval training durin[g] World War II, it afterward housed [a] branch of the University of Illinoi[s.] The pier fell into neglect in the 1960[s] but was renovated in the 1990s an[d] has become one of Chicago's majo[r] tourist attractions.

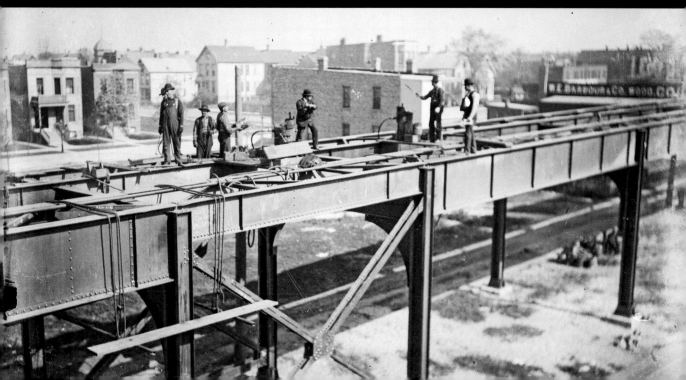

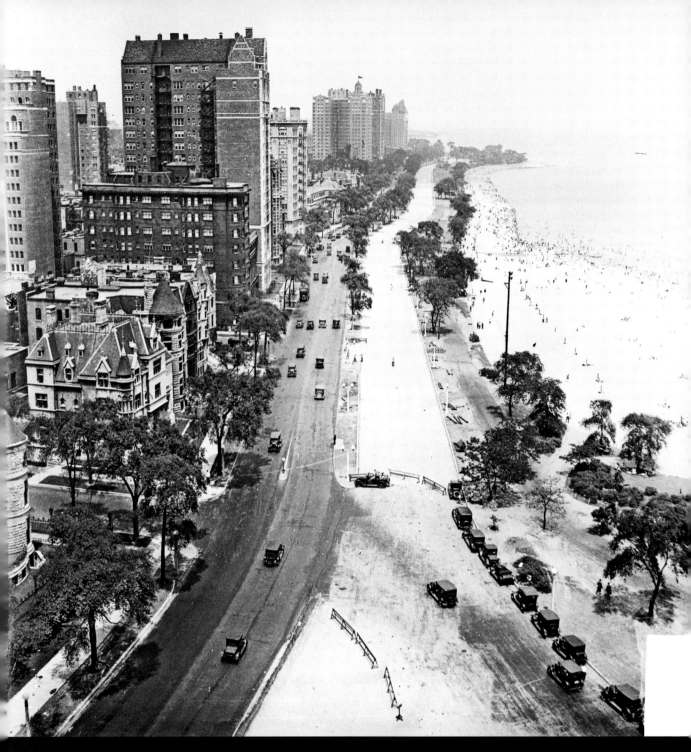

n the late nineteenth century, Lake
Shore Drive was a charming loca-
ion for new mansions and was de-
cribed as "one of the handsomest
carriage ways to be found in the

world." But in Chicago, the lake-
front was not just for the wellborn,
and the democracy of the automo-
bile created a thoroughfare that was
as bustling as it was beautiful. This

view north from the Drake Hotel in
1927 shows Lake Shore Drive as a
four-lane road—impressive in the
days before superhighways but a
mere gully compared to the eight-

lane channel it would later become
Indeed, Chicago's signature road
reflects the city's outlook: Neve
forget the past, but never be bound
by it either.

READINGS AND REFERENCES

Abramoske, Donald J. "The *Chicago Daily News*: A Business History, 1874–1901." PhD diss., University of Chicago, 1963.

Adams, David Wallace. "More Than a Game: The Carlisle Indians Take to the Gridiron, 1893–1917," *Western Historical Quarterly*, spring 2001.

Algren, Nelson. *Chicago: City on the Make.* 1951; Chicago: University of Chicago Press, 2001.

Allsop, Kenneth. *The Bootleggers and Their Era.* Garden City, N.Y.: Doubleday, 1961.

Angle, Paul M., ed. Article on acquisition of *Chicago Daily News* photographs. *Chicago History*, winter 1960–61.

Aschenbrenner, Joyce. *Katherine Dunham: Dancing a Life.* Urbana: University of Illinois Press, 2002.

Barnhart, David K., and Allan A. Metcalf. *America in So Many Words: Words That Have Shaped America.* Boston: Houghton Mifflin, 1997.

Barnhart, Robert K., and Sol Steinmetz, eds. *Chambers Dictionary of Etymology.* Edinburgh: Chambers, 1988.

Bergreen, Laurence. *Capone: The Man and the Era.* New York: Simon & Schuster, 1994.

Berg, A. Scott. *Lindbergh.* New York: Putnam, 1998.

Bernstein, Arnie, ed. *The Movies Are: Carl Sandburg's Film Reviews and Essays, 1920–1928.* Chicago: Lake Claremont Press, 2000.

Bierley, Paul E. *John Philip Sousa: American Phenomenon.* Englewood Cliffs, N.J.: Prentice-Hall, 1973.

Block, Eugene. *Fingerprinting: Magic Weapon against Crime.* New York: David McKay Company, 1969.

Boulding, Elise. *The Underside of History: A View of Women through Time.* Boulder, Colo.: Westview Press, 1976.

Brandt, Nat. *Chicago Death Trap: The Iroquois Theatre Fire of 1903.* Carbondale: Southern Illinois University Press, 2003.

Brecher, Jeremy. *Strike!* Boston: South End Press, 1997.

Bushnell, George D. "The International Aviation Meet, 1911," *Chicago Historical Society* magazine, spring 1976.

Cahn, William. *A Pictorial History of American Labor.* New York: Crown, 1972.

Calistro, Paddy, and Fred E. Basten. *The Hollywood Archive: The Hidden History of Hollywood in the Golden Age.* New York: Universe, 2000.

Carlebach, Michael L. *American Photojournalism Comes of Age.* Washington, D.C.: Smithsonian Institution Press, 1997.

Casey, Robert J. *Such Interesting People.* Indianapolis: Bobbs-Merrill, 1943.

Chu, Chi-ying (Jim). "Henry Justin Smith 1875–1936: Managing Editor of the *Chicago Daily News*." PhD diss., Southern Illinois University, 1981.

Cowan, David. *Great Chicago Fires: Historic Blazes That Shaped a City.* Chicago: Lake Claremont Press, 2001.

Cronon, William. *Nature's Metropolis: Chicago and the Great West.* New York: Norton, 1991.

Cox, Henry J., and John H. Armington. *The Weather and Climate of Chicago.* Chicago: Geographic Society of Chicago/University of Chicago Press, 1914.

Cox, Bill, Bill Francis, William J. Helmer, Gary C. King, Julie Malear, David Nemec, Samuel Roen, and Billie Francis Taylor. *Crimes of the 20th Century.* New York: Crescent Books, 1991.

Davis, Jeff. *Papa Bear: The Life and Legacy of George Halas.* New York: McGraw-Hill, 2005.

Davis, Jerome. *The Russian Immigrant.* New York: Arno Press, 1969.

Davis, Ozora Stearns. "Victor F. Lawson, Journalist." Undated typescript, *Chicago Daily News* Records, Newberry Library, Chicago.

Dedmon, Emmett. *Fabulous Chicago.* 1953; New York: Atheneum, 1981.

Dempsey, Jack, with Bob Considine and Bill Slocum. *Dempsey, by the Man Himself.* New York: Simon & Schuster, 1960.

Dennis, Charles H. *Victor Lawson: His Time and His Work.* 1935; New York: Greenwood Press, 1968.

Dickson, Paul, comp. *Baseball's Greatest Quotations.* New York: Edward Burlingame Books, 1991.

Divine, Robert A. *American Immigration Policy, 1924–1952.* New York: Da Capo, 1972.

Drell, Adrienne, ed., with the staff of the *Chicago Sun-Times.* *20th Century Chicago: 100 Years, 100 Voices.* Champaign, Ill.: Sports Publishing, 2000.

Duis, Perry R. *Challenging Chicago: Coping with Everyday Life, 1837–1920.* Urbana: University of Illinois Press, 1998.

Farr, Finis. *Rickenbacker's Luck: An American Life.* Boston: Houghton Mifflin, 1979.

Fox, Paul. *The Poles in America.* New York: Arno Press, 1970.

Frommer, Harvey. *Shoeless Joe and Ragtime Baseball.* Dallas: Taylor Publishing, 1992.

Fury, David. *Johnny Weissmuller: Twice the Hero.* Minneapolis: Artist's Press, 2000.

Fussell, Betty Harper. *Mabel: Hollywood's First I-Don't-Care Girl.* New Haven, Conn.: Ticknor & Fields, 1982.

Garraty, John A., and Mark C. Carnes, eds. *American National Biography.* New York: Oxford University Press, 1999.

Georgano, G. N., ed. *Transportation through the Ages.* New York: McGraw-Hill, 1972.

Gilbert, Martin. *Winston S. Churchill.* Vol. 5, *The Prophet of Truth, 1922–1939.* Boston: Houghton Mifflin, 1977.

Gilbert, Paul, and Charles Lee Bryson. *Chicago and Its Makers.* Chicago: F. Mendelsohn, 1929.

Glines, C. V. "Captain Eddie Rickenbacker: America's World War I Ace of Aces," *Aviation History,* January 1999.

Gorn, Elliott J. *Mother Jones: The Most Dangerous Woman in America.* New York: Hill and Wang, 2001.

Granger, Bill, and Lori Granger. *Lords of the Last Machine: The Story of Politics in Chicago.* New York: Random House, 1987.

Green, Jonathon. *Cassell's Dictionary of Slang.* London: Cassell & Co., 2000.

Griffin, Dick, and Rob Warden, eds. *Done in a Day: 100 Years of Great Writing from the Chicago Daily News.* Chicago: Swallow Press, 1977.

Grossman, James A., Ann Durkin Keating, and Janice L. Reiff, eds. *The Encyclopedia of Chicago.* Chicago: University of Chicago Press, 2004.

Hatch, Anthony P. *Tinder Box: The Iroquois Theatre Disaster, 1903.* Chicago: Academy Chicago Publishers, 2003.

Hecht, Ben. *A Child of the Century.* 1954; New York: Primus, 1985.

———. *Gaily, Gaily.* Garden City, NY, Doubleday, 1963.

———. *A Thousand and One Afternoons in Chicago.* 1922; Chicago: University of Chicago Press, 1992.

Heise, Kenan. *The Chicagoization of America, 1893–1917.* Evanston, Ill.: Chicago Historical Bookworks, 1990.

Higdon, Hal. *The Crime of the Century: The Leopold and Loeb Case.* New York: Putnam, 1975.

Hilton, George W. *Eastland: Legacy of the Titanic.* Stanford, Calif.: Stanford University Press, 1995.

Janeway, Elizabeth, ed. *Women: Their Changing Roles.* New York: New York Times, 1973.

Katz, Ephraim. *The Film Encyclopedia.* 3rd ed. Rev. by Fred Klein and Ronald Dean Nolan. New York: HarperPerennial, 1998.

Keil, Hartmut, and John B. Jentz, eds. *German Workers in Chicago: A Documentary History of Working-Class Culture from 1850 to World War I.* Urbana: University of Illinois Press, 1988.

Klingaman, William K. *1919: The Year Our World Began.* New York: Harper & Row, 1987.

Kobler, John. *Capone: The Life and World of Al Capone.* New York: Putnam, 1971.

Kogan, Herman, and Rick Kogan. *Yesterday's Chicago.* Miami: E. A. Seemann, 1976.

Lanning, Michael Lee. *The African-American Soldier: From Crispus Attucks to Colin Powell.* Secaucus, N.J.: Carol Publishing, 1997.

Lewis, Lloyd, and Henry Justin Smith. *Chicago: The History of Its Reputation.* New York: Harcourt, Brace, 1929.

Lindberg, Richard. *Chicago Ragtime: Another Look at Chicago, 1880–1920.* South Bend, Ind.: Icarus Press, 1985.

———. *Return to the Scene of the Crime: A Guide to Infamous Places in Chicago.* Nashville: Cumberland House, 1999.

———. *To Serve and Collect: Chicago Politics and Police Corruption from the Lager Beer Riot to the Summerdale Scandal, 1855–1960.* 1991; Carbondale: Southern Illinois University Press, 1998.

Lubell, Samuel. *White and Black: Test of a Nation.* New York: Harper & Row, 1964.

Lynn, Kenneth S. *Charlie Chaplin and His Times.* New York: Simon & Schuster, 1997.

Lovell, Mary S. *The Sound of Wings: The Life of Amelia Earhart.* New York: St. Martin's, 1989.

MacAdams, William. *Ben Hecht: The Man behind the Legend.* New York: Scribner, 1990.

Maisel, Albert Q. *They All Chose America.* New York: T. Nelson, 1957.

Maltin, Leonard, and Richard W. Bann. *Our Gang: The Life and Times of the Little Rascals.* New York: Crown, 1977.

Mayer, Harold M., and Richard C. Wade. *Chicago: Growth of a Metropolis.* Chicago: University of Chicago Press, 1969.

Melton, J. Gordon. *Biographical Dictionary of American Cult and Sect Leaders.* New York: Garland, 1986.

Merriner, James L. "Chicago's Political Conventions: From the 'Smoke-Filled' Room to 'The Whole World Is Watching." *Illinois Issues,* August 1996.

Messadie, Gerald. *Great Modern Inventions.* Trans. Melanie Hanbury; adapted by Bill Houston, Min Lee, and Penny Smith. Edinburgh: Chambers, 1991.

Mix, Paul E. *The Life and Legend of Tom Mix.* South Brunswick: A. S. Barnes, 1972.

Morris, Charles. *American Catholic: The Saints and Sinners Who Built America's Most Powerful Church.* New York: Vintage, 1998.

Nash, Jay Robert. *Bloodletters and Badmen: A Narrative Encyclopedia of American Criminals from the Pilgrims to the Present.* New York: M. Evans and Co., 1995.

———. *Makers and Breakers of Chicago.* Chicago: Academy Chicago Publishers, 1985.

Newcombe, Jack. *The Best of the Athletic Boys: The White Man's Impact on Jim Thorpe.* Garden City, N.Y.: Doubleday, 1975.

Panati, Charles. *Panati's Parade of Fads, Follies, and Manias: The Origins of Our Most Cherished Obsessions.* New York, N.Y.: HarperPerennial, 1991.

Pettifer, Julian, and Nigel Turner. *Automania.* Boston: Little, Brown, 1984.

Price, Jack. *News Pictures.* New York: Round Table Press, 1937.

Pyke, Magnus. *The Science Century.* New York: Walker, 1967.

Pryor, Louis L. "Years of Transition: The *Chicago Daily News* under Publishers Strong, Knox, Knight." Typescript, ca. 1963, *Chicago Daily News* Records, Newberry Library, Chicago.

Rich, Doris L. *Amelia Earhart: A Biography.* Washington, D.C.: Smithsonian Institution Press, 1989.

Richardson, Ernie, Joyce McKee, and Doug Maxwell. *Curling.* New York: D. McKay, 1963.

Roberts, Randy. *Papa Jack: Jack Johnson and the Era of White Hopes.* New York: Free Press, 1983.

Robinson, David. *Chaplin, His Life and Art.* New York: McGraw-Hill, 1985.

Robinson, Ray. *Rockne of Notre Dame.* New York: Oxford University Press, 1999.

Rosaaen, K. S. Letter to the editor concerning John Philip Sousa. *Time,* May 30, 1927.

Ross, Ishbel. *Silhouette in Diamonds: The Life of Mrs. Potter Palmer.* New York: Harper & Brothers, 1960.

Roth, Walter, and Joe Kraus. *An Accidental Anarchist: How the Killing of a Humble Jewish Immigrant by Chicago's Chief of Police Exposed the Conflict between Law & Order and Civil Rights in Early 20th-century America.* San Francisco: Rudi Publishing, 1997.

Sandburg, Carl. *Chicago Poems.* 1916; Urbana: University of Illinois Press, 1992.

Sawyers, June Skinner. *Chicago Sketches: Urban Tales, Stories, and Legends from Chicago History.* Chicago: Loyola University Press, 1995.

Scamehorn, H. Lee. *Balloons to Jets.* Chicago: Regnery, 1957.

Schiavo, Giovanni E. *The Italians in Chicago: A Study in Americanization.* New York: Arno Press, 1975.

Schneider, Dorothy, and Carl J. Schneider. *American Women in the Progressive Era: 1900–1920.* New York: Facts on File, 1993.

Schoenberg, Robert J. *Mr. Capone.* New York: Morrow, 1992.

Scott, Emmett J. *Scott's Official History of the American Negro in the World War.* 1919; New York: Arno Press, 1969.

Smith, Richard Norton. *The Colonel: The Life and Legend of Robert R. McCormick, 1880–1955.* Boston: Houghton Mifflin Co., 1997.

Sugar, Bert Randolph. *The Sports 100: A Ranking of the Greatest Athletes of All Time.* New York: Carol Publishing, 1997.

Swanson, Gloria. *Gloria on Gloria.* New York: Random House, 1980.

Smith, Alson J. *Chicago's Left Bank.* Chicago: Regnery, 1953.

Smith, Henry Justin. *Deadlines: Being the Quaint, the Amusing, the Tragic Memoirs of a News-room.* Chicago: Covici-McGee, 1922.

———. *Josslyn: The Story of an Incorrigible Dreamer.* Chicago: Covici-McGee, 1924.

Spear, Allan H. *Black Chicago: The Making of a Negro Ghetto 1890–1920.* Chicago: University of Chicago Press, 1967.

Stead, William T. *If Christ Came to Chicago!* 1894; Evansville, Ind.: Unigraphic, 1978.

Stone, Melville E. *Fifty Years a Journalist.* 1921; New York: Greenwood Press, 1968.

Taylor, John W. R., and Munson, Kenneth. *History of Aviation.* New York: Crown, 1872.

Tuttle, William M., Jr. *Race Riot: Chicago in the Red Summer of 1919.* 1970; Urbana: University of Illinois Press, 1996.

Uglow, Jennifer S., ed. *The Northeastern Dictionary of Women's Biography.* Boston: Northeastern University Press, 1999.

Waldrop, Frank C. *McCormick of Chicago: An Unconventional Portrait of a Controversial Figure.* Englewood Cliffs, N.J.: Prentice-Hall, 1966.

Ward, Geoffrey C., and Ken Burns, with Jim O'Connor. *Shadow Ball: The History of the Negro Leagues.* New York: Knopf, 1994.

Werstein, Irving. *The Great Struggle: Labor in America.* New York: Scribner, 1965.

Wittke, Carl. *We Who Built America.* Cleveland: Press of Western Reserve University, 1964.

Young, David M. *Chicago Maritime: An Illustrated History.* DeKalb: Northern Illinois University Press, 2001.

———. *Chicago Transit: An Illustrated History.* DeKalb: Northern Illinois University Press, 1998.

WEB SITES

Chicago Daily News photo archive, American Memory (Library of Congress). http://memory.loc.gov

Chicago History Museum. http://chicagohs.org

Chicago Public Library. http://chipublib.org

Eastland Memorial Society. http://eastlandmemorial.org

Graveyards of Chicago. http://graveyards.com

Hyde Park–Kenwood Community Conference. http://hydepark.org

Illinois Labor History Society. http://kentlaw.edu/ilhs/

Jane Addams Hull-House Museum. http://uic.edu/jaddams/hull/

Jazz Age Chicago. http://jazzagechicago.com

Poetry magazine. http://poetrymagazine.org

Polish National Alliance. http://pna-znp.org

Rich Samuels. http://richsamuels.com

ILLUSTRATION CREDITS

Images are listed by page, with negative numbers given for photographs from the Chicago History Museum archive of *Chicago Daily News* negatives. Except for the image on page iii, all *Daily News* photos are from glass-plate negatives.

47. Maxwell Street sweatshop, DN-0002416
48. Girl with coal basket, DN-0000497; boy smoking, DN-0001019
49. Coal gathering, DN-0000522
50. Salvation Army, DN-0000528; iceman, DN-0058281B
51. George Streeter and wife, DN-0065393
52. Mother Jones, DN-0065279; Lucy Parsons, DN-0063954
53. Emma Goldman, DN-0003882; Ben Reitman, DN-0052268
54. "Umbrella Mike" Boyle, DN-0067691
55. Men in line, DN-0000935
56. Strikebreaker hanged in effigy, DN-0001418
57. Troops in Gary, DN-0071491
58. Train station immigrant room, DN-0009228
59. Children outside Polish saloon, DN-0000729
60. Maxwell Street market, DN-0068689
61. Annie Carlo-Blasi, DN-0062624
62. Chinatown "city hall," DN-0085864
63. Mexican workers, DN-0068516
64. Native Americans, DN-0004923
65. Girl on stacked trunks, DN-0008851
66. Booker T. Washington, DN-0056935
67. Soldiers guarding homes, DN-0071302; men on street corner, DN-0071297
68. Blackface at Great Lakes Naval Training Center, DN-0069003
69. Amos 'n' Andy behind bars, DN-0088828; Amos 'n' Andy with young black men, DN-0088835

CHAPTER THREE

71. Re-creation of Saint Valentine's Day Massacre, DN-0087709
72. "Big Jim" Colosimo, DN-0063234
73. Al Capone, DN-0087660
74. John Scalise and Alberto Anselmi, DN-0082640; Frankie Lake and Terry Druggan, DN-0079320
75. Angelo Genna's funeral, DN-0079121
76. Sam Peller on stretcher, DN-0082096
77. Joe Aiello, DN-0084495C
78. Scene of Saint Valentine's Day Massacre, DN-0087707
79. Re-creation of Saint Valentine's Day Massacre, DN-0087709

80. Louise Rolfe, DN-0087855
81. Ole Scully, DN-0086947
82. Beulah Annan, DN-0076798; Belva Gaertner, DN-0076749
83. Nellie Higgs, DN-0062636
84. "Terrible" Tommy O'Connor, DN-0071445
85. Henry Spencer, DN-0061183; Thomas Jennings, DN-0008842
86. Nathan Leopold's glasses, DN-0077995
87. Leopold's typewriter, DN-0077610; Leopold, Richard Loeb, and Clarence Darrow, DN-0078021
88. Jail guard, DN-0006595
89. Peter Hoffman, DN-0060457; Mary Margaret Bartelme, DN-0076674
90. Lazarus Averbuch, DN-0005898
91. Victoria Shaw, DN-0055519; "Yellow Kid" Weil, DN-0070628
92. August Rosengard, DN-0000411; Mr. Kocha, DN-0004439
93. Fred Wahlenmeyer, DN-0008717; Julius Duc, DN-0004110

CHAPTER FOUR

95. Lupe Velez, DN-0088251
96. Alexander sisters, DN-0078662
97. John Philip Sousa, DN-0063145
98. Enrico Caruso, DN-0072477
99. Will Rogers, DN-0084993
100. Cube Theatre, DN-0087333
101. Irene Castle, DN-0075298
102. Chicago Theatre, DN-0075429
103. Theda Bara, DN-0068220
104. Selig movie company, DN-0062405
105. Mary Pickford, DN-0085860
106. Charlie Chaplin, DN-0009913
107. Gloria Swanson, DN-0089960
108. "Fatty" Arbuckle, DN-0072778
109. Mary Miles Minter, DN-0068195
110. Mabel Normand, DN-0073443
111. Buster Keaton, DN-0075108
112. "Sunshine Sammy" Morrison, DN-0078980; Tom Mix and Mayor William Dever, DN-0078892
113. Rin Tin Tin, DN-0080493
114. Lupe Velez, DN-0088251
115. Lorado Taft, DN-0060199

CHAPTER EIGHT

CHAPTER NINE

INDEX